IMAGE MAKERS, IMAGE TAKERS

Zones of Exclusion **PRIPYAT AND CHERNOBYL**

Robert Polidori

Thames & Hudson

IMAGE MAKERS, IMAGE TAKERS

THE ESSENTIAL GUIDE TO PHOTOGRAPHY BY THOSE IN THE KNOW

ANNE-CELINE JAEGER

218 ILLUSTRATIONS, 179 IN COLOUR

This edition published in the United Kingdom
in 2007 by Thames & Hudson Ltd, 181A High
Holborn, London WC1V 7QX

www.thamesandhudson.com

British Library Cataloguing-in-Publication Data

A catalogue record for this book is available from
the British Library

ISBN-13: 978-0-500-28662-3
ISBN-10: 0-500-28662-0

Printed and bound in China by C & C Offset
Printing Co. Ltd

CONTENTS

Introduction

'YOU DON'T TAKE A PHOTOGRAPH, YOU MAKE IT.' **ANSEL ADAMS**

As early as 1888 George Eastman, the founder of Kodak, was promoting the notion that taking a picture was an utterly straightforward task. When he invented the Kodak towards the end of the nineteenth century, a small, easy-to-use camera, which contained one hundred pictures on a dry gelatin roll, the advertising slogan read, 'You push the button and we do the rest.' With that, Eastman lay down the foundation for making photography available to everyone.

Half a century later, in 1943, when photography had become even more accessible to the masses thanks to an ever-progressing evolution in technology, Josef Albers argued that the Kodak slogan promoted 'a taking of pictures with the least care possible.' He maintained that 'such a way of looking at photography ... is of the lowest level possible and should not be our way of approaching and understanding photography.'[1]

As cameras have become ever smaller and easier to use in the wake of the digital revolution, we have perhaps reached an apex of effortlessness when it comes to taking pictures. Due to the immediacy of the medium, and its automatic qualities, the element at the heart of photography – light – has for the most part been forgotten.

Hence the message of the Kodak slogan, even if we were unaware of it, is now most certainly instilled in us. Moreover, in an era of endless print media, on-demand TV viewing, mobile-phone photography and advertising campaigns tailored to the individual, our eyes have become so accustomed to the daily onslaught of images, that we are no longer able to look at them with a discerning eye.

That said, you may wonder what is needed besides the push of a button to make a great photograph? How can we look through our lens with more than just our eyes? How can we learn to really see an image once it has come into existence?

Using conversations with some of the most respected photographers from the fields of art, portraiture, documentary and fashion and advertising, as well as discussions with some of the world's leading curators, picture editors, photo agency directors and art book publishers, *Image Makers, Image Takers* attempts to explore these questions. It examines the nature of the creative process involved and analyses which photographic approach translates into talent. This collection of twenty-eight interviews gives an insight into how photography's contemporary masters think and work, hopefully inspiring you to look not only at a photograph, but also through your lens, in a whole new way.

In particular, this book addresses the act of 'seeing' and what is involved for both photographer and viewer. Often overlooked, 'seeing', in photography, is an active pursuit. It involves a conscious endeavour to look beyond the mere reproduction of a subject. The eye – of both photographer and viewer – should be trained like any other muscle in the body.

Josef Albers argued that 'photographs reveal the individuality of a photographer if we as spectators are able to read it. Just as the unmusical ear is not competent to judge music, so it is likewise with pictures, whether they are paintings, drawings or photos. Only a sensitive and trained eye gives us the right to judge, as it gives us a deeper reading and enjoyment. It belongs, I believe, to education to get beyond the point of mere likes and dislikes.'[2]

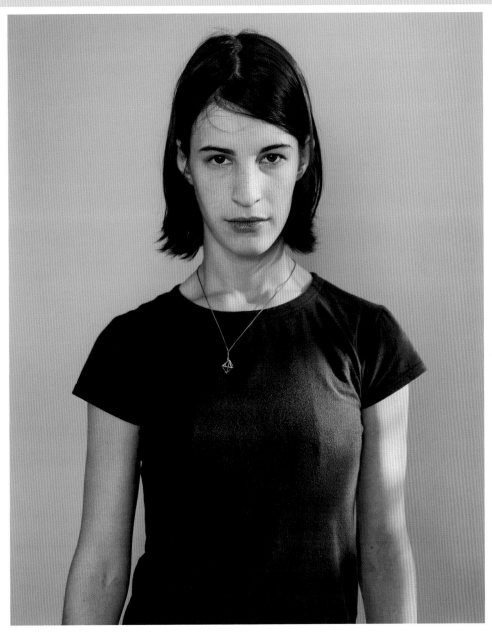

Rineke Dijkstra, *Shany, Herzliya, Israel, August 1*, 2003

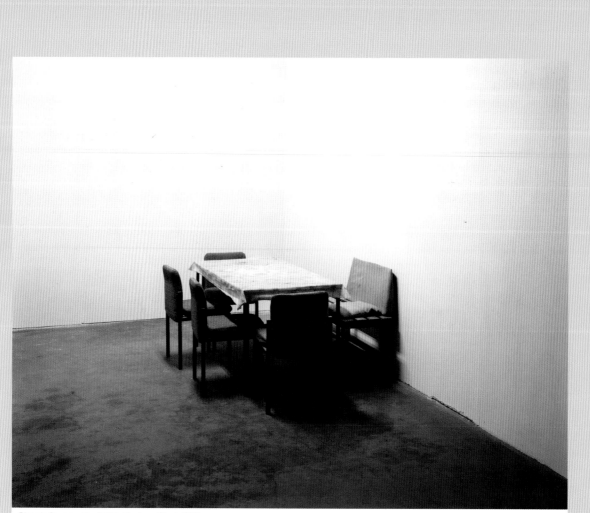

Ricarda Roggan, *Vier Stühle, Tisch und Bank*, 2002

"I want my pictures to ask questions. I want people to look at my pictures and have an emotional response."

It is a common phenomenon today that people believe they can judge an image because they see what's on the picture. Dr Inka Graeve Ingelmann, chief curator of photography at Munich's Pinokothek der Moderne, says: 'people think they understand photography because it is represented in a figurative way.... But for someone to actually figure out what it is that the artist wants to show us, or for someone to develop a sophisticated way of seeing, that doesn't happen often.'

One need only observe how individuals move through a gallery or museum. On the whole captions are read first, carefully and attentively, then the viewer will glance at the image in question and swiftly turn to the next caption. Although we have a feeling of understanding and insight as an explanation was given to us, we haven't, for the most part, actually assessed the image ourselves. The thought process – 'How do I feel about it? What is the image telling me? What does it make me think?' – has been side-stepped. Similarly, when we look at newspapers or magazines. How often do we actually give an image time to leave an imprint on our mind? Is it not more often the case that we have forgotten it by the time we turn the page?

If this is our approach when looking at photography, presumably it is not too dissimilar when we are taking a picture. It is probably fair to say that most of us, 'take' pictures, we don't 'make' them. Why? Perhaps because we haven't fully grasped the limitless possibilities the medium provides. Or perhaps, because as André Kertesz pointed out 'everybody can look, but they don't necessarily see.'[3] Photography, at its best, goes way beyond the pretty picture.

'To me, photography is the art of observation,' Elliott Erwitt says. 'It's about finding something interesting in an ordinary place…. I've found it has little to do with the things you see and everything to do with the way you see them.'

Most outstanding photographers, including the ones represented in this book, would argue that 'seeing' is paramount. Or, to put it a different way, a 'singularity of vision' is needed to create a remarkable image. By addressing the notions of vision and philosophy, *Image Makers, Image Takers* attempts to unravel the essence of great photographs, both from the point of view of the person 'making' the image and the person who at a later stage sees it.

In reference to the question, 'What do you look for in an image?' Kathy Ryan, picture editor of *The New York Times Magazine*, suggests that 'It's about great seeing and authority. The pictures people remember resonate on an emotional level. An image has to command attention and reward you with something when you stare it down. It should either give you a deeper understanding of a subject

Mario Sorrenti, *Goya, Men Feeding* (*Another Magazine*), 2004

or allow you to appreciate something in a completely new way, to let you see the world anew.'

So in order to 'make' a picture, far more is needed than the mere push of a button. Indeed, the Kodak approach couldn't be further from the minds of the photographers interviewed in this book. Most use the medium as a means to investigate, to ask questions. Mario Sorrenti explains 'I want my pictures to ask questions. I want people to look at my pictures and have an emotional response.

A certain kind of sixth sense, it appears, also comes into play for photographers. When asked what she looks for in her subjects, Rineke Dijkstra says 'I try to find people that have something special. I don't even know what it is. It's intuition.' Equally, when asked to illustrate how he decides whether something is worthy of being captured or

William Eggleston, *UNTITLED, DUNKERQUE*, 2005

limited edition prints, even of very young photographers, at times now sell for extremely high sums, the motivation of some photographers emerging on the scene today may have shifted somewhat.

In his interview, Stephen Shore harks back to the days when, as a twenty-four-year-old, he had his first solo exhibition at the Metropolitan Museum of Art, New York. He says that 'things were different then'. According to Shore, you could be the best photographer in the world and still only sell your prints for $35. At best, a hundred people might have known your name. He argues that 'today, unless you're sure of yourself, you might get swayed by the art market.' Shore also refers to a shift he has observed in some young photographers: 'I meet young artists and it becomes clear that with some the main motivation is getting a show in Chelsea. It strikes me that this is very different to the way it was for me, which was that I wanted to understand photography and the world and myself. I'm always exploring some question or another.'

The notion of exploring questions is not just of utmost importance to the photographers in this book, it is also paramount to the individuals who 'take' the images from photographers and present them to the public. Key figures in the industry, from picture editors through to curators, maintain that a photograph should kick-start a thought process or instigate some kind of a reaction. 'I think photography is one hundred per cent about asking questions. Pictures with the most staying power transcend literal meaning. There's poetry,' says Kathy Ryan.

And, when discussing how he goes about choosing photographers he'd like to publish, the godfather of art book publishing, Gerhard Steidl, says: 'It's an emotional reaction. And sometimes it's linked to stringent curiosity. If something attracts me on an instinctive level, but I haven't actually fully understood what it's about, then I'll usually go with the project, because I feel like I can learn something or discover something new.'

Perhaps Henri Cartier-Bresson expressed it best, when he said: 'As far as I am concerned, taking photographs ... is a way of shouting, of freeing oneself, not of proving or

not, William Eggleston replies: 'I never know beforehand. Until I see it. It just happens all at once. I take a picture very quickly and instantly forget about it.... Even the most uninteresting, ugly or boring places can for an instant become magical to me.'

There is no doubt that the landscape of photography has changed drastically since the medium was wholeheartedly accepted as an art form. More and more, photography is being exhibited in galleries and museums. Photography festivals are booming and collecting prints is, amongst art collectors, ever more fashionable. Given that

asserting one's own originality. It is a way of life.'[4] When it comes to photography, a certain dose of obsession certainly doesn't go amiss. Photographer Edward Steichen once spent a whole summer photographing pears. That kind of persistence indicates a longing or need to solve a problem of an aesthetic, conceptual or formulaic nature – or a combination of all three. With this sort of commitment and curiosity, 'seeing' takes on a whole new dimension. It becomes a highly attuned sense that goes beyond merely leaving an imprint of a subject on the retina, or on film, for that matter. The outcome, whether you are a documentary, conceptual, portrait or fashion photographer remains the same: by the time it comes to pushing the button, you will be 'making' a picture rather than simply 'taking' it.

And it is this sort of commitment that is evident in the photographers interviewed for *Image Makers, Image Takers*. Whether speaking to Tina Barney in the sunlight-flooded Janet Borden gallery in New York, or to Sebastião Salgado, who spends up to three months on location photographing, for example, the workers of the Serra Pelada goldmine in Brazil or documenting marine iguanas in the Galapagos, it becomes clear that each photographer in this book lives and breathes their art. They immerse themselves in the medium, fully and utterly, whether it's by going to art shows, doing eighteen-hour day shoots or, as was the case for Russian photographer Boris Mikhailov, spending months with the homeless in the Ukraine.

Given that there is a distinct fluidity in photography as well as a multitude of interpretations available for any given photograph, most photographers interviewed here do not sit comfortably solely in one category. Hence, Tina Barney, could just as well feature in the 'art' as in the 'portraiture' section. Similarly, Mary Ellen Mark straddles both the 'documentary' and the 'portraiture' category, but even she at times also shoots advertising campaigns. Indeed fashion photography in general, has become much more conceptual in recent years, resulting in editorials or fashion campaigns being seen not just in their intended context but also in photography books or exhibitions. And when it comes to documentary photographers, most

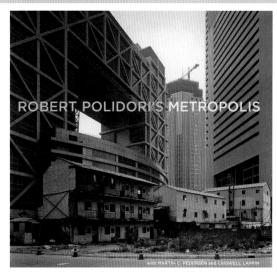

Robert Polidori, *Metropolis*, published by Steidl, 2004

would never opt to be included in the 'art' section, although it must be noted that limited editions prints by photographers such as Martin Parr and Sebastião Salgado are currently being sold in a gallery context, alongside more traditional art photography.

So why split these photographers up into categories at all? Dividing the twenty image makers into five distinct sections covering art, documentary, fashion and advertising, portraiture and next generation, is a useful tool to help navigate through the book, giving the reader an overview of what each individual photographer is best known for. It allows you to witness how they work, bearing in mind each photographer's particular focus, and enables you to compare their approach.

In order to see what differentiates the young successful photographers from those with decades of experience, *Image Makers, Image Takers*, also includes a 'next generation' section which includes photographers from each of the four main categories (portraiture, documentary, art and fashion and advertising).

Boris Mikhailov, *Case History*, 1998–99

Given that, as Robert Doisneau once said, 'We must always remember a picture is also made up of the person who looks at it,'[5] I felt it was important to include interviews with the people who select images and display them ready to be viewed by the public: picture editors, curators, art book publishers, gallerists and photo agency directors.

After all, these individuals are to some degree taste-makers and define what images reach the masses. It could even be argued that they dictate, almost more so than photographers themselves, what makes a great image. Hence, I was curious to know, how does a curator go about choosing an image for a gallery wall? How does a picture editor select which photographer is to get the next commission? What qualities must a photographer possess in order to become the next member of Magnum?

When talking about what attracts him to working so closely with photographers when co-creating their books, Gerhard Steidl says, 'The subtlety and little experiences that emanate from the creative process and lead to the understanding of art, that's what most fascinates me. I feel very comfortable in the role of the student. Every artist that comes in teaches me something new, whether it's about colour, framing or design. I'm allowed to glimpse into the atelier, the kitchen, the mind of the artist. I'm always at the source.'

Photography and seeing has evolved tremendously since its birth in the nineteenth century. Nevertheless the notion of an instamatic image seems to be stuck in our collective consciousness. No matter how well versed we think we are in photography, no matter how talented, we should always strive towards a deeper level of understanding. Even Michelangelo used the phrase, '*Ancora imparo*' (I am still learning) as his motto at the height of his career.

The aim of *Image Makers, Image Takers* is to lead you into that atelier, that kitchen Steidl refers to and into the minds of those photographers, curators, gallerists, agency directors, picture editors and publishers, thereby unravelling some of the mystery behind the creative process involved.

Because unlike Kodak's 1888 catch-phrase suggested, great photography is anything but straightforward. Perhaps a better slogan would be: 'It's not what you click, but how you tick.'

1 An unpublished lecture by Josef Albers preserved at The Josef Albers Foundation. Delivered by Albers at Black Mountain College on 24 Feb 1943
2 An unpublished lecture by Josef Albers preserved at The Josef Albers Foundation. Delivered by Albers at Black Mountain College on 24 Feb 1943
3 An interview with André Kertesz, *Camera*, Apr 1977
4 Henri Cartier-Bresson, *Aperture History of Photography* Volume 1, 1976
5 An interview with Robert Doisneau, *Camera*, Nov 1977

PART 1
IMAGE MAKERS, IMAGE TAKERS

ART, DOCUMENTARY, FASHION AND ADVERTISING
PORTRAITURE, NEXT GENERATION

Thomas Demand

Inspired by political events and using pre-existing images frequently derived from mass media, the German artist Thomas Demand builds life-size recognizable environments from paper and cardboard and then documents these short-lived constructions with a large format camera. His work, which is removed from reality by several degrees, is at once staggeringly real and curiously artificial, and it is this tension he creates that keeps the viewer engaged in an attempt to find answers. By merging conceptual thinking with skilled artistry, Thomas Demand pushes the boundaries of photography. He has had numerous solo shows and has published several books including *Thomas Demand Phototrophy* and *Thomas Demand*.

Thomas Demand, *Gate*, 2004

You were a sculptor first, but when did you get into photography?

That's true, I was a sculptor, but the sculptures I made were never made to last. They were quite flimsy, and supposed to be thrown away at the end. At some point, I started to document what I was doing, and the documentation became a problem because the photographs of the sculptures never showed what I found interesting when making the sculpture.

Given that Bernd Becher told you that you needed three years to become proficient in photography, how did you teach yourself?

It wasn't so much that I wanted to work like Bernd and Hilla Becher, it was more that they were the ones running the photographic workshop at the Düsseldorf Academy, so they were the only ones to ask. But the whole point of my sculptures was that I didn't want to spend time making things over a long period of time. I used materials like paper, cardboard and sticky foil and didn't want to spend much more than a day or two on them. Therefore studying photography for three years was exactly the opposite of what I wanted to achieve.

So for a while, it was easier for me to make two sculptures. One which was a three dimensional representation of the formal idea I wanted to express, and the other following the rules of perspective according to a 35mm lens.

How did you get from the point of making two sculptures, to making just one and shooting it the way you wanted it?

By the time I was making only the one sculpture, I knew how to use a camera. It's actually quite easy. You don't need three years of training.

Are you still using a 35mm camera?

No, I use a large format camera.

What would you call yourself now if you had to give yourself a label?

I don't have to give myself a label. What I can do is say 'no' to certain things. For example, if I'm invited to do a photography show, I tend to say no. The medium itself, I find, is a relatively boring context. You would never see a show about acrylic paint. If it's that kind of understanding of the medium, it's completely uninteresting on an intellectual level. I make art. I don't come from a photographic background and I try to stay away from contexts where the work is diminished down to how it's made. For example, I wouldn't do a show about Fuji film.

Have you been asked to do a show about Fuji film?

No, but obviously I get asked to be in photography shows quite a bit, especially shows about whether photography lies or not. I always say 'no' to those.

How do you come up with concepts for the things you construct?

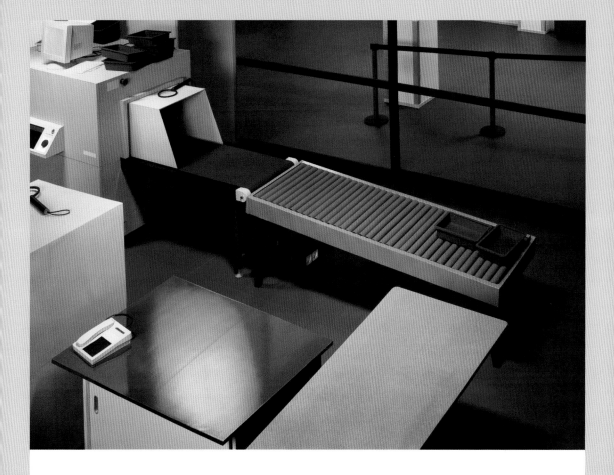

"All I can show you are the things necessary to demonstrate the thought that led me to this picture. I can't show you the actual thought. Otherwise I'd write a pamphlet and put it on the wall."

In retrospect it always seems like a master plan. But essentially it's threads of interest, which you keep running after, or formal ideas that you've had in your mind for ages, such as representing the same object twice or numerous times on a photograph. Then it's about how you turn that simple formal premise into something more than that.

Thomas Demand, *Lichtung/Clearing*, 2003

You mentioned that you create your sculptures quickly. Presumably something like *Lichtung/Clearing*, however, is not a one-day job.

It depends on the subject. At the beginning, I wanted to keep the sculptures as simple as possible and not build up some artificial task for myself. But things develop, not only because you have different

interests than before, but also because you've already done certain things. The longer you look into something, the more complex your understanding becomes. For example, if you play chess, in the beginning you're happy to just move the figures according to the rules. Once you become good at that, however, that is no longer of much interest. Then you start thinking about the connection between one more and the next one etc.

Can you reveal what kind of work is involved in creating something like *Lichtung/Clearing*?

Thirty people assembling trees for three months.

What about something like *Archiv/Archive*?

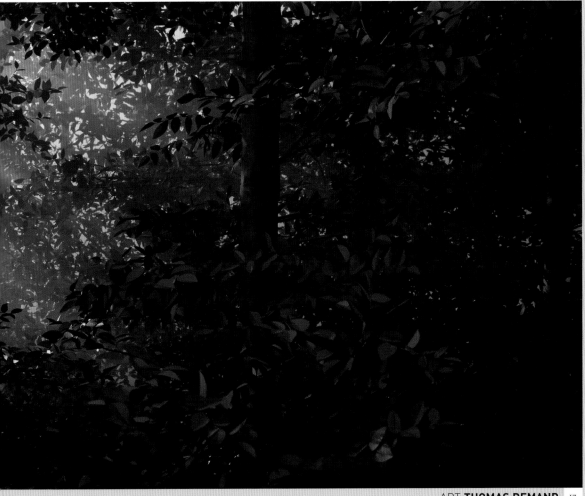

The idea, which finally led me to *Archiv/Archive* was based around the concept of something similar to an Agnes Martin painting. The same formal element repeated again and again. Take Andy Warhol's coloured bottles. Why does it look different when you have so many next to each other? That was the beginning of my thought process. Then you see an image of files for example. And on a very banal level, filing systems are made of paper, so you have another reading of the material in your pictures and what's showing. However, the archive of files in itself is not an inspiring topic, being that it's a very common, Kafka-esque metaphor. That would just be executing somebody else's thought. So you drop that, but at that point you already have whole threads of interest, which come from totally different contexts. Often thoughts sit around before they come back and hit you. To get the final idea that connects all the threads can take anywhere between two days and several years.

What kind of a thought-process do you hope to elicit in the viewer?
I know what I think as an artist, but it's impossible to say what other people might think. That's total speculation. Look at it from a different perspective. If you go to a museum and look at a Titian, say a portrait of King Charles V, do you need to know what Titian thought about Charles V to enjoy the painting? I would say no. All I can show you are the things necessary to demonstrate the thought that led me to this picture. I can't show you the actual thought. Otherwise I'd write a pamphlet and put it on the wall.

Do you think people get your work?
I think some people get it more, and some less. And some probably get it more than I get it. There are always lots of floating variables in terms of understanding an art work. Coming back to Titian, for example, you can get a context if you want it in a museum. But I wouldn't say that the person who wants to read more about Charles V necessarily has a better understanding of the painting than the bus driver who thinks that the painter has a funny name.

What kind of art sticks with you the most when you go to a show?
First and foremost things I don't understand and things with a quirky sense of beauty. If for example, you read Matisse's writings, you learn that he wanted to achieve something fairly ugly to overcome the Academy's idea of beauty. So the perfection of Matisse is not in making a perfect picture but in creating the perfect balance between what you see and what it triggers in you.

Thomas Demand, *Archiv/Archive*, 1995

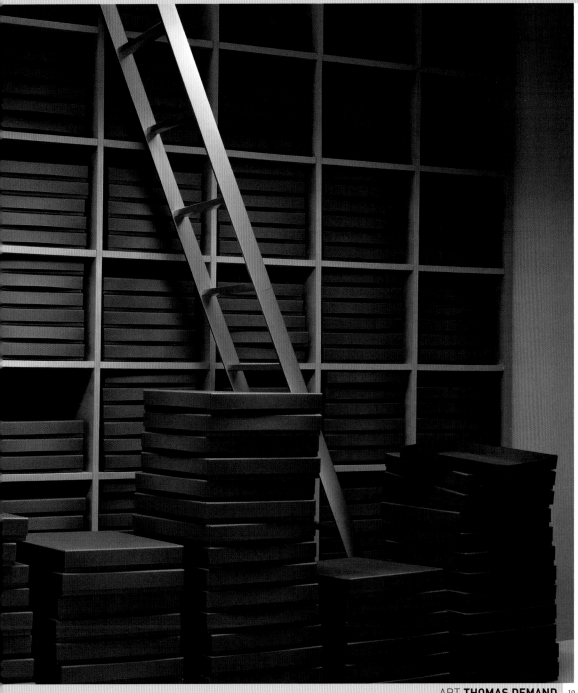

> "I feel like the artists who matter to me most stick to one theme and that's where the real development comes from – the act of revisiting things."

In conceptual art in particular, the balance between effort and outcome is fantastic, as is the total lack of metaphor. The things you normally expect art to have are totally missing. It's obvious that beauty is not about how elegantly someone can draw, or what material they used, or how their piece is situated in a space, but essentially it's a very elegant thought, which hardly needs a thing in order to be articulated. Those are the things I find interesting.

You mention a lot of painters – were you more inspired by these than by photographers?

No. I recognize that what I do – making things out of cardboard for example – is quite an eccentric technique. It's enough to keep myself entertained and raise a few questions. On another level, I work with sculptures and things come into the picture, which are concerns of painting. So you have elements of painting and sculpture being combined with a third medium, which is photography. But my background is not in photography, it's in art.

Did you study art?

I studied art and for some time philosophy.

Do you think you need a philosophy to produce a great piece of work?

I don't know what you need. But I know that at art school you don't necessarily learn to develop a thought through to the end the way

a philosopher does. You stutter things out. What about this? What about that? It's ongoing thinking and the act of exploring one topic that has not only fascinated me, but also informed the way I work. I feel like the artists who matter to me most stick to one theme and that's where the real development comes from – the act of revisiting things. Look at the work of John Baldessari. He comes back to the same few ideas, which is fantastic, because those are incredibly ground-breaking. To me that's what an artist does – he has an idea and he tries to find a form for that.

Do you destroy what you've made once you've made your image?

Yes. I just want to have it out of the way. They are large life-size sculptures that are built to scale. So what you see in the print is what the lens saw. The reason I started making films was because I wanted to get the sculptures more in the foreground of my attention again. You realize that a photograph is not just showing you one view of a thing, but the thing itself actually allows different views.

If you look hard at your images, you can see slight imperfections in the sculptures, but you really have to look....

But that's what art is about. Looking. On a very obvious level, everything in my images has the same surface, whereas real life doesn't. On a more detailed viewing, if

someone doesn't see that, they probably see that nothing has writing on it, or that there are no signs of usage on anything. Things are like their own prototype. But the objects on the photographs themselves are to some extent convincing.

They suggest a certain context. You have a feeling, for example, in *Copyshop,* that it's not just any copyshop, but that it's one specific copyshop, at a specific point in time. If people don't see that I can't help them anyway. Part of what I said about a sense of perfection is about thinking how much do I leave in and how much do I take out?

Tell me about *Gate*. It's no longer possible to walk through an airport without thinking about that work....

You can never say exactly how something came about, but something might come to your mind and keep coming back. With *Gate* I was interested in two things. First of all it was CCTV cameras. With those you have a constant production of images until something important happens. It's the complete opposite to how a photographer works. They either produce an event or wait for the right moment to take a photograph. Working with existing pictures, like I do, you constantly think about the flood of images we are subjected to and you want to figure out how you can make sense of it. Also, it turns out that digital photography is actually keeping alive the debate about whether

photography lies or not. For example, everyone now has a camera phone. So authorship and authenticity is the interesting point. If anything is dying it's the author. But coming back to surveillance, the starting point was footage taken from the moment before 9/11, before the terrorists went on the plane, when that part of the world still seemed to be intact. And these machines are machines of recognition – optical devices to find things, which incidentally, they didn't find. The CCTV camera recorded it to prove that they didn't find anything, so you have this picture of a circle of failure.

What are you looking for in the printed version of your work? How do you go about editing?

I usually know where the camera should be situated when I start building a sculpture. During the last two weeks I might start defining the viewpoint. I then get a sense of where the light has to sit and try to minimize what I think is a mistake. The whole editing process for me is taking a picture, seeing something I don't like and then changing the sculpture. That's why for me, a computer is pointless, because I can go behind and in front of my camera and change it then and there.

How many attempts until you get the image you want?

At times, hundreds of attempts, but at other times just a couple. *Lichtung/Clearing*, for example,

> "Working with existing pictures, like I do, you constantly think about the flood of images we are subjected to and you want to figure out how you can make sense of it."

was particularly difficult. I tried loads of times until the light hit the leaves exactly how I wanted and put other leaves in the shade.

Do you know when you have the right image?

Usually I have three or four prints at the very end. Then it's like sharpening up the context. Sometimes you get deluded by something in your image because it looks nice and it came out as a surprise, but then you realize that that wasn't the reason you took the picture. It's good to control whether something is what you wanted or whether it just looks good.

What kind of advice would you give to a budding photographer?

I don't teach photography students, I teach art students, and if they think they can make use of a camera that's fine. But probably they've started at the wrong end because they've chosen their medium before they've chosen their content. Having said that, the chances of making it as an artist are so small, I'd advise anyone to do something they are really passionate about, rather than speculating about what other people might be interested in. That way, if you don't make it, which is quite likely, you at least know you were working on something that meant something to you.

Thomas Demand, *Copyshop*, 1999

William Eggleston

Often referred to as the 'father of colour photography', William Eggleston was already experimenting with colour in the early 1960s, at a time when working in black-and-white was the norm for most of his peers. Using his home environment – Memphis and Mississippi – as his subject matter, William Eggleston became famous for monumentalizing everyday subjects in his large-format prints. In 1976, the Museum of Modern Art's groundbreaking one-man show entitled 'William Eggleston's Guide', established his reputation as a pioneer of modern colour photography.

William Eggleston, *UNTITLED, DUNKERQUE*, 2005

When did you first get interested in photography?

A friend of mine who was really into photography made me buy my first camera – a Canon – when I was studying at Vanderbilt University in Nashville in 1957. I was fascinated immediately. At the time there weren't really any decent photographers that were published, so I pretty much taught myself. I started developing my own black-and-white pictures in a darkroom I made in my dorm room.

Do you think it's important to be technically proficient?

You become technically proficient whether you want to or not, the more you take pictures. To me it was obvious what I needed to learn.

What camera do you use?

I use all kinds of cameras, but mostly I use 35mm Leicas. Sometimes I use large format cameras, such as a 6x9 and up to 5x7 inches. But I don't think about what camera I should use that much. I just pick up the one that looks nicest on the day.

How often do you shoot these days?

All the time. I just go out and shoot. I don't really have any projects in mind, I just have a camera along wherever I go. I might be at a friend's house. It doesn't make any difference. I'll just shoot wherever I happen to be.

How do you decide if something is worthy of being captured?

I never know beforehand. Until I see it. It just happens all at once.

I take a picture very quickly and instantly forget about it. Not for good, but for the time being. Suddenly I just feel like I have to take a picture. Sometimes I'll leave the house with a fully loaded camera and end up with nothing. It's just about being there. Anywhere. Even the most uninteresting, ugly or boring places can for an instant become magical to me.

What goes through your mind when you are framing a shot?

Nothing really. It happens so fast. I compose very quickly and without thinking, but consciously. I take a picture instantly and never more than one. Sometimes I worry about the picture being out of focus, but I take that chance. A long time ago, I would have taken several shots of the same thing, but I realized that I could never decide which one was the best. I thought I was wasting a lot of time looking at these damn near identical pictures. I wanted to discipline myself to take only one picture of something, and if it didn't work out, that's just too bad. But it's pretty much always worked.

Do you think a photographer needs a philosophy to do good work?

I don't know how to answer that, but I suppose it must be there. Somewhere.

What would you like to elicit in the viewer?

If anything I would probably like the viewer to study the entire picture and everything that's in it, where

"Sometimes I'll leave the house with a fully loaded camera and end up with nothing. It's just about being there. Anywhere. Even the most uninteresting, ugly or boring places can for an instant become magical to me."

it's placed, the composition. I would also hope that the image would register in the viewer's mind after seeing it in print. It's not even so much about remembering the image, but *seeing* it.

How did the historic Museum of Modern Art show come about?

A number of friends suggested I should show my work to John Szarkowski, at the time the curator of photography at the museum. So I called him right away when I was in New York and asked whether I could come by and show him some work. We formed a very close friendship over a long period of time. We worked together almost daily looking at pictures that I would bring with me. Over a period of years, we selected images out of thousands and it developed into an important show and book.

Did you have anyone to discuss your work with when you started out?

When I started in 1957 there really weren't any other photographers out there doing the kind of work I knew I wanted to do. My associates, people like Lee Friedlander, Garry Winogrand, Diane Arbus, we all knew each other. We felt like a secret society that believed in each other. We never criticized each other's work, although we took extremely different kinds of pictures, we would just look at each

William Eggleston, *UNTITLED, GREENWOOD, MISSISSIPPI*, 1973

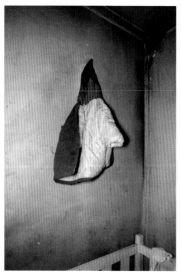

William Eggleston, *UNTITLED,*
NEAR JACKSON, MISSISSIPPI, c. 1970

other's work. I guess we all learnt and borrowed from each other – only with the best of intentions of course. It wasn't copying.

Do you think discussing work is a useful tool?

I used to have very little to say about other people's work. There's almost nothing to say. I just like looking. I've never been able to do that about my own work or other people's, at least not verbally. I've just been asked to write an introduction to Andreas Gursky's book. I respect his work immensely, but I just don't know where to begin. I don't feel I can comment on it. I feel like I get my point across without speaking, especially when I'm showing things of mine to people I respect. Lee Friedlander and I for example, have a connection like that.

Where do you get your inspiration?

I don't really look at other people's photographs at all. It takes enough time to look at my own. Occasionally, I might look at a book, but I have a great love of music. I play and compose. I'm not sure I can say it inspires my photography. However, the fact that I work in groups of pictures, sometimes very large groups of pictures, is perhaps an indication that I wish to create a flow with my images equivalent to that of a fine piece of music.

What makes one image stand out more than another?

I don't have favourites. I look at

pictures democratically. To me they are all equal. There are still so many pictures that I wish were seen, but that have never had the chance. And then there are some pictures that have become very well-known, which I never picked as favourites. For example, the picture of the red ceiling. That wasn't taken with anything in mind. I was actually in this small town in Mississippi, lying on a bed with a friend of mine, who had this queer habit of painting different rooms in different colours. And we were just lying there on the bed with his wife talking and I looked up and there was this lightbulb and this red everywhere and I instantly took the picture. It doesn't bother me one bit if other people choose a selection when putting a book or an exhibition together. I usually let them do it. I don't even give guidelines. But they are usually people I have come to respect and know. People like Thomas Weski and John Szarkowski.

How do you find your subjects, such as the woman with the red hair or the blue jacket hanging in an isolated room?

The red-headed woman was a complete stranger. I was just walking by and I took her picture and then kept walking. It was taken in the Gulf of Mexico. I wish I had met her because she's so beautiful, but I left too fast and never went back. Often I take pictures while I'm in the process of moving, either

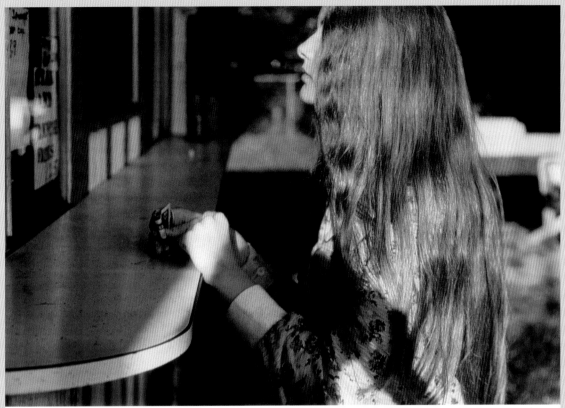

William Eggleston, *UNTITLED (BILOXI, MISSISSIPPI)*, 1974

"I used to have very little to say about other people's work. [...] I just like looking. I've never been able to do that about my own work or other people's, at least not verbally."

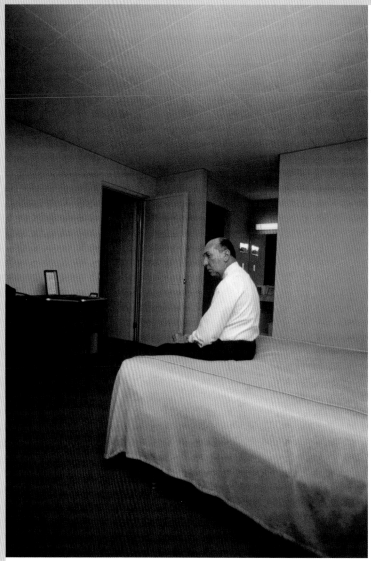

William Eggleston, *UNTITLED (HUNTSVILLE, ALABAMA)*, 1972

walking, or driving. It's just a split second during a particular voyage.

The blue jacket I took in central Mississippi. This friend of mine took me out to a place where several families lived all together in this very humble house that was torn down once a year and then rebuilt using really cheap materials, like cardboard etc. I was just wandering around. I'd never been there before. They were strangers to me but they didn't mind my being there. I saw that picture and took it instantly, with a flash, because it was dark in there, then I carried on roaming around the other rooms.

What about the man sitting in the motel room or the old man who is showing you his gun?

The motel room picture came about when I was invited by the US Navy to do an inspection tour of the Nasa Space base. I'm not sure they knew I was a photographer, but I had my camera. After a day of touring the place where they built rockets, a group of us went back to this hotel and I just walked down the corridor and I happened to know this man and I walked in and instantly took a picture and left. He was just sitting at the end of the day, relaxing, fixing himself a cocktail.

The old man and his gun was taken in this tiny town, where a distant relative of my wife's lived. The man used to be the night watchman of the town and he

would stroll around and keep the peace. He showed me the gun he carried on him. He was retired, but he told me various stories about incidents. Right before I took that photograph he showed me bullet wounds. The picture was taken in his house, on his bed.

Do you think you can learn a way of seeing?

I grew up playing the piano from a very young age. I was self-taught. I have an ear for it and can play things whether I have the notes in front of me or not. The same goes for photography, it's either in you or it's not. You can't really learn it.

Did any photographers inspire you?

Yes. The first one I felt had any sense was Cartier-Bresson. They'd just published a book of his when I was at college and I started looking at it and comparing it to a few other people I knew at the time. I thought it was the only thing that had art about it. I could tell that he was familiar with Degas, Matisse, Toulouse-Lautrec. It was reflected in his compositions.

When does something become art?

Whether it's Kandinsky, who is my favourite painter or Bach, who I have studied a great deal – when something is original it makes sense. Bach never repeats himself. I could say that about Kandinsky and Klee too. But take music. It's not just entertainment. There's a difference between entertainment and learning. If I look intense when

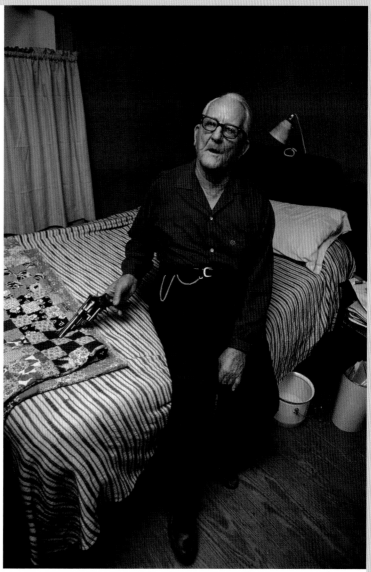

William Eggleston, *UNTITLED (MORTON, MISSISSIPPI)*, c. 1972

I'm listening to music, it hopefully means I'm learning something.

What excites you most about photography?

Probably the fact that I want to, and know that I can, take pictures that no one else has taken before. I certainly don't think about what other people might think looking at them. It's more about what I'm going to think myself when I look at them. When someone asked him why he took pictures, my old friend Garry Winogrand said, 'Because I want to see what something looks like when it's photographed.' I've never been able to top that quote. I feel the same way.

Do you ever shoot on assignment?

I'm not against assignments. Often they are projects I would never have thought of myself, or challenges, and I like to see how they will work out. I've just been commissioned by *The New York Times Magazine* to photograph a bird, known as the Ivory-billed woodpecker, which was thought to be extinct for years. I've never shot a bird before and we don't even know whether we'll find it or not. Nobody has seen it in a thousand years.

What about commercial work?

I try to get out of it politely. I'm just not interested.

What advice would you give a budding photographer?

Keep trying. I would also tell them, frankly [he laughs], to look at my pictures.

William Eggleston, *UNTITLED (MEMPHIS, TENNESSEE)*, c. 1975

"When someone asked him why he took pictures, my old friend Garry Winogrand said, 'Because I want to see what something looks like when it's photographed.' I've never been able to top that quote. I feel the same way."

Boris Mikhailov

Born in the Ukraine in 1938, Boris Mikhailov first picked up a camera when he was twenty-eight years old. Driven by the political landscape infecting his homeland, Boris Mikhailov's photographs demonstrated a satirical criticism of the Soviet Regime during the 1970s and 1980s. Following the downfall of the Soviet Union, Mikhailov's focus shifted to capturing the social disintegration affecting his country. He has published several books, including *By the Ground*, *At Dusk*, *Case History*, *Salt Lake* and *Boris Mikhailov: A Retrospective*. Boris Mikhailov was the recipient of the Hasselblad Award in 2000 and the Citibank Photography Prize in 2001.

Boris Mikhailov, from the 'Case History' series, 1998–99

When did you start taking pictures?

I was working as an engineer in a military factory in the Ukraine and got bored. I wasn't very good. I liked other things like basketball better. In the 1960s engineers were nobodies because that's what everybody was, but everybody loved artists – they were well-respected in society at that time.

One day, the factory where I worked told me to make a film about it. I was released from my main job but continued receiving my engineer's salary. So through this strange incident, my first 'art work' was about a very important and well-known Russian pedagogue who, after the Revolution, took homeless children and taught them how to take pictures in a photo-camera factory. They were the first workers in the very same factory where many years later I came to work. But I didn't like the idea of only showing something once. Making the movie inspired me to take pictures, and they were quite good. I just photographed more and more and over time became a photographer. I was twenty-eight years old when I started taking pictures.

Did you teach yourself?

We didn't have photography schools. I got some advice from other photographers, but otherwise I'm completely self-taught.

What was it that attracted you to photography?

I had to 'discover' everything myself, experimentally, step by step. I also started working with photography because I was very pleased with a picture I had made. It was a photo of woman holding a cigarette. The combination of woman and cigarette was a radical break from the norms of Soviet photography of that epoch: you were only supposed to show Soviet women as an ideal. If naturalism didn't coincide with the ideal, it was simply not to be made public. Generally I intuitively felt that photography was the field where I could express myself as a citizen and a human being. At the time, everything from print labs to typewriters were being watched because of their potential to be used to propagate information that didn't coincide with the Party line. Soon after I started taking pictures, I got into trouble. The KGB came to my studio and took all my negatives – three years of work – and destroyed them. For example, they found a negative of a naked woman and destroyed it. So I went to a lawyer and I showed my pictures to the Party people and explained that I wasn't a pornographer, that I wasn't a bad man. They said, 'Nobody gave you permission to take these pictures, even if you've seen it in a Czech magazine.' It was then that I realized the Soviets were about double standards. I got angry but that only made me stronger.

Boris Mikhailov, from the 'SOZ-Art/SOTS ART, USSR' series, 1975–78

"I intuitively felt that photography
was the field where I could express
myself as a citizen and a human being."

Were you working as an engineer and a photographer simultaneously?

For a while yes, but I left the factory after the KGB incident. I was fired from the factory where I had worked as an engineer and started working in a photo lab. I became a technical photographer at the big Project Institute. Then in 1994, I went freelance.

How important is the political undercurrent in your work?

Because the ideological press was so strong it was important for me to express myself on a political level, which I did in 'The Red' series and in the 'SOTS ART' series for example. Very often my negative or ironic images – at that time images of social critique – could be treated as a political utterance. It was very important for me.

Sometimes, it is even possible to interpret my work that was taboo in a political way ... even taking photographs of women. Ortega y Gasset has a good explanation as to why totalitarian regimes prohibit nudity. He connected it with the fact that in totalitarian–atheistic regimes one can lose the feeling of guilt (losing connection with the Church) so it becomes difficult to manipulate. Therefore prohibition encourages guilt and obedience.

Could you exhibit your work?

For a long time I'd show my pictures amongst friends. It was impossible to show any kind of

Boris Mikhailov, *Superimpositions from the 60s–70s*, 2005

negative or critical information. You could only show the positive or the beautiful. It wasn't even possible to be openly surrealistic or formalistic. Quite quickly I discovered how to take a good picture. For example, by doing superimpositions with slides or colour photographs. I got very good results and that gave me the feeling that I was a step ahead, that I was doing something new, something nobody had ever done before in my country. That gave me confidence to continue even if I couldn't exhibit.

Did you have access to international photographers' work?

Not really. Sometimes we'd see a Cartier-Bresson or an American colour photographer, but we only got to see 'normal' things, nothing

that was very deep. But I understood after a while that it wasn't important for me to look at foreign photographers' work. They have a really strong aesthetic, which corresponded to the Western environment and technology and which, I guess, was in direct contrast with my life. In my life there is dirt, things are broken. Even the way foreign artists organize a picture is really clean. It was important for me to take pictures about what the Soviet Union was about. I needed to concentrate on what was real, what our life was about and to create an identity through that.

What is the importance of working in a series to you? Do you think an individual picture can have impact?

Boris Mikhailov, from the 'Salt Lake' series, 1986

I don't like to mix styles and I always think in terms of a book, so shooting in a series makes sense. I always try to create a great individual picture, but some come out better than others and you can create a flow. Also, you might find that after a while, the picture you thought was a little less good is actually the better picture. In a series, at least you'll have them both. For 'Salt Lake' for example, it was important to work in a series because I wanted to show the different aspects of the same location – a place where a factory spills untreated water directly into the sea and people swim in it because they believe it has healing powers. I also wanted to show that it wasn't just a sudden phenomenon, something that happened on one day. I wanted to show this was life.

What kind of equipment do you use?

When I started, I was working with a variety of Soviet cameras. Later I began using foreign cameras. The 'By the Ground' and 'At Dusk' series were shot with Gorizont and the 'Case History' series with a 35mm Nikon and Leica. Now I use Canon.

Do you think it's important to be technically proficient?

I was always against good technique because it didn't work with Soviet life. Good quality equals foreign life. Now that technology has improved in my country too, I need to think about how to compare the new technology with our new life.

Why have you done a lot in post-production in the past?

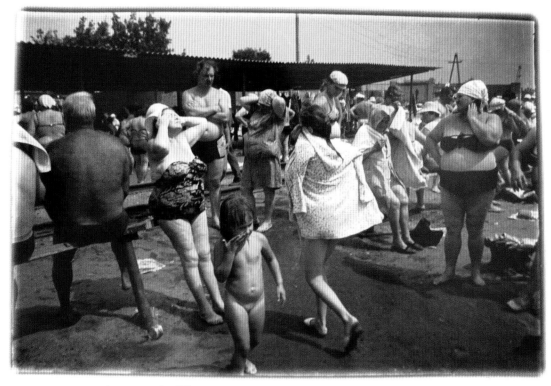

Boris Mikhailov, from the 'Salt Lake' series, 1986

"It was important for me to take pictures about what the Soviet Union was about. I needed to concentrate on what was real, what our life was about and to create an identity through that."

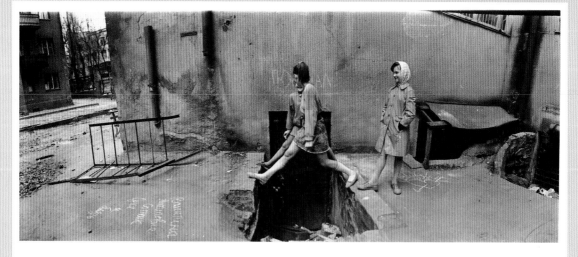

The way that I work is that I take a picture and then later think: what does this mean? Once I've understood it a little bit, I try to organize the pictures in a certain way. When I started, the quality of my camera was quite bad. It didn't produce sharp images, and my eyes didn't work well either. I wanted to add things, sometimes colour, sometimes words to give the images a new dimension. For example, I added brown to the 'By the Ground' series because I wanted viewers to think about what their life was like now and how we lived before the Revolution. The pictures look like life a long time ago and yet they were taken in 1990, after the Perestroika.

How did the 'Case History' series come about?

I went back to the Ukraine after a long absence – I had been living in Berlin – and was shocked at how different life was. For a month I didn't take a picture because I wasn't really sure what was happening. I saw many homeless people and that was really new. I understood how capitalism works. The rich get richer the poor get poorer. Once I understood that I started to take pictures. Access was difficult and at times dangerous, but after a while I got to know my subjects and people stopped being suspicious of me.

Why did you pay your homeless subjects to take their picture?

I'd never paid models before but I wanted to help them the little I could. It was very important to me. There are only three ways you can take someone's picture: the reportage method, with love (such as using a 'friend'), or by paying. Paying is the capitalistic way.

Is it important to have a philosophy to be a good photographer?

I think you need more than a pretty picture. In Russia everyone who became a photographer had been an engineer, they had all had a good education. I think you have to understand life, then you can take a picture. If you have a good mind, you can take a good picture.

What do you think about when you are framing a shot?

I don't look in the frame. I look later. First I look in life. I normally only take one image of a subject because theme usually overrides aesthetics. For the 'Case History' series, I tried not to be aesthetic, in case that made the images less truthful.

Above: Boris Mikhailov, from the 'By the Ground' series, 1991
Opposite: Boris Mikhailov, from the 'Case History' series, 1998–99

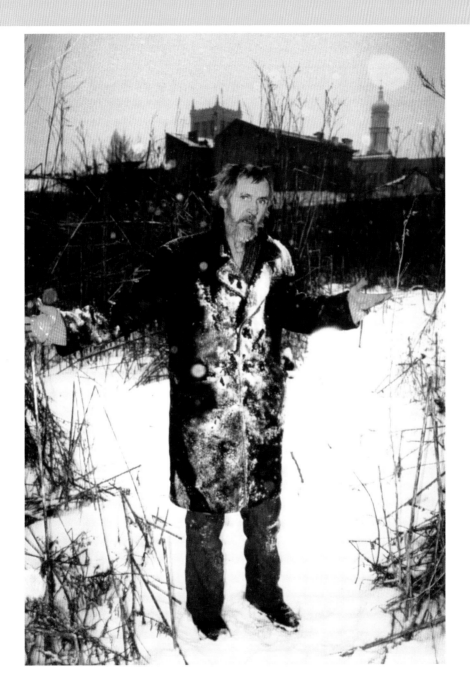

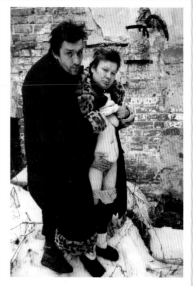

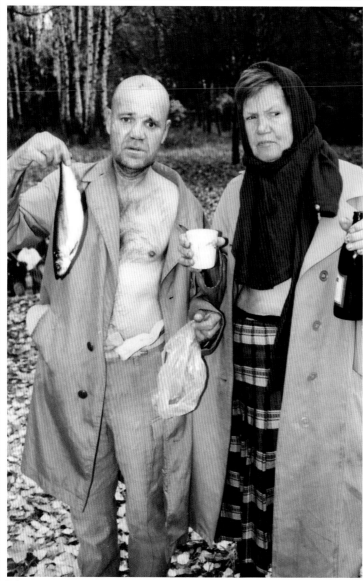

Left and right: Boris Mikhailov, from the 'Case History' series, 1998–99

Do you think it's possible to learn a way of seeing?

I think you can learn a little bit. Everybody has something to give but it's difficult to find out what that thing is. Photographers must be very aggressive and open for life, you have to be a very social person. You have to be able to look inside yourself.

Where do you get your inspiration from?

Ideas come to me quite suddenly. For example for the last project I did, I went out to take pictures of people during carnival and I ended up taking pictures of old people because I saw them in the street for the first time and I thought, 'I belong to that group now.'

Is the Ukraine still your main source of inspiration?

I'm living in Berlin now, part-time, and it's hard for me to understand what life is really about here because I don't speak the language. I don't think being in Berlin is very good for my work. You need to live in the place you want to photograph to really understand it, to play with it.

Will politics play a part in future projects?

I think photographs are always on the social side otherwise you could say it was a painting. For example, when Lee Friedlander took pictures of trees, even those could be interpreted on a social level.

What advice would you give to a budding photographer?

I think it's very difficult to find themes these days. You have to look around you and ask yourself: what is my life about? It's difficult to find a new kind of life, but when you do, it will be a success. Look at Robert Mapplethorpe. He was important because he found something and transformed it into a new life, a new way of seeing. Same goes for Nan Goldin: she took pictures of a new life.

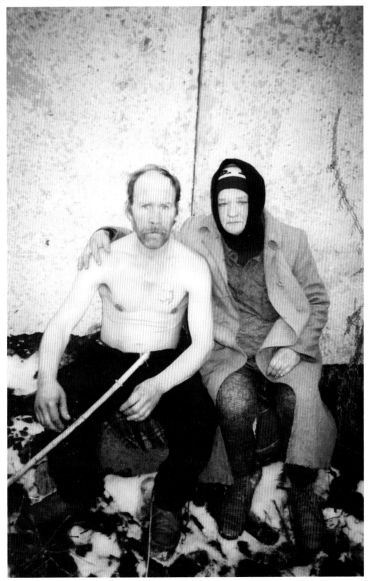

Boris Mikhailov, from the 'Case History' series, 1998–99

Stephen Shore

A pioneer of colour photography, Stephen Shore began taking pictures just before his ninth birthday. By the time he was fourteen, he had sold three prints to the Museum of Modern Art and at twenty-four, had secured the first solo exhibition at the Metropolitan Museum of Art ever to be granted to a living photographer. In the 1970s, Stephen Shore began travelling through America, documenting the country's cultural landscape. He has published numerous monographs including *American Surfaces* and *Uncommon Places*.

Stephen Shore, *West Market St and N. Eugene St, Greensboro, NC, January 23*, 1976

When did you first get interested in photography?

When I was six years old I was really interested in chemistry and a relative of mine gave me a darkroom kit made by Kodak, which included rubber trays and an instruction booklet. At the time I wasn't taking pictures myself, but just developing and printing family snapshots. This led to an interest in taking pictures and when I turned nine I got my first 35mm camera.

Are you completely self-taught?

I did a ten-day summer workshop with Minor White in 1970. That was the only time I had formal training, but technically, photography isn't very hard. For a long period of time in the 1970s, I met regularly with John Szarkowski. I consider that a period of instruction. One never stops learning....

In what way did John Szarkowski help your development?

I would bring him pictures whenever I had new work. We would talk about it and he would give me guidance. Unfortunately these days, young photographers don't get that opportunity. Because there were so few of us then, you could go to the Light Gallery and if the director had nothing else to do, he'd sit with you and talk to you about your pictures.

Did you know early on that photography was your calling?

I think I knew by the time I was fourteen.

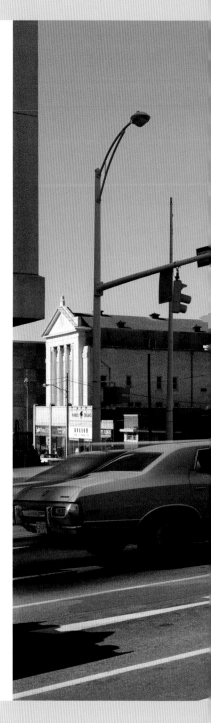

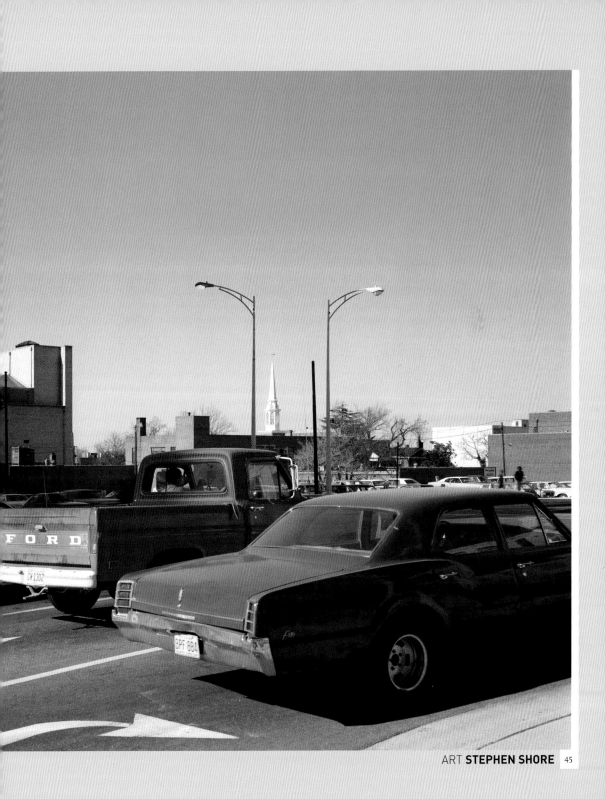

Stephen Shore, *Zugspitze*, 2006

"At this point I'm interested in having fun. I don't feel like I have to do something that looks like a Stephen Shore picture. I'm doing what I've always done, which is take pictures that interest me."

What did photography give you?

I found it fascinating. It was my language. I think I could communicate better in pictures than in words. To give you an example, in the 1970s I took a series of cross-country trips and in 1973, I kept a journal for one of these trips and recorded things like how many miles I drove that day, where I ate, what I watched on TV, I stuck in postcards, receipts for gas and food, and I also wrote down a list of the pictures I made that day. It seemed natural to me, but I realize that it's not the same journal other people would create. It didn't include any impressions of the day, or what I was feeling. It wasn't subjective. Giving a taste of an experience using a collection of facts – that, I guess, is the journal of a photographer.

How did you manage to sell your first print aged fourteen?

I didn't know any better. I called up Edward Steichen, who was the Director of Photography at the Museum of Modern Art in New York, and asked for an appointment and he gave me one. When I met him, he bought three of my prints, mostly pictures of people, for the 'study collection'. They weren't particularly good.

What was it like to be the first living photographer to have a solo show at the Metropolitan Museum of Art?

It was very exciting, but at the same time it was a real shock to my system. When I took in my work to the Met, I wasn't expecting a show because they'd never given one to a living photographer, but days later when I walked into the office I saw they had framed one of my prints. The experience was numbing. It was like that old saying, 'Be careful what you wish for.' In one way it was a dream come true but in another, it also turned out that my life was the same in most ways afterwards. Having a show doesn't solve all the problems of a twenty-four year old.

You've been teaching photography for over twenty years. Do you encourage young students to present work for a show?

It depends on the person. Some are survivors and things happen and they still come out on top, others may not. I don't think I'd found my voice at the time of the Met show, but I guess I see myself in that first category of people. It didn't phase me. But things were different then. You could be the best photographer in the world and your prints would still only sell for $35 and one hundred people might know your name. The art world is very different today. A former student of mine just had his first show and was selling prints for $9,000 and that may affect what he does. I'm delighted photographers can now make a living from selling their work, but I can see that unless you're sure of yourself, you might get swayed by the market. Collectors buy indiscriminately now. Just like people investing in a bunch of IPOs. If you buy ten young artists at a good price and two sky-rocket, you've done well.

What equipment do you use?

For a long time I was working with an 8x10 camera, but for the past few years I've been working mostly with regular consumer digital cameras.

What are you currently working on?

I'm currently using digital technology to make small artist books. They are made using print-on-demand technology from digital files. I do editions of twenty. All the books I make are photographed in one day and with the book in mind, so I think about how the pictures relate to each other.

How do you come up with the concepts for these shoots?

They arise from what's in front of me. I go to a place and an idea will come to me. For example, I did two in Germany last month. One was in Garmisch and one was on the top of the Zugspitze. I didn't start with preconceived ideas. When I started working on the book about the Zugspitze, I was struck with jagged, rocky peaks in sunlight set against the clouds below. Sometimes the shadow of the peaks were on the clouds. I was interested in the different variations on that theme.

Where do you get your inspiration from?

Stephen Shore, *Landscapes – Brewster County*, 1987

From all kinds of things: listening to music, walking around, going to the movies. These days, because of teaching and having to put myself in the position of my students, I get a lot of photographic ideas that don't always relate to what I'm known for in my photography. At this point I'm interested in having fun. I don't feel like I have to do something that looks like a Stephen Shore picture. I'm doing what I've always done, which is take pictures that interest me.

What photographers have influenced you greatly?

In terms of the work I'm best known for, I'd say it was Walker Evans. I felt an immediate kinship with how he saw the world. There was something in his classicism that related to something deep in me – the more formal, emotionally restrained, non-manipulative picture. My three years working at Andy Warhol's Factory, Ed Ruscha, and J. S. Bach also had a huge impact on me. It is through Bach, that I have begun to understand structure.

Stephen Shore, *Landscapes – Brewster County*, 1987

What attracted you to landscapes after *American Surfaces* and *Uncommon Places*?

By the end of the 1970s I felt that I was beginning to imitate myself in my work. I felt that the questions that were driving my work about the American cultural landscape had been answered. A couple of years later, when I was living in Montana, I became interested in landscape because there was one lingering question that was outstanding from my earlier period of work. I was fascinated by the fact that sometimes when I looked at a photograph, in other words, a flat piece of paper, there was an illusion of three dimensional space. I tried to understand it in formal terms in the 1970s, by using a one-point perspective, by having things break into the frame from the side, or using building edges that would interrupt the space of the picture. I thought: would it be possible to create a picture that had a sense of space if I stood in an open landscape, without trees, roads or any other structural devices?

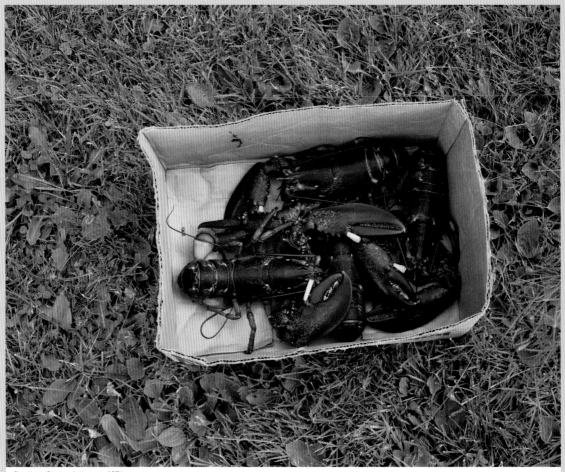

Stephen Shore, *Lobsters*, 1974

"I'd call it 'conscious attention'. It's a condition of seeing the world in a heightened state of awareness."

When is something worthy of being photographed for you?

I'm open to any kind of idea that rises up in me. What I've learned though, is that if light looks dull it will come out dull in the picture, so the best thing is not to take it.

Do you need a philosophy to do great work?

I would call it 'intentionality'. Sometimes I meet young artists and it becomes clear that for some the main motivation is getting a show in Chelsea. It strikes me that this is very different to the way it was for me, which was that I wanted to understand photography and the world and myself. To do that, I produced work. The work that was shown was like a by-product, but never the purpose of my photography. The thought process doesn't even have to be conceptual or intellectual. It can be visual, or a layer of thought that's wordless. I'm always exploring some question or other, but it may not even be formulated as such. I believe the work produced by most established artists, was produced as a by-product of their personal explorations.

In the past you've used the following quote from Hamlet to describe your approach to photography: 'Suit the action to the world, the world to the action, with this special observance, that you overstep not the modesty of nature.' Can you explain what you mean?

There is a unity of form and content that it derives from content. Form gives clarity and meaning to content, rather than starting from form and imposing it on content. Also, the last part of the quote, 'To show the very age and body of time, his form and pressure,' was very much on my mind when I drove around when working on *Uncommon Places*. I can't help but think I was taking pictures that tried to understand that.

What is it that you give or do to an everyday subject to make it uncommon?

I'd call it 'conscious attention'. It's a condition of seeing the world in a heightened state of awareness. I think most people have experienced walking down the street and for a few minutes, everything looks brighter or more vivid, or space and time feels more tangible; things seem more real. I imagine that it's quite possible that the quality of mind can imprint itself on a picture through the choices a photographer makes – including the choice of camera. That's why I was attracted to the 8x10 initially. It is the technical means of communicating what that vividness looks like to me.

How much do you shoot?

I don't shoot madly. It comes from years of using an 8x10 camera. You just learn not to waste film, even when you're working with a digital camera. I never bracket, and never take more than one picture of

the same thing. For example, for the book I did on the Zugspitze, I probably used twelve images in the final edit, and shot about twenty-five frames in total.

How do you go about editing your work? Does it come naturally to you?

No it doesn't. I'm about to have a show at the 303 Gallery in New York, where we want to include pictures from *Uncommon Places* that never made it into the book. I've started opening boxes and looking at contact sheets and seeing stuff that never made the initial edit. It makes me wonder what kind of an editor I am.

What do you look for in an image?

It's hard to answer. I love it when I look at a work of art and it opens my eyes to something, something unexpected happens or I experience something emotional, psychological or perceptual.

When does something become art for you?

I don't even think about that.

What was it like to do your first fashion advertising campaign for Bottega Veneta and your first fashion shoot for *Another Magazine* recently?

I'm very excited about that. The advertising campaign came first and I took it on for two reasons. First of all because working with models was so different from anything I'd ever done, but also because it was great to be paid so well to take on a challenge for

> "I love it when I look at a work of art and it opens my eyes to something, something unexpected happens or I experience something emotional, psychological or perceptual."

myself. The Bottega Veneta pictures don't look recognizably like my pictures, but the art director was interested in certain qualities of light, poise and stillness in my work. I really enjoyed the Bottega Veneta project, so when the *Another Magazine* shoot came up shortly after, I jumped at the chance. Working together with the stylist Venetia Scott was a fabulous experience. I hope to be doing more shoots in the future. I find it fascinating. I want to solve new visual problems.

What excites you most about photography?

There is something deep in me that relates to expressing myself or communicating this way.

Do you think you can learn a way of seeing?

No, but I think a person with talent can be guided and helped.

What advice would you give to a budding photographer?

Read the book *Letters to a young artist* published by Art on Paper. Also, find out what your motivation is – are you trying to answer questions as part of an exploration, or is your ultimate aim a show?

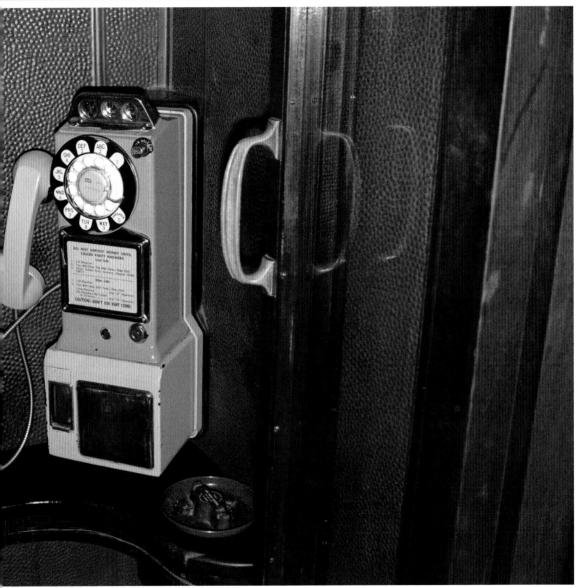

Stephen Shore, *Telephone*, 1972

Mary Ellen Mark

A contributing photographer for *The New Yorker*, Mary Ellen Mark achieved worldwide recognition following the publication of her book *Falkland Road: Prostitutes of Bombay* in 1981. She has since published numerous monographs including *Streetwise, Twins, Indian Circus* and *Exposure* and received countless awards such as the Cornell Capa Award for her outstanding work. Landmarks in the field of documentary photography, Mary Ellen Mark's images reflect a high degree of humanism and often depict people at the edge of society.

Mary Ellen Mark, *Ram Prakash Singh with His Elephant Shyama, Great Golden Circus, Ahmedabad, India*, 1990

When did you get into photography?

As a child and teenager I always took pictures of my friends for myself. I studied painting and art history at the University of Pennsylvania and when I graduated I received a scholarship to go to the Annenberg School for Communication at the University of Pennsylvania. At that time it was more of an art school. They taught photography and film. I loved photography from the moment I first picked up a camera and knew from the very beginning that my life would be devoted to photography. When I graduated I got a Fulbright Scholarship to photograph in Turkey. I spent many months there taking pictures. Then I moved to New York with my portfolio.

The world of magazine documentary photography was very different then. In the mid-1960s magazines would give you the opportunity to do your own work. Magazines loved documentary photography and the possibilities were limitless. That kind of idealism doesn't exist any more. The world is much more commercial now. I consider myself very lucky to have had the opportunities that magazines gave me at that time. For example, in the late 1970s, I did a series of pictures on prostitutes in Bombay for *Stern* and *Geo*. I spent three months in India working on this book and the magazines paid all of my expenses. This work became a book called *Falkland Road*. It was like having the most incredible grant to do my own work.

How did you develop your own way of seeing?

I don't think you can develop or learn a 'way of seeing' or a 'point of view'. A 'way of seeing' is who you are, how you think and how you create images. It is something that is inside you. It's how you look at the world. For example, look at the work of some of the great photographers like Robert Frank, Irving Penn, André Kertesz, Helen Levitt and Henri Cartier-Bresson. It's easy to recognize their pictures because their photographs reflect their distinct vision. Learning to be graphically good on the other hand is something that can be learned and improved on over time with lots of practice.

Do you know what you want to say before you take a picture?

I prefer not think ahead about what I'm going to say with my photographs. I would rather be surprised and see what my subjects bring to the photograph. Even in a studio situation when all you have is a grey or white background, something can always happen that will surprise you. I like to allow for the unexpected, because that can sometimes produce a much better photograph. For example, in the early 1990s I did a series of pictures for *Life* magazine about a school in

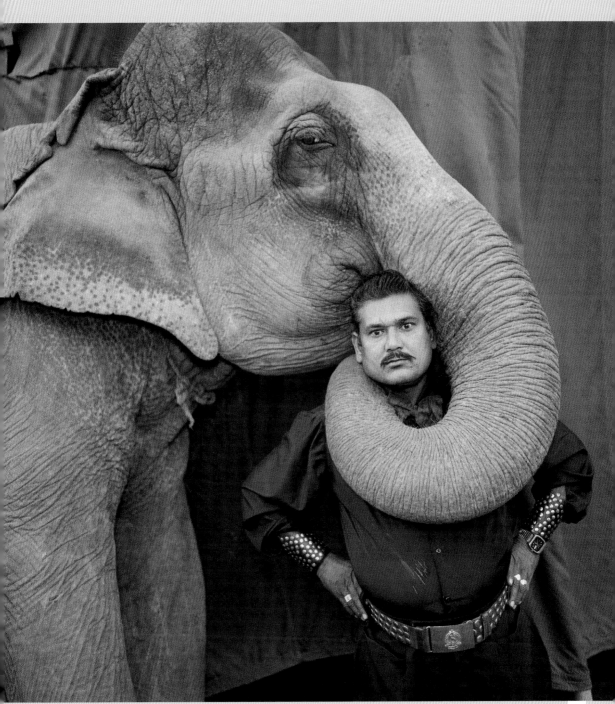

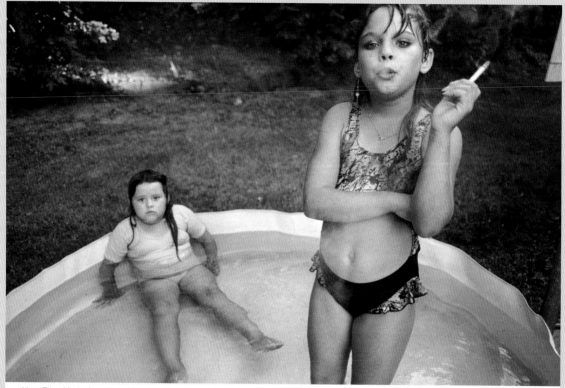

Mary Ellen Mark, *Amanda and Her Cousin, Amy Valdese, North California*, 1990

North Carolina that worked with problem children. One day I followed a girl named Amanda home in the school bus. She was the most difficult student, a feisty eight year old. When the bus reached her house Amanda dashed into the woods. I followed her and discovered her deep in the forest smoking a cigarette. I said: 'I promise I won't tell your mother, let me take your photograph' and she said, 'My mom already knows that I smoke, stupid.' The next day, I returned to their house and discovered that Amanda totally controlled her mother and asked her for cigarettes when she ran out. Amanda was very excited about being photographed. She put on lots of make-up and fake nails. When I finished photographing her, I packed my equipment, and was ready to leave. I just kept my Leica around my neck. I went in the back yard to say goodbye to her. And there she was standing in her baby pool, smoking. Two frames. That was the best picture I took on the entire assignment.

How important is patience in your job?
You have to be patient and wait for the right moment. You have to try and understand how to best portray your subject or subjects. There is so much we see today in magazines, especially in magazine portraiture, that is not about the subject but about the photographer and the clever ideas he or she might have. Photographs like that are too easy because they are not about content.

Mary Ellen Mark, *Kamla Behind Curtains with a Customer, Bombay, India* (from the 'Falkland Road' series), 1978

"I went in the back yard to say goodbye to her. And there she was standing in her baby pool, smoking. Two frames. That was the best picture I took on the entire assignment."

Mary Ellen Mark, *Relatives, Tunica, Mississippi*, 1990

"I want my photographs not only to be real but to portray the essence of my subjects also. In order to do that, you have to be patient."

They are about surface. Also, today you can manipulate so much with Photoshop. It becomes a different medium. Most magazine portraiture is certainly not about reality. I am much more interested in reality. I want my photographs not only to be real but to portray the essence of my subjects also. In order to do that, you have to be patient. I prefer doing portraiture on location. I especially like making portraits of my subjects in their homes. When you go to someone's house there are certain hints that tell you personal things you learn about them. People feel more comfortable in their own surroundings. Most often the ideas that the subjects have about portraying themselves in a portrait are a thousand times better than any idea the photographer might have. For example, when I was working on my book *Indian Circus*, I was photographing an animal trainer who had a massive ego. He was both a ringmaster and elephant trainer. During our portrait session, he took the trunk of his beloved elephant Shyama and wrapped it around his neck like a necklace and of course that was my picture. I would never have thought of something that clever.

How do you develop people's trust?

You have to be yourself. And you have to understand and be really interested in your subject. People can sense it if you are not. Most importantly, you have to command

the situation. Even if you're photographing a famous person you have to take control. Your subject has to feel your confidence.

What thoughts go through your mind when you are framing a shot?

When I am framing an image, I think about how I can make that frame work best. How I can make the strongest photograph. I think about what elements I need to include in my frame and what elements I need to exclude. Sometimes the photograph works because of what's left out. Sometimes it doesn't work because what's necessary in the frame is not there. I also think about the total design of my photograph, including the background, light, and of course the attitude of the person I am photographing.

Do you aim to make a change and break through people's compassion fatigue with your pictures?

I don't expect to change the world with my photographs, I just want to make pictures that have substance. I believe that people really long to see images with content in magazines. We don't see those pictures much these days. By now many people that look at magazines are suffering from 'fashion fatigue and celebrity fatigue'. My hope is to take pictures that will move people. I don't know if a photograph can make a change in society. I think there have been only a very few pictures that have made a real

sociological change, for example Nick Ut's photograph of the burned Vietnamese girl running down a road in Trang Bang, or Larry Burrows' famous war image of a wounded soldier being carried on a stretcher during a moment of great chaos in the battle. Those few war pictures did make a change and perhaps they helped to hasten the end of the war in Vietnam.

How do you make sure when you're working on much-photographed themes such as droughts in Africa, that you show something new or different?

As a documentary photographer you have to be aware of images that become too familiar. You must try to see things in your own way as well as a new way. Some years ago I was assigned to do a portfolio on rural poverty in America for *Fortune Magazine*. It was very difficult to photograph poverty in a way that hadn't been seen before. As part of this assignment I photographed a family in rural Tennessee. One of the many extraordinary things about this family was that all of the children (from six months to fifteen years old) sucked their thumbs. I felt this was significant because it showed how deprived they were, both economically and emotionally. I waited for the moment when all of them could be in the same frame sucking their thumbs. It was a difficult moment to catch, because the older children were very

embarrassed when they sucked their thumbs. They would turn away and try to hide it from me. Finally it happened and I was able to make the photograph.

Do you ever feel guilty or as if you're exploiting your subject, for example when you took the picture of the hydrocephalic girl?

I don't feel at all guilty about taking this photograph. It's a very strong image. It is a disarming image because it is a picture of a severely disabled child. It was taken in a hospital in Turin. I got permission from the child's family in order to photograph her. The family wanted to have this picture of their disabled daughter, with her sister.

Often viewers project their own embarrassment and discomfort when they look at difficult images. It is important to recognize all people, especially the poor and disabled. They have the right to be seen and heard also.

Do you think that a documentary photo can ever be objective?

All documentary photographs are subjective. But great photographers are special because of the way they see the world. They have a personal vision.

What excites you most about photography?

The personal contact I have with the people I photograph and the possibility of making great images. These are the reasons I became a photographer many years ago. I still feel the same way.

Where do you get your inspiration from?

I get my inspiration from looking at a great work in painting and photography and especially in films.

How important is it to be technically proficient?

I think it's very important to be technically good. It makes your photographs stronger if great content is combined with great technique. Perfect technique can make a powerful photograph even stronger.

Do you ever work in digital?

My entire photography library is digitally archived. The digital revolution has been a great benefit to photojournalists; especially newspaper photographers that need to send their photographs back immediately. It is also a benefit in some commercial applications where time is an issue and the client can see the work immediately.

I still work with film. I think there is something special about it that I'm not ready to give up at the moment. Tri-X is my preference. I encourage my photography students to learn digital and film because it is important to understand both techniques.

Do you prefer black-and-white or colour photography?

I'm more of a black-and-white photographer. Personally I feel colour photography is more difficult. I think colour is technically more difficult because you have another element to deal with, 'colour'. This affects both design and technique. The projects I choose translate better in black-and-white film. For example, I can't imagine having photographed my *Missions of Charity in Calcutta* in colour. The reality of colour would make the subject matter harder to deal with. The abstraction of the black-and-white emphasized the spirituality of the subject. My 'Twins' images were photographed in 20x24 Polaroid. I chose black-and-white Polaroid because I love the quality of the black-and-white film. The richness and tonality is different than the 20x24 colour film.

Is it hard to balance personal work with editorial work?

There is a difference between personal work and assigned work. Personal work and personal projects are the work that comes from your heart and soul. It is part of your body of work as a photographer. Assigned work is work that is fulfilling the needs of your client. I have a very strong commitment to everything I do. When I accept an assignment from a magazine I try my best to make great photographs, as I do with my personal work. I feel a total responsibility to the editors and the art directors I work with. I want to please both them and myself.

Mary Ellen Mark, *Hydrocephalic Girl with her Sister, Turin, Italy*, 1990

Mary Ellen Mark, *Girl jumping over a wall, Central Park, New York City*, 1968

In the past, my personal work often overlapped with my magazine assignments. For example, Mother Teresa's *Missions of Charity in Calcutta*, *Streetwise*, and *Falkland Road* were all magazine assignments that eventually became books and part of my body of work. These were stories about ordinary people, the 'unfamous'.

Today magazines are very different than they were when I began to photograph in the early 1960s. Magazines are more commercial now; they are often governed by advertising. They are mostly interested in celebrity and fashion. When there is a human-interest story about the 'unfamous', most magazines prefer single portraits rather than extended portfolios and essays. I'm hoping this will change. There are hints of a changing trend. For example, there are a few American magazines that have assigned me some very interesting essays to photograph recently.

How many cameras do you travel with?

It depends. The project or assignment determines which cameras I bring. When I'm doing documentary work, I travel with either a Mamiya 6x7 or a Hasselblad – but I always bring a Canon or Leica as well. I like working in different formats; 35mm, medium format, 4x5 and 20x24. For portraiture, I use the Mamiya RZ, Hasselblad or 4x5.

When I'm shooting on the street alone I just take one camera with me – either my Canon or my Mamiya 645 or my Mamiya 7.

What about lights?

I often use strobes. I have all kinds. When I'm street shooting alone, I use my Metz 54MZ-3 or my more powerful Quantum T4Ds. When an assistant is working with me on the street I use two of the even more powerful Quantum X5s for exterior lighting, one as a front light, the other as a 3/4 back light. I have Pro-7s, which are small strobes and very good for lighting interiors as well as location lighting. They are excellent to travel with because they are small and compact. For studio lighting I use the more powerful Broncolor Grafit A4 units.

Can you talk me through your editing process?

Editing is extremely difficult. It's taken me a long time to learn how to edit. Teaching has helped me a lot with editing. One of the ways I teach is to assign my students work and then edit their contact sheets with them every day. I must have edited thousands of my student's contacts sheets by now.

When I'm editing my own work, I do a first general edit. Someone in my studio then scans my edits and enlarges them to approximately 5x7. We place all the enlarged scans side by side which makes it easier to see which frames are the best. Then I choose the final edit.

I am a much better editor now than I was when I began to photograph. I've found pictures on old contact sheets that I had overlooked. For example, the girl jumping over a wall in Central Park, taken in 1968. I found this image thirty years later when I was looking for photographs to include in my book, *American Odyssey*.

What about cropping?

I don't crop my photographs. I consider the entire frame while I'm shooting. It's a discipline I learned when I began to photograph. All of the photographers I loved at that time, and still do, never cropped their work; Robert Frank and Henri Cartier-Bresson. I don't allow my students to crop their work.

What advice would you give to a budding photographer?

Be true to yourself and follow your hopes and dreams. Look at the work of great photographers and try to understand what makes their images great. Be inspired by great photographers but don't copy their work. You must have your own point of view, your own way of looking at the world. The worst thing someone can say to you is that your work reminds them of somebody else's work.

Martin Parr

Martin Parr's singular vision and oblique approach to social documentary has not only caused great debate, but also hugely influenced contemporary photographic culture. Famous for his use of colour and for approaching his subjects with irony and wit, Martin Parr focuses on themes like mass tourism, globalization and consumerism. He has published numerous monographs, including *Last Resort*, *Think of England* and *Martin Parr*. More recently, he has also started making documentaries, curating exhibitions and editing photography books.

Martin Parr, *G.B. ENGLAND. Henley-on-Thames*, 1996

How did you first get into photography?

My grandfather was a keen amateur photographer and I used to go and stay with him when I was a teenager. I guess he was the person who introduced me to photography. He gave me a camera, we went out shooting together, and we would come back and process the films and make prints. By the time I was thirteen or fourteen, I'd got it into my head that I was going to be a photographer.

Did shadowing your father, who was a keen birdwatcher, help develop your seeing?

Not so much that, but I inherited the obsession that came with his bird watching. I took on board his obsessive genes and became an obsessive photographer, which I guess, is the only type of photographer you can be.

What was your time at Manchester Polytechnic like?

I was taught in an era, in the early 1970s, when the line of thought was you should train to become an assistant and then move from that to commercial photography. This idea of doing your own work didn't emerge until much later. I'd say my peer group was as informative as my teachers. Now of course you are much more likely to be encouraged to become a documentary or art photographer, just as much as you might be encouraged to become a commercial photographer. I am always amazed when I see myself

doing advertising now because at the time I had absolutely no interest in it whatsoever. I almost despised it.

Do you do commercial jobs with a sense of irony then?

I do them because I get commissioned to do them. They throw money at you, and if they throw enough at you, at some point it might stick. Most photographers end up doing commercial work at some point, even the ones who have successful careers selling prints in the gallery system. You get invited to solve problems using your photographic skills. It's not a priority for me, but I have to generate income to have the creative freedom I enjoy.

After graduating from Manchester Polytechnic, you moved to Hebden Bridge in Yorkshire with some of your peers – what did you get out of that time together?

Hebden Bridge gave me a chance to develop a set of pictures about one particular place. It gave me the chance to document this declining sense of community, which was quite tragic and nostalgic. At college we never really got to that stage because you're moving from one assignment to the next so quickly. I was there for five years and enjoyed it immensely. I also set up a workshop called the Albert Street Workshop with three or four other artists, which was a drop-in centre for the growing artistic community and an exhibition space. It was terrific.

"You know intuitively when you've got the right angle, or the right thing happening. But you can't entirely predict that because photography has this unpredictable element to it, which is what's so interesting about it."

> ## "In a sense my main manifesto is documenting the newfound wealth of the West, because to me, it's the biggest subject – bigger than or just as big as war and famine."

It was like St Ives, slightly hippyish but very northern at the same time.

How did the project you did in the mid-1970s about the Crimsworth Dean Methodist Chapel affect the way you approach people?

Technically, I got quite close to people working on that project and I realized that in the end, no matter how close you get, you can never be a part of what you're photographing. So I suppose I became more aloof after that. But it was a very good experience. All of those people are now dead. I feel privileged and honoured to have met those people. We are now left with a good memory of a particular time and place that has long since gone.

To what degree did the criticism you got for *Last Resort* affect you?

I've always been indifferent about criticism. I'm very clear about what I'm doing. I understand my work is controversial, but I also understood at a very young age that criticism never did you any harm. I sort of feel like if I wasn't photographing this, nobody would. To a certain extent, I'm critiquing the problems of modern society, and not really the people in them. I'm critiquing Toryism, consumerism, tourism. They are all part of the Western world we live in and it seems bizarre to me not to photograph it.

What are you thinking about when, for example, you are taking a picture in New Brighton of a young mother and kids eating chips opposite an over-flowing dustbin?

I'm thinking, 'Here's a family on their day out and the litter is spewing over because it's a bank holiday weekend.' The great thing about New Brighton is that there is domestic, family activity going on in the usual way – Scousers are very friendly and great with their families – and yet there is this backdrop of litter and shite. That, in a sense, was part of the political idea of that work.

How did the Thatcherism influence your work?

I had lived in Ireland for some years and when I came back to England it was almost like I saw it more clearly. It was the height of Thatcherism and I didn't particularly like Mrs Thatcher. I had a really strong motivation to take pictures. First I did the New Brighton pictures and then I did the *Cost of Living*. Although I didn't like Thatcher, it was a very positive time for me because it really motivated me and made me be able to focus on what I wanted to do. Mrs Thatcher was very good for art in this country because everyone hated her so much.

Do you feel as though that aspect of consumerism and tourism has changed much since the 1980s?

I think we're even more globalized and homogenized than before. So the problems that started in the 1980s, if that's what you want to call them as it's only one way of looking at it, have continued. People are wealthier; there are more flights than ever before. In a sense my main manifesto is documenting the newfound wealth of the West, because to me, it's the biggest subject – bigger than or just as big as war and famine.

How do you come up with ideas and concepts for your series?

They just happen. *Bored Couples*, for example, just struck me as being a funny idea. The *Autoportrait* book came about because I noticed there were all these amazing portrait studios. I'd go to them and suddenly I thought, I'll have my own photo taken, then I can get a picture. It's a very serious project. Like all things I do, it's meant to look lightweight, but it's actually very serious. I didn't know at first whether it would be a book, but then I had a series and thought they'd look better together. So you think about doing a book and a show and you're off.

Your pictures have a sense of humour and sadness about them....

That's life. It's funny and tragic at the same time.

How do you manage to get the colour saturation in your images?

I use normal amateur film. I don't do anything in Photoshop or enhance the printing in any way. If you use colour film and process it, at times using fill-flash or ring flash, it can give you that bright colour. Colour film is capable of doing that.

What equipment do you use?

I use a 67 camera, a Mamiya 7 and a Nikon 35mm with a ring flash. I use whatever is appropriate.

What are you thinking about or looking for when you are framing a shot?

I'm not really looking for anything. You know intuitively when you've got the right angle, or the right thing happening. But you can't entirely predict that because photography has this unpredictable element to it, which is what's so interesting about it. It's so easy and yet so difficult at the same time.

What's the easy bit and what's the difficult bit?

The easy bit is picking up a camera and pointing and shooting. But then you have to decide what it is you're trying to say and express. If you don't have that, it's not going to come through in your photographs. Because if you can't identify what you're trying to say, it's unlikely that the viewer will. It's very easy to spot when people don't know what they're doing or why they're doing it.

In that respect, do you think it's important to have a philosophy to do good work?

Not really. It's enough to be interested in something to take a good picture.

How do you go about editing – do you know the picture you want as soon as you've taken it?

You usually have a hunch, but the great thing about photography is that it's so unpredictable, so you never quite understand how and when a good photograph comes about. But when editing, I do contact sheets, then machine prints and then select from that.

What makes one image stand out more than another?

I don't know, but I know it when I see it. I'm a photographer. I know the pictures I want to take, but I can't tell you how or when I achieve that.

Is it an emotional or an intellectual reaction?

It must be intuitive. If it were intellectual, I'd be able to explain what happens. That's why I'm a photographer. I express myself visually, not verbally.

Do you think people can learn a certain way of seeing?

When I used to teach, I would try to draw people out do the best for themselves. You see what they're interested in and you try and guide them so that they can be more themselves. You can learn that to a certain extent, but some people have either got it in them, that obsessional gene that helps make it happen, or they don't.

How would you describe your way of seeing?

I suppose 'Martin Parr', what else can you say? I take pictures of ordinary life, perhaps sometimes made to look slightly surreal. Because real life is surreal.

How has being a member of Magnum influenced your career?

It's been an advantage commercially because the whole point of Magnum is that we're a cooperative, where we do what we want to do and employ others to market our work. So I still have the freedom to do what I want, but my work is sold and marketed by them, and when commissions come in they negotiate on my behalf, which gives me the ability to be more free and relaxed but at the same time earn more money.

What are you currently working on?

I've just come back from a trip to China where I was doing a story about the Beijing Harrow School for *The Telegraph Magazine*. I've also got a book on Rome, which just came out and in three weeks a book of mine is coming out on Mexico and America and the relationship between the two countries and their cultural iconography. Next year, I'm going to do more work in the UK because

I haven't photographed here so much recently. I'm looking forward to doing that.

Your work now extends beyond taking pictures – what other projects are you working on?

I do other things like curate, edit, make films and consult on TV. It's another aspect of what I enjoy doing. For example, I was the artistic director for the Festival d'Arles in 2004 and this year I am curating a show in Arles about David Goldblatt, a renowned South African photographer. I'm putting together the show and there will be a book, which is really exciting. I also edit books for Nazraeli Press. Another project I've done is the *History of Photography* books.

What excites you most about photography?

Seeing other people's work, rediscovering photographs from the past and taking new ones for myself. I like the fact that when taking pictures you have to articulate your thoughts and put very complicated ideas into a simple picture. Of course in the sequencing of simple pictures, you try to make some larger and more complicated statement.

Do you tend to think in sequences when you work?

You obviously hope that the individual component is as strong as it can be, but I'm wise enough to know that it's virtually impossible. You need a body of work to make a statement. Clearly the stronger the individual components, the more chance there is of making your case more persuasive.

What kind of advice would you give to a budding photographer?

Get out there and do it. If it's good, it will be seen. There is no such thing as a brilliant new contemporary photographer, who is undiscovered. A lot of young photographers aren't good, because they haven't thought through or become passionate about what they're doing and they're just emulating someone else's work. There is a lot of generic work out there that just looks like a copy of the influences. I think it's important to touch base with what's gone before in order to find your own platform. The difficult thing is finding your own voice.

Martin Parr, *G.B. ENGLAND. New Brighton*, 1985

Eugene Richards

Renowned for confronting difficult aspects of society with humanity and compassion, Eugene Richards has published thirteen books including *Exploding into Life, Cocaine True, Cocaine Blue* **and** *The Fat Baby*. **His black-and-white photographs on such diverse topics as drug addiction, HIV and AIDS, poverty and the effects of war have appeared in countless publications including** *The New York Times Magazine, Life, Time, Newsweek* **and** *The Nation*. **Among numerous honours, he has won the W. Eugene Smith Memorial Award and a Guggenheim fellowship.**

When did you first get interested in photography?

I was a child who drew a lot and entered art contests. When I was sixteen, I received a birthday gift, my first real camera, a used Exakta, from my mother, who was working as a housekeeper then. That summer, when school was out, I was given a job as part of a youth programme. I went out onto roadsides in a region called the Blue Hills, which was near my home in Massachusetts, and painted construction barrels bright yellow. It was a wonderful job; I was totally alone to do my own thing. I'd paint barrels, then wander away to take colour slides of the ponds and the fog.

Do you think it's important to be technically proficient?

I see photographers using fill flash and don't have a clue how to do it, though I'm often blown away by what they're capable of doing. Still I usually shoot in black-and-white, use minimal flash, a few lenses. I use complicated light setups when I need to, but feel that simplicity and directness have their place.

Did you know early on what direction you wanted to take in photography?

Depends upon what you mean by 'early on'. In college I took the usual pictures of girlfriends and did nudes and landscapes for a literary magazine. All the while I was becoming more and more aware of what was going on in the world outside of college. Having made the very difficult decision not to serve in Vietnam, I cut up my draft card and waited to see what would happen to me. I studied photography for a year before going into a programme called VISTA, where I served as a kind of social worker. But the most important thing was my decision not to go to the war. I was plummeted into the real world with all its complexities. Photography was secondary to political thought and action. I remember that I truly loved my studies with Minor White, where we looked at the natural world and the beauty of the body and of light. But I needed to get out of the academic art world to try to understand and photograph what was going on.

Why do you choose to shoot in black-and-white?

My sole photo instructor was Minor White. He began our studies with the Zone System, which is a means of creatively controlling the contrast and tones of black-and-white film. He revered the black-and-white print, spoke of its creative possibilities. When I left him and went south as a social worker and newspaper photographer, I carried with me the love of black-and-white photography. It felt as appropriate a tool for revealing the racial violence and social change in the Arkansas Delta as it did for revealing the beauty of flowers.

Why do you often add text to your pictures?

A story is often more complex than the pictures show. For example, I just came back from doing a story on a soldier on leave from Iraq. On the one hand, I was trying to address the sadness being felt by his mother; this I could show. On the other hand, the most important element of the story was that mother and son disagreed about the war. Then there was the soldier's sister, who made it clear to me that she didn't want her brother to go back to Iraq. But her anger didn't show itself visually, only in the things that she said. It was necessary for me to add words to augment and enlarge upon the photographs.

Do you see yourself more as a photographer or a journalist?

I go out into the world as a photographer, but if I were to tell the truth, if I could become a very fine writer, I wouldn't need to take photographs anymore.

How did the personal projects you've worked on come about?

Many of my projects began as magazine assignments. My book, *The Knife and Gun Club*, which speaks about life inside an inner city emergency room, began this way. With my first wife being sick at that time with cancer, I had no interest or taste for hanging around a hospital. Then I met doctors and nurses and paramedics who were saving lives and so I stayed on, ultimately doing a book.

More recently, I've started working on a personal project about the war in Iraq, which is running in a magazine called *The Nation*. The 'War Is Personal' stories concern the very personal ways in which war impacts people. The last story that I did was about a man named Carlos, who after being informed by two Marines that his son had been killed in the war, started smashing the windows of their van. Overcome with grief, he set the vehicle and himself on fire.

How do you get close to your subjects?

Many assignments that I've received seldom last more than an hour, at most a day, so you get what you can, and generally this is unsatisfying. What I love to do is have the time to talk with people and work out ways to hang out with them. Given time, almost everyone pretty soon forgets that I'm around. They stop posing, get more relaxed.

I'm a pretty shy photographer, but I'm persistent. In the mid-1980s, I went to Tennessee to photograph a family living in poverty. When I arrived, the family of eight or nine people posed on their front porch. It was sort of like a Walker Evans picture, except that this wasn't what I was there for. Out of courtesy, they didn't make me go away when I said that I wanted to know them better, so I sat on their porch for three days. On the third day, the family let me into their house. Soon they began treating me like a member of the family. No locks, no limits, except that I continue to respect them as people.

What goes through your mind when you are framing a shot?

Often things happen so fast that framing is an instinct, not a conscious process. But there are other times, like when I'm shooting a portrait, that I have to look for something that reveals the person, that accentuates my feelings about them. It could be light, shadows, cropping, the colour of the background. Light can be soft and affectionate, or a brutal and ugly tool, which can be used on someone you don't like.

"What I love to do is have the time to talk with people and work out ways to hang out with them. Given time, most everyone pretty soon forgets that I'm around. They stop posing, get more relaxed."

Years ago, Arnold Newman made a picture of a World War II munitions manufacturer named Krupp. He elongated the man's skull, using a wide-angle lens, showed Krupp with a greenish complexion. Arnold Newman hated the man for what he did to slave labourers and he showed his hatred in his picture.

Do you ever feel uncomfortable taking a picture? Where are your boundaries?

I'm often uncomfortable taking pictures, especially if people are grieving, or hurt, or hungry. At such times I have to remind myself that I'm a photographer and that this is my job. Recently I had a very difficult time photographing a man who had lost his son in Iraq. I said to myself, 'If I could do this, it will show the public what he's going through.' In the end, the father of the deceased young man told me he was glad that I'd been with him.

What kind of impact do you hope to have with your images?

People will always haul out images, like the My Lai massacre and the Abu Ghraib prison, that have been used in political debate when arguing that photographs change things. But generally, it is pretentious for photographers to believe that their pictures alone change things. If they

Eugene Richards, *Still House Hollow, Tennessee*, 1986

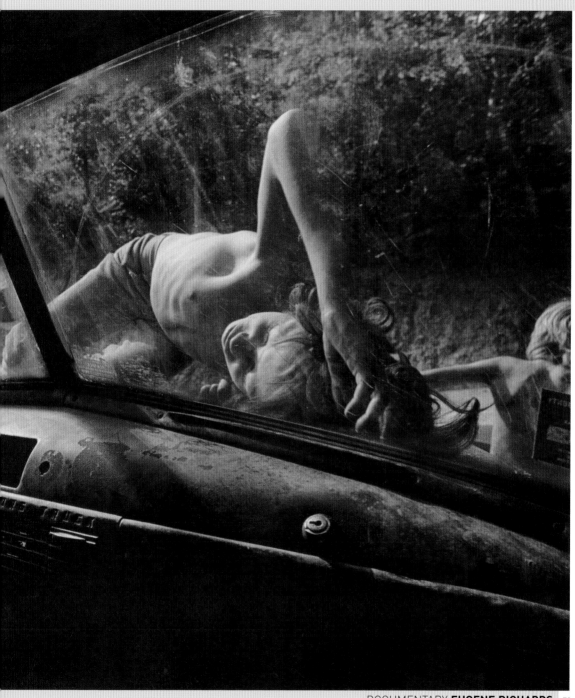

did, we wouldn't be besieged by war, by incidents of genocide, by hunger. A more realistic assessment of photography's value is to point out that it is illustrative of what's going on, that it provides a record of history, that photographs can prompt dialogue. What we can do as photographers is to carry viewers into the lives of others – the life of an African villager or a drug addict or a new mother – so hopefully viewers will be more understanding and sympathetic. But even if they are, that's a long, long way from outright change.

How do you avoid cliché?

Pretty much everything in life has been seen, photographed, sculpted, painted before, if that's what you mean by cliché. In an interview, Cartier-Bresson once said that he didn't know what it meant to be dramatically new. In other words, there was nothing that he had seen that others hadn't seen. All you can do then is try to respond as best you can, with all the knowledge of the world that you've accumulated. What you don't want to do is copy the work of others. And what you don't want to do is dismiss the situation because it has been photographed before. Because if something isn't new doesn't mean that it's not important.

Do you think it's important to be objective?

If I'm doing a picture story, I feel duty-bound to try to explore more than a single side of an issue. World issues are too complex for a single hard-and-fast viewpoint. For example, while I'm very much against the Iraq war, I sympathize with what the young soldiers in Iraq are going through. In the end, I have to make decisions, like we all have to, about what takes precedence. In the end, the result of that is the subjective view.

How do you edit?

I pretty much know that a photograph is 'successful' or not when I take it. So when I'm home from an assignment, what I mostly do is go looking for those 'successful' pictures, hoping that I wasn't kidding myself or that I didn't screw up.

What kind of equipment do you use?

A mix of mostly manual 35mm cameras. I still use Olympus cameras, though they stopped manufacturing them a few years ago; Leica reflex cameras for my colour work; and Canons when I need a camera to be physically reliable, since the tiny, light Olympuses are prone to break. Whatever cameras I use, I travel with three camera bodies, five lenses, and an old Vivitar flash.

Do you think a photographer needs a philosophy to do good work?

A single, overt philosophy? Maybe not. A viewpoint on life – of course you need that if you're going to be a creative person. I get upset by the monstrous behaviours that I see out there. But this is not a philosophy. Being upset and angry causes me to do a lot of my work.

What excites you most about photography?

Being out there and meeting different people all the time.

Do you think you can learn a way of seeing?

You can be taught to see more acutely and more quickly, if that's what's meant by a way of seeing. But it's much more difficult to develop viewpoints and to have something to say that will sustain your photography. I've given assignments in workshops to assist students in getting a hand on their most obvious problems – shyness in approaching subjects, for example. I've gone so far as to ask reluctant students to do nude studies of the person sitting next to them. First off, of course, they need to talk in order to understand something about the other person and to get a sense of the limits of how far you can go in making such a

"What you don't want to do is copy the work of others. And what you don't want to do is dismiss the situation because it has been photographed before. Because if something isn't new doesn't mean that it's not important."

picture. In the end, this assignment results in pretty extraordinary pictures, as people grapple with more than the visual rules. In order to develop a personal way of seeing, you have to study the work of other people, look at where you fit into your own society, and work to develop your own vision out of all of this.

How has your work changed you?

Seeing so much, life has become even more precious to me. Still I don't feel any wiser, and I am certainly no more comfortable photographing than I used to be.

What story left the biggest imprint on you?

In terms of stress, it was when I was working on my book about the illegal drug world, *Cocaine True, Cocaine Blue*. Daily I was being ignored, or pushed around and spat on in the drug neighbourhoods. One night when I came home, my wife, Janine, tickled me and I reacted by slapping her away. That never happened again.

As for stories that I can't get out of my mind, that would be my journey to a village in Niger called Safo. People were suffering from chronic hunger, children were dying, there was AIDS, and yet everyone in the village welcomed and cared for me, even though they had less than nothing.

What makes one image stand out more than another?

Robert Capa made a picture of a woman walking through a Paris street. She had a shaved head, was holding a baby and was surrounded by tormentors. Her shaved head had me thinking of concentration camp inmates, also of my first wife, Dorothea, who went bald after treatments for cancer. The picture is complex. Maybe the woman was a villain, maybe she was a collaborator, maybe she did have a baby with a German soldier, but she's also the only one in the photograph behaving with dignity. In the end, the picture is a singular moment that is full of questions, that expands your thinking.

How did being a member of Magnum help or hinder your work?

I am no longer a member of Magnum; I've joined the VII Photo Agency. But I have some fond memories, particularly of my first Magnum meeting. I had never been out of the USA and the meeting was in Paris. Early in that meeting, a call came from *Life* magazine asking whether anyone was willing to cover the war in Beirut. I put my hand up because I wanted to be a part of things. But my hand was, at first, the only one that went up. Suddenly I was on my way to Beirut. Josef Koudelka poured champagne over my head to celebrate as I headed out the door. I had to borrow cameras, had no experience, no personal knowledge of war. I was lucky, I suppose, to have survived. In the end, though I feel that it was an honour to have belonged to this group, things just didn't work out.

What kind of advice would you give to a budding photographer?

If I had to give advice, I would tell that person to educate himself or herself as widely and deeply as possible in areas outside of photography; then study photography, particularly its history; look at visual books, really look at them so that you'll know who came before you; know what the photographers achieved, and begin to understand what motivated them. Then go and try to do things you've never done before. Make mistakes and learn from them.

Sebastião Salgado

A trained economist, Sebastião Salgado has been photographing the human struggle – from the difficult working conditions of gold-miners in Brazil to Vietnamese refugees – with humanism and dignity for over three decades. He has published numerous books including *Other Americas*, *The Children*, *Workers* and *Migrations* and won a variety of awards, such as the Photojournalist of the Year, awarded by the International Center of Photography in 1988 and the Hasselblad Award in 1989. He is currently working on an eight-year project entitled *Genesis*.

Sebastião Salgado, *Marine iguana (Amblyrhynchus cristatus), Rábida Island*, 2004

You did seven years of economics studies before you picked up a camera – when did your interest shift to photography?

My interest in photography started in the early 1970s, when I was working on my PhD in Paris. I had moved to Paris from Brazil with my wife. She was studying architecture at L'École des Beaux Arts and had bought a camera to take pictures of buildings etc. I started using her camera and pretty soon we set up our own dark room and were doing our own black-and-white prints. Three years later I abandoned my career as an economist.

What kind of pictures were you taking in Paris?

A bit of everything to start with. I did some sports photography, and also tried my hand at nudes, landscape and portraits. One day, I can't tell you how, I started doing social photography and reportages. My life in Brazil had been about participating in the social aspect of life and we had emerged from an era of political militancy. Also, we came to France as students after 1968. Life was all about activism, politics, militancy and the social. It was a natural progression for me to become a social and documentary photographer.

When did you do your first big reportage?

I went to Niger, Africa, with my wife in 1973, shortly after I started taking pictures. There was a horrendous drought. We stayed with a friend of ours who lived in Niger and who worked for an NGO. Thanks to him we were able to establish contacts.

Was the story published?

Absolutely. Many times over. That was my first real entry into magazine photography. It all started with that story. With the money I made from publishing the story in different magazines, I bought my first Leica, my first enlarger and also my first glazing machine. I still use them today.

How did you manage to become part of a photo agency only one year after you started taking pictures?

The first reportage I did in Africa was published in lots of magazines, both in France and internationally. Immediately after that, at the end of 1973, we got a commission from the World Council of Churches to do a reportage about the famine in Ethiopia. I started working for Sygma in 1974, then in 1975, I started working for Gamma, and in 1979 I went to Magnum.

How important are personal projects to you, and how do you come up with ideas for projects such as *Other Americas* and *Workers*?

For me, photography is so integrated in my life, it has become a way of life. Photography and working with a camera gives me much joy and pleasure. For years I developed my own films and did my own printing in the dark room. Also, my activism

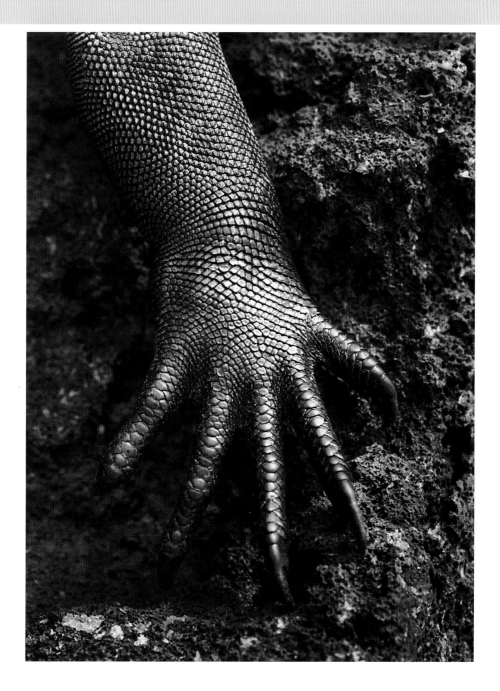

and militancy is very linked to my work. At the end of the day, it's my way of thinking and being that I photograph in life.

I've always worked on long-term projects. When I worked on *Other Americas,* for example, I worked on it for about seven years. I went back to the various countries sixteen times. It was during a time when I had a really big need to go back there. As I had left Brazil at the end of the 1960s, I wasn't allowed to go back during the dictatorship. I missed it enormously. The way I dealt with it was by going to all the countries that were close to its borders. After a while, those became like my home.

When Brazil opened up in the 1980s and I was allowed to go back, I included it in my work as well. In a way, I've worked like that all my life. I photograph elements of my life, places where I feel comfortable, where my way of thinking is in line with what I am doing.

Sometimes it's difficult for people to understand why I have worked extensively on famine in Africa and also on the poor in Latin America, but it's what was on my mind. That was my life. It wasn't that I was imposing myself on their life, it was what I was living.

After that, I started a long-term project about the end of the first industrial revolution. That's when I did *Workers*. You have to bear in mind that I was an economist.

My education was pretty left-wing, where the work of men was always important. It was during the time when everything in Europe was being modernized. It was a huge deal in France because from one moment to the next, for example, there was no more employment in the steel industry. It was extreme. I found myself within that.

At first I started doing reportages for magazines. I spent years photographing the end of an era and it turned into a book. It was a concept, but it also became my way of life and that's how I tend to work.

Also, for each project I do, I write a concept and proposal. It's a way of putting my idea into words in a coherent way so that, editors can get an idea of what I am trying to do.

How do you fund your projects?

I always work with various magazines at the same time. It gives me the chance to publish the same pictures in a number of different countries, such as the UK, France, Italy, USA, Spain etc. When people have to create a magazine every week, they need to produce about fifty-five issues a year. So if you come to them with concrete ideas, a point of view, information and a good set of photos, they'll be very happy to work with you. Even today, working on *Genesis*, which is an eight-year project, I am working with six different magazines: the *Guardian Weekend Magazine* in the UK, *Paris Match* in France, *Rolling Stone* in

the US, *La Vanguardia* in Spain, *La Repubblica* in Italy and *Visão* in Portugal. These constitute the backbone of my funding.

You also work with a lot of charities don't you?

Yes, I've worked with a number of different charities over the years. When I did my first reportage in Niger, I was working alongside the French organization, the Catholic Committee against Famine and for Development. I've also worked a lot with Christian Aid in the UK and with Médecins Sans Frontiers (MSF). I spent eighteen months with MSF in Africa and it became my life. We made a deal with Magnum that for every photograph published a percentage of the sales would go to the organization. I am also a Goodwill Ambassador for UNICEF and have worked with them a lot. I recently did a book with UNICEF and the World Health Organisation about the attempt to eradicate polio.

What equipment do you use?

I've always used a Leica 35mm from the M and R series. For the new project, *Genesis,* I'm using a medium format Pentax 645 camera because I need the negatives to be of better quality.

What is the idea behind *Genesis*?

In part, it is a project born of an initiative that my wife, Lélia Deluiz Wanick, and I took to reforest 1,500 acres of land that we own in Brazil with the original species of the Atlantic Forest. We are planting one

"I photograph elements of my life, places where I feel comfortable, where my way of thinking is in line with what I am doing."

million trees and have also founded the Instituto Terra to provide practical environmental education to municipal officials, teachers, farmers and students. This project brought me really close to nature.

As I am now sixty-two, I decided that for my next project, which may be the last big one I ever do, I would pay homage to our planet. The idea was based on the fact that we all belong to nature. We are a part of it; we are all related. But us humans have distanced ourselves brutally from that. We have become solely urban and rational. The whole instinctive and spirtitual side of us that allowed us to survive until today has been almost completely abandoned and replaced with the rational.

My aim is to find the places on earth, which have not yet been destroyed by man. Forty-six per cent of the planet is still fairly pure, that includes tropical rain forests, the big deserts, the cold climate forests, the Arctic and Antarctic and the big mountain chains over three thousand metres. It's a surface we have to preserve and maintain if we want to ensure survival on this earth. As an attempt to reconnect our species with our planet, I am exploring this world in order to record the unblemished faces of nature and humanity: how nature looked without men and women; and how humanity and nature long coexisted in what today we call ecological balance.

Can you explain your approach to the people you photograph? You've said, 'the picture is not made by the photographer, the picture is more good or less good in function of the relationship you have with the people you photograph.'

I feel that the more we become integrated and the more we love what we do, the closer we are going to get to those we are trying to get close to. It's not just the case with humans, but with other animals also. If you arrive in a place in a rather brutal way, too fast and with no respect for your subject, you will end up with cold and distant images. But if you approach your subject in a refined way, and attempt to understand their life and live with them for a while, your images will be of a different quality.

Do you think you need a philosophy to do good work?

No, but I think you need to educate yourself. It's not just about being a photographer but also about being informed and enjoying being there. You can't impose yourself for an assignment and do something you don't like.

For example, for a photographer, there's nothing better than having the luxury of spending a whole day or

"It's not just about being a photographer but also about being informed and enjoying being there. You can't impose yourself for an assignment and do something you don't like."

Why do you think it's important to spend a lot of time with your subjects?

You need time to do things properly. You need to understand, feel and respect the people you are photographing. And they have to accept you, otherwise you risk not getting the full picture. It bothers me when people come to a place for two hours and take pictures for a reportage and then go home. It's very unilateral in terms of point of view. It's like bringing back the ideas you came out with in the first place. You need time to look and see properly. Of course that's my point of view and I wouldn't want to impose it on anyone.

I come from a Latin American world, where you believe in things and you form a relationship with your surroundings. I also grew up with a sense of mysticism and belonging. I feel that we are a communal being. I think it's important to look at my work in the context of where I grew up. My thoughts evolved in Latin America. The cynicism that exists in certain kinds of photography and that pleasure of seeing oneself as a deep individualist, that's not for me. I see that as a moment, but not as the truth. We are a gregarious species made to live together. Our history is one of community, not individuality. That's the point of view of my photography and the starting point of all my work.

How much time do you tend to spend in one place, for example,

how much time did you spend with the tuna fishermen in Sicily for *Workers*?

I spent a lot of time there. I did the first part in three weeks, but had to come back for the big catch. I became friends with the head fishermen and one of them called me to say, 'Fly out tomorrow, it's all happening in two days.' I arrived but we waited another fifty-one days before the tuna arrived, so I spent more than two months there.

Now, on *Genesis*, I do about three reportages a year, and tend to be in one place, such as the Galapagos or the Antarctic, for two to three months.

There is a sense of poetry in the way in which you portray the dignity and strength of your subjects, who are often in struggle. At times it has been described as 'religious'. How do you achieve this?

I don't believe in Christianity or any other religion. But I respect and believe in a sense of community and the human species. Photography is full of symbolism, it's a symbolic language. You have to be able to materialize all your thoughts in one single image. My social, community -focused outlook, in a way, is not too dissimilar from the basis of most religions.

Can you talk me through your editing process?

I do a first choice from contact sheets and then do many, many work prints. From that, I then choose an average of six images

week with your subject. I remember when I was doing the tunnel pictures for *Workers*, someone from the UK tunnel construction organization accompanied me, and after two days he said, 'Sebastian, watching you work is akin to watching the grass grow.' He was bored out of his wits, but I had such pleasure being there from morning until night and becoming integrated and meeting the people who were working on the tunnel. It was my life. If you are not doing a job voluntarily, you shouldn't do it.

Do you think a photograph can make a change?

I don't think a photograph alone can make a change. Not at all. But a picture combined with a system of information and the organizations that surround it, yes.

per film. Then I reduce it down to whatever is needed for the magazine in question. I shoot about two to three hundred rolls of film, if I am away for several months.

What makes one image stand out more than another?

It's difficult to explain why we are more attracted to certain images than others. For me, black-and-white photography has a certain kind of power. I'm not talking about conceptual photography but instantaneous photography, the kind that happens in a fraction of a second. It's when that fraction of a second materializes into a formal language. When there is form, composition, content. A great picture is one that transmits a lot of emotion and where you can see who took it; who that person is. For example, last night, I was looking at a book of Bill Klein's work. Looking at it, I saw his life. I lived it. His obsessions, his mind, everything. It's marvellous. I experienced New York, Tokyo, Rome and Paris. It was so strong and so much like him. I think that's the power photography has to have.

Can you learn a way of seeing?

I think you can become more refined but I don't think you can learn a way of seeing. It's intrinsic. I'm just putting together a book about Africa and I have pictures in there that I took in 1973, shortly after I started photographing, and they are not very different from the pictures I took fifteen days ago. I think that our mind, our history is formed by the time we are fifteen or twenty years old. It's very difficult to change that and put something else in its place.

What advice would you give to a budding documentary/social photographer?

First of all, you have to be a visual person. But secondly, you need to immerse yourself in sociology, anthropology, economics, politics and geopolitics to understand the framework in which you are working. You need to create an idea of the whole of society and the planet we live on. Otherwise although you may be enthusiastic, you may enter into the photographic world lacking understanding about the bigger picture at hand.

"You need to understand, feel and respect the people you are photographing. And they have to accept you, otherwise you risk not getting the full picture."

David LaChapelle

David LaChapelle is famous for creating surreal, uncompromisingly original visual worlds. Often saturated in bright poppy colours, his images have appeared in Italian *Vogue*, *Vanity Fair*, *Rolling Stone*, *i-D*, *Interview* and British *GQ*. LaChapelle has shot advertising campaigns for a variety of clients including L'Oréal, MTV, Diesel Jeans and Phillip Morris, and has published three monographs: *Hotel LaChapelle*, *LaChapelle Land* and *Artists & Prostitutes*. He also directs music videos and has directed a feature-length documentary called *Rize*.

David LaChapelle, *Jurassic Moment* (Italian *Vogue*), 2004

When did you first get interested in photography?

Ever since I was young, I knew I was going to be an artist. From the time I was in fourth grade primary, I was obsessed with Andy Warhol and I thought I was going to be a painter. In high school, I used to try to stand out and look different by dressing up in 1950s clothes, or wearing cowboy outfits etc. When you don't fit in, the kids pick on you and I ended up dropping out. My mother couldn't understand my decision to leave school because education meant everything to her. So I had to leave home at fifteen. I went to New York and started working in clubs like Studio 54 and Harrah. I was a bus boy, but I never stopped going to arts classes.

Two years later, my father came to get me and said, 'You have to finish high school.' He enrolled me in the North Carolina School of Arts and it completely changed my life. For the first time ever, I was around like-minded people. All the other kids were artists. I learnt photography there. I had always fantasized about taking pictures, but I always thought it would be really technical and mathematical. I never learnt the Zone System or that Ansel Adams method. For me photography was like cooking: a little bit of this, a little bit of that. It was intuitive. I never got cerebral about it. I understood the process and could feel when the exposure was right. I literally moved into a darkroom and for six years, I only shot black-and-white.

To what degree did your mother, who was also an artist, inspire you to become one?

My mother was the first person in my life to introduce me to creativity. She came over to Ellis Island after the war. She'd been in the camps and met my dad picking tobacco. They didn't have much, but nevertheless she would always decorate the house in the most amazing way at Easter and Christmas. She'd make things, like lambs being born and beautifully rendered centrepieces for the dining table. She frequently transformed our house into a wonderland. Often, we'd all get dressed up and go to places outside the neighbourhood. She created an imaginary life for us, the one that she would have liked us to have. We were living out the life she'd dreamt up for herself as a young girl working as a maid in Berlin. My parents helped me as best they could. If I wanted crayons and paper, they would get them for me. If I wanted to go to an arts class, they'd drive me there. They let me dress how I wanted and never made me feel like a faggot. They just let me express myself.

Do you think formal education is important?

I think art history is crucial for anyone in visual arts, no matter whether you are a designer, an architect or a photographer. You have

to be referenced in that. Not so you can have a conversation at a cocktail party, but to understand how ideas evolve and to understand concepts of authorship, originality and communication. Even the notion of revolution is important, and learning about the struggles certain artists shared and what informed their lives to lead them to create what they created. I don't understand when kids come to me today saying they want to be a fashion photographer and all they know is last month's *i-D*. At least immerse yourself in fashion history. The contemporary fashion world is so limiting. It's all about what's hot and new and trendy now.

How do you come up with the concepts for editorials, such as the shoot you did for Italian *Vogue*, with hurricane and disaster backdrops?

The pictures for that story were shot before Hurricane Katrina happened. Italian *Vogue* knows that and that's why they published them. I came up with the idea because there were all these natural disasters happening, the weather was changing and all we were doing was shopping and consuming. We're buying the next Viktor and Rolf outfit – which is a good distraction because at least it's creative – but all around us the world is falling apart. It was a comment on that insane need for

David LaChapelle, *House at the End of the World* (Italian *Vogue*), 2005

luxury items, the obsession with materialism. We're at a crucial time in history and we're all out shopping. There is no revolutionary spirit in the young today. The political system is so fucked up we believe that we can't change anything. It's so sad. In the 1960s and 1970s, there was this idea that you could make a difference. Lots of my pictures are about our inane consumption.

What fashion magazines do you mainly work for?

I work mostly for Italian *Vogue*. I like their editors and their philosophy. They are very particular about what goes in the magazine and it has weight and standing in the industry. There are ten billion magazines out on newsstands these days, so you have to choose which one you want to be seen in. Italian *Vogue* uses great photographers; they have an importance many other magazines don't and people collect the issues. Some of the other mags are all about selling. Italian *Vogue* still has an artistic sensibility to fashion. It is the last *Vogue* worldwide, to only use fashion models on the cover. I really enjoy working for them and when I do, I go all out. I love building huge sets, even if it comes out of my pocket, which it often does.

How much creative freedom do you get?

Pretty much full creative freedom, but you always work together with the art director and editor of the magazine, because there are always certain clothes you need to show.

I like having some rules, because they give you boundaries. Otherwise you have too many options. The worst is when someone says, 'Do whatever you want.'

Who comes up with the ideas when you do advertising campaigns?

It depends on the client. I came up with the Patrick Cox, Motorola, and Diesel campaign ideas for example. But lots of advertising people tell you what they want. And you do it. Like Helmut Newton said, 'You're a gun for hire'. The best is when a client says, 'We have this product, what can you come up with to make it work?' Then you can use the material for your portfolio.

Where do you get your inspiration?

If I don't already have ideas in my head or in my journals, which I keep and draw pictures in, I stimulate myself with Renaissance art, architecture, erotic paintings, art books, art collections, vintage *Playboy* magazines, the history of fashion and listening to music. I try to get the visual part of my brain turned on. It's like a muscle that you need to start working. Once I do that, the ideas just start coming.

How do you fit into the fashion world?

I've always been an outsider. My goal has always been to photograph what's happening in pop culture. I love fashion, but I see myself as an onlooker, not an insider. I'm not really accepted by the art world either – because I do commercial work as well. I always thought I'd

work for American *Vogue*, but I never did. I had a meeting with Anna Wintour to discuss photographing the band The Fugees. She wanted me to shoot them in Tommy Hilfiger. I didn't want to do that. I wanted to shoot them in couture. They didn't agree with my concept and I never heard from them again.

What equipment do you use?

I use a medium format camera. I've just changed over to digital, and I'm not sure what the exact system is called.

What made you change to digital?

Digital is getting really good now. You can blow the prints up really big without loosing any quality, and the depth of field is even better than with analogue. I also like the clarity and sharpness. I used to do work prints, but I always felt that the amount of chemicals and paper used was an awful waste and really bad for the environment. It's a new start for me.

How do you get that colour saturation and pop in your images?

It all starts in the art direction. I'm really attracted to certain colours and I work very closely with specific background artists that I've hand-picked over the years to come up with the sets we use, which can be very elaborate. People think I'm all about post-production, but there is so little we actually do in post-production. Lighting is also important. Sometimes we use reflector boards, sometimes flash, diffused light, or strobes. It all

David LaChapelle, *My House* (French *Vogue/Couture Story Icons*), 2001

"I try to get the visual part of my brain turned on. It's like a muscle that you need to start working. Once I do that the ideas just start coming."

depends on the mood we want to create for the concept.

How do you go about editing?

I make contact sheets and go through them. I don't overshoot much any more. Now I get it and know when I've got it.

What makes one image stand out more than another?

I don't know. I've always wondered what makes one painting, painted by the same artist, in the same year, more of a masterpiece than another? There are some works of art that everyone just gets. It's that thing everyone reacts to. I think people like things that touch them; they want a piece of art to be authentic, they like to feel there was a reason behind it. It's like soul music. You don't need the perfect voice, but if someone sings with a voice that's full of emotion, people will respond to it.

The same goes for photography. Images that stand out are those that haven't been taken just to shock or impress you. You might not know why a picture was taken, but there is a reason. There is a certain sincerity to it. There was an obsession, and it had to come out.

Do you think you can learn a way of seeing?

I think you either have it or you don't. If you have it, you have to discipline yourself to prove it.

David LaChapelle, *Jesus is My Homeboy "Foot Wash" (i-D)*, 2002

David LaChapelle, *Death by Hamburger* (Italian *Vogue*), 2001

"The key is to photograph your obsessions, whether that's old people's hands or skyscrapers. Think of a blank canvas, because that's what you've got, and then think about what you want to see."

You will always improve the more you do, just like with any artistic endeavour, such as dancing or painting.

How has shooting videos, album covers and doing the documentary *Rize* changed your approach to photography?

I really have to have a strong desire to photograph a person, for me to do it. It can't just be the next young thing. Whoever I'm photographing has to be really interesting, or outrageous or have an astounding talent or artistic voice.

Do you think you need a philosophy to do great work?

I don't know. I think you certainly have to think beyond the latest model and dress. The great photographers all had an interest and passion in life. They saw beyond the moment. There was something that informed their work. I'm always growing and trying to be, first of all, a better human being and artist in every way. I don't believe artists have a right to mistreat people. They create. They're not allowed to destroy or be abusive. There's no sense in creating a beautiful picture if everyone had a bad time at the shoot. It's so easy to take advantage, when people are kissing your ass, but it's not right. I don't subscribe to that. Whenever I'm overworked and loose my temper, I always feel horribly guilty but thankfully my staff are great as they pull me up on it. I feel blessed

to do what I do. I'm always growing and never feel like I've arrived. I treat every new job like the first.

What does photography give you?

I've come to realize that for me, it's the act of taking the picture that I love. That moment you have, when you are working with your staff, and everything is coming together, and you look around and everyone is excited and thinking, 'We've got it.' I'm really lucky. I've got people around me that love what they do. They're not at all jaded. And that energy is priceless.

What advice would you give to a budding photographer?

My biggest advice would be to take the pictures you want to take. Don't think about the marketplace, what sells, or what an editor might say. And don't think about style. It's all bullshit and surface stuff. Style happens. For example, I never thought about colours, I was just attracted to them. The key is to photograph your obsessions, whether that's old people's hands or skyscrapers. Think of a blank canvas, because that's what you've got, and then think about what *you* want to see. Not anyone else. Make yourself happy, and other people will get it too.

David Sims

British fashion photographer David Sims had his first editorial stories published in magazines such as *The Face* and i-D shortly after he began working in 1989. Following an influential catalogue for Yohji Yamamoto, he signed an exclusive contract with *Harper's Bazaar* (USA) in 1993 and went on to shoot his first campaign for Calvin Klein jeans. Having been an *enfant terrible* on the fashion scene, due to his at first rebellious, casual style, David Sims chose a deliberate *volte-face* and is now one of the most established fashion photographers worldwide, shooting campaigns for exclusive brands such as Jil Sander, Balenciaga and Benetton. As well as doing exhibitions and working on personal projects, his work continues to appear in publications such as *W* magazine, French *Vogue* and *V* magazine.

David Sims, *Boy with short hair and red light, Isolated Heroes*, 1999

How did you get into photography?

I was offered a job as a studio assistant with a commercial photographer when I was seventeen, and I think initially I felt like it was a chance to do something because I wasn't particularly successful at anything at that point. During my time as an assistant, I was allowed to attend an O' level course. On Fridays we always had lectures with slides. I think it was during those discussions and lectures that I realized how powerful photography was.

Was that your 'learning' period?

Absolutely. It couldn't have been better. It was in the early 1980s and everything was very much analogue at the time. We worked using transparency, which in itself was a different kind of discipline. You really have to make sure that what you want is there in camera. There wasn't the amount of retouching or post-production there is now. If nothing else, it was very technical and I learnt a lot. I was grateful and still am to have been given the chance. When I was nineteen, I decided to go to London and assist fashion photographers. I did that for another four years.

What attracted you to fashion?

I'd never been interested in fashion and I didn't know much about it. I was interested in style more than fashion, and that was through music. Assisting a fashion photographer seemed like an exciting job.

Do you think you need to have a philosophy to do great work?

Philosophy becomes so integral, you don't really think about it unless someone provokes you to. Having done it as long as I have, people accept that I work the way I do. However, when I started working, it was paramount for me that my pictures didn't look like the work of my contemporaries. That was my big obsession. Also, I wanted to earn respect for the way my pictures were executed. I wanted to be extremely proficient technically. I didn't want to create copies of what was going on at the time. When I first started late in 1989, it felt as though London was struggling after an intensely progressive period. I guess it's what happens after about ten years, it's hard to still be radical a decade down the line. I felt sad that London had stopped being the centre of creativity.

How do you come up with the concepts for shoots such as the Raf Simons *Isolated Heroes* campaign?

I didn't come up with the *Isolated Heroes* book. Raf Simons did the casting for the boys and used them in his show and I shot them afterwards. None of the boys were models. They all had a very individual look and I can identify with that. It's what I've always strived to create in my own work. It was an extension of the kind of work I already did.

David Sims, *Benetton girls jumping in stripey tops* (Benetton), 2005–06

"I've got to try and make sure my vision equals or betters the previous campaigns. That in itself is a kind of freedom."

How much creative freedom do you have when shooting a campaign like Benetton?

The simple answer would be to suggest you don't have any, but the reason you get booked is because people feel they need or want to use whatever style you bring. So you're free in that sense, but you are also working with the ingredients that they set down in front of you. I enjoy working for a company like Benetton because I like the heritage that comes with the brand. It's had fantastic campaigns in the past. I like the idea of stepping into that house. It gives me something to aim for. I've got to try and make sure my vision equals or betters the previous campaigns. That in itself is a kind of freedom. I like to work in a frame-work. Fashion can be very sloppy, if you don't create certain circumstances.

Are you actually interested in fashion now?

I've become versed in a certain kind of language. But I'm not someone who knows a great deal about the history of fashion. I try to do things in a contemporary way. But it's inevitable that you borrow from other eras and styles. It's part and parcel of the fashion process. It is very self-referential, even more so now than before.

What do you hope to achieve with your images? What do you want to elicit in the viewer?

I think it's important to create a legacy for yourself. You can get distracted from that. I use my photography to try and express something, which feels more fundamental but it's difficult to find the component, or something so deep and meaningful that you can lend that amount of importance to it.

Early on I did a lot of images with sets. I like those pictures a lot but the idea became so common place for a while that I stopped doing it. I'm not totally against doing it now but much can be lost in using a strong background. I think the story is always best 'written' on the subject. It leaves the viewer free to invent a scenario for themselves.

How important are personal projects like 'Visionaire 40 Roses' to you?

Photography is a very internalized thing for me. When I started working on 'Visionaire 40 Roses', I suppose I was feeling a sense of longing. I needed to find out, how I got from being a seventeen-year-old kid given a job as an assistant, to someone who no longer really resided in England, and who was flying here and there in a slightly bewildered state. I decided to go back and so I went back to my old school. I did thirty portraits with the students but didn't find any answers. It was on leaving the school through the front entrance – which I'd never done – that I first noticed a garden with a bed of roses. Because they were in and amongst the bricks and cement they felt more profound to me.

So I photographed one and left. Later I realized that the roses were what I should be photographing. Because they are seasonal, it took a long time to do.

The roses, to me, sort of represent my experience of growing up. A rose by definition is meant to be perfect but they are at the mercy of the wind. When a rose blows into the stem of another rose, they get torn. Some are pristine, some damaged. School is an incredibly tough experience. As kids, especially boys, you are generally not given the chance to talk about yourself. You take a knock every day at school and it shapes you. I came out of school angry and pissed off. I went in as a shy and sensitive person and came out bigheaded and strong-willed, a 'fighter'.

How did photography shape you?

For a long time photography was the only thing I cared about, at the expense of all other relationships and at a certain point, I found myself alone. I had to allow myself to step back. So for a couple of years, I stopped being so prodigious. It's only really now, that I feel I'm giving it my heart again. At times a personal project for me means sitting down and *not* taking any pictures, but just thinking and enjoying the people you know. Not coming at life from behind a box.

What equipment do you use?

Most days I use a Mamiya RZ system. It used to be purely

analogue but I started working digitally recently, mostly because clients want you to. I enjoy it and its uses are primarily geared towards delivering quickly and allowing clients to see images while you work. There's a lot you can do now on a computer that you couldn't do previously. But for my pictures, I like to make sure there is a minimum amount of retouching. I take a great deal of time in at least attempting to make things work in the camera.

How do you go about editing?

My approach has changed since I moved over to digital. As opposed to waiting for my contacts to come back and editing over a weeklong period, now I do it as I go along. That makes life very easy: you can see when you've got your shot and move onto the next thing. There used to be a certain amount of shooting extra just to be sure, which inevitably meant working longer.

What makes one image stand out more than another?

It can be any number of things, but I look to see whether the subject looks good.

Are there many photographers who shoot a lot and hope for the best, because digital allows that?

Yep. The power of digital and the influences it's had is such that it's like the Olympics on steroids.

How has the fashion industry changed since you first started?

I think that it's far more commercially minded now. This bears down heavily

Above: David Sims, *Yellow Rose, Visionaire Rose Exhibition*, 2002
Opposite: David Sims, *Raquel Zimmerman in gold trousers with cigarette in her mouth* (French *Vogue*), 2005

"I think it's important to create a legacy for yourself. You can get distracted from that. I use my photography to try and express something which feels more fundamental."

David Sims, *Tom in briefs against a red and blue background*, 1993

on many young photographers because there is this expectation that you come with solutions rather than a particular style. When I was starting out, the struggle was about establishing your own style regardless of what everyone else thought. You were not expected to do things in two days. Some stories I did with Melanie Ward for *The Face*, for example, took weeks. We spent a lot of time simply talking about how we wanted a story to look and feel, we tried to build up an atmosphere first. There is not much time for that now.

Do you discuss ideas at length with clients before a shoot?

I do this less than I used to. These days I don't really try to radicalize clients. It's not the thing I want to do anymore. I don't feel I have to prove it to myself now, and I don't take any pleasure in a fight. I did a good enough job doing that when I was working for Jil Sander. I was lucky enough to have a designer who would allow me the freedom and give me that kind of trust. I didn't necessarily photograph he clothing but the things that were in my head. But I don't want to keep doing that arbitrarily. And neither do I want to be stuck in a mould.

What made you decide to take on a more commercial approach?

I wanted to. At first, my aim was to be iconoclastic, then to be ironic and oblique. And after that I came back wanting to produce a picture

that was as commercial as possible. But I still wanted that to be irksome. It's very much part of who I am. When I first started, I set out to make photographs that were difficult or not straightforward in a fashion sense. It's important for me to express myself stylistically and eventually that turned into doing something that I deem commercial. I wanted to be Mr Commercial and do something that felt American and not in the slightest bit European. It was a hard thing to learn.

Where do you get your inspiration?

It's a pretty broad spectrum, but if I had to plump for one thing, I'd say music.

What photographers have influenced you greatly?

I would be lying if I didn't tell you that Avedon, Mapplethorpe, Larry Clark and Mick Rock had been massive influences but I've looked at all kinds of work and been inspired. I can't help but be impressed by the work of war photographers, such as Larry Burrows, Don McCullin and even further back to Matthew Brady. Whilst I orbit in a world that lives, eats and breaths pretense it's difficult to qualify it. I'm not trying to suggest that you'll find evidence of their work in mine but I am overwhelmed by their integrity and their art. That should be an influence for anyone.

What advice would you give to a budding fashion photographer?

I would tell my assistant, 'Don't walk out of my studio and straight into yours. Take the money you've earned and travel. It can be in your head, or abroad, it doesn't matter. Find something that captures your imagination and fall in love with it creatively. You need to be free and experiment and not pay any regard to what people expect you to do. Working in full view of an expectant group is tricky. Get yourself to a point where you have a body of work – and it may happen accidentally, that doesn't matter.' For years people said my pictures were no good, that everyone looked miserable in them but I didn't care. You have to trust your own taste, trust your instincts.

David Sims, *Lily Donaldson in blue/violet light* (Jil Sander), 2004–05

"At first, my aim was to be iconoclastic, then to be ironic and oblique. And after that I came back wanting to produce a picture that was as commercial as possible. But I still wanted that to be irksome."

Mario Sorrenti

The Italian fashion photographer, Mario Sorrenti, famous for his precisely composed, often fearlessly sexual images, became obsessed with photography from the moment he entered a dark room aged seventeen. Only three years later, at the beginning of the 1990s, he was shooting stories for *The Face*, *Harper's & Queen* and the UK edition of *Elle*. These days, aside from doing editorial work for the world's most prestigious fashion magazines such as *W*, *Another Magazine* and French *Vogue*, Mario Sorrenti shoots advertising campaigns for clients such as Calvin Klein, Prada and Joop! and continues to work on personal projects. He has also published *The Machine*, a photography book that documents his brother's suffering before he died.

Mario Sorrenti, *Kate Moss* (Calvin Klein Obsession campaign), 1993

How did you get your first big break?

The first three years I was taking pictures I was completely obsessed with photography. I built my own dark room, was printing my own pictures and bought tons of photography books. I was trying to absorb as much as I could. I dropped out of college, where I was studying fine art and started working as a model. I took behind-the-scenes pictures of models and friends with a Pentax 6x7 and made them into photographic diaries. Phil Bicker, who at the time was the art director of *The Face*, asked to see my work when I was in London and recommended I go see some agents. The first one I saw, Kim Sion, took me on and I started working straight away.

How did you learn about the technical aspects of photography, for example, lighting?

My mom was a stylist. She and my step-dad had a photo studio in New York where I hung out a lot. I used to get my friends over and have parties and take pictures of everybody. I'd just set up the lights and umbrellas. To me it seemed very natural. I knew what I wanted to do with the light. I think it came from painting and drawing at college. I understood shadow and light, and what it took to make sculptures and shapes with the body.

What kind of a camera do you use?

I use a digital Hasselblad with a Leaf back. One of the reasons I got into photography was because of the immediacy of the medium. I used to sit in front of a canvas for weeks trying create something. Now I can see the image right away.

How much creative freedom do you have on an editorial shoot?

It depends on the magazine. A lot of magazines have really strict requirements about clothes and how they are photographed. French *Vogue*, for example, has a very clear vision of who the French *Vogue* woman is and what she wants and the shoots are for the most part controlled by their stylists.

However, some of the younger magazines – the ones that don't have any money such as *V* and *Another Magazine* – give you much more freedom. But you usually end up paying for the shoot yourself. Those shoots are purely driven by the passion for what you do. I did a shoot for *Another Magazine* once where I spent thousands of dollars of my own money. I had just discovered all these drawings by Goya and I wanted to replicate the drawings in photographs. The shoot involved an intricate set and a lot of props. We were in the studio until 1am three days in a row and I had to pay for everyone from the stylist to hair and make-up etc, but I loved the photographs in the end and that's what counts most.

Where do you get your inspiration from?

I used to visit all the churches in Italy with my dad and my art education was classical. Because of that I am hugely influenced by religious imagery and the Renaissance. Recently, I did a shoot for *W* magazine, which was inspired by a picture of a refugee holding a baby, which I'd found on the cover of a newspaper. It looked like a Renaissance painting of the Madonna with Child. It was a striking image. I called Dennis Freedman at *W* straight away to discuss using the image as inspiration for a fashion story. Working for *W* is like a dream come true. Dennis gives me a lot of freedom. We built a whole stage set in Paris for the shoot. It was huge, like a set for a film. And the images were all painterly in the way they were composed. I'm also inspired by photographers like Diane Arbus, Irving Penn, and a few fashion photographers like Bruce Weber and my friend David Sims.

What is your aim when you're shooting a fashion story?

I have always tried to push the boundaries of fashion photography. For example, I did a story for *V* magazine recently where I was trying to see the pictures as sculptures. I was trying to create very graphic shapes and figures. After all, why should a fashion photograph only talk about clothes? Why can't it talk about something

Mario Sorrenti, *Refugee*, 2005

else? I want my pictures to ask questions. I want people to look at my pictures and have an emotional response. I want them to think: What am I seeing? What does it mean? Do I love it? Do I hate it?

What do you think about when you are framing a shot?

I think about the light, the models' clothes, the hair, the composition, the beauty of it all. To me all those elements have to come together in a way that's exciting. If I'm excited by what I see, I know it's right.

How much do you do in post-production?

I do very little re-touching. I might alter someone's skin to make it flawless, but I would never change the colour. I know what I want and shoot that. I then send a layout to the creative director so they get a really clear idea of my vision.

Do you need to have a philosophy to be a good photographer?

Yes. That's why you don't need to be technically great, because if you have a strong philosophy people will be moved by your pictures regardless. The most important thing is to figure out what you want to try and say. You should constantly be asking yourself: 'What do I want to say next? What do I believe in? Who am I? What is my image? To be a successful photographer, you have to have a unique point of view otherwise you'll get lost in the mix. For me photography is about exploring – either myself or another place.

Does the philosophy then translate into a signature style?

I think style is something that should come naturally to people. I think you're either talented or you're not. You can learn to frame a shot, but not really to have a point of view. There are visionaries and imitators. There's Jimi Hendrix and then there 's a million other guitarists who try to play like him.

How did the iconic Calvin Klein image of Kate Moss naked on the sofa come about?

That was a long time ago. Fashion was so much freer then. Calvin Klein

Above left: Mario Sorrenti, *Kate Moss* (Calvin Klein Obsession campaign), 1993
Above right: Mario Sorrenti, *Shannon with Hand in Mouth*, 1996
Opposite: Mario Sorrenti, *Goya Donkey* (*Another Magazine*), 2004

had seen pictures of Kate and me on holiday that I had in my diary and he just said: 'Go back to that island and take more pictures like that.' Kate and I were going out at the time and were extremely intimate. It was incredible. I don't get that much freedom anymore. These days everyone from the art director to the marketing people get involved. They tell you: 'Do it like this, it's got to be soft, it's got to be light, it's got to be sensual, it's got to be clean....' Some art directors these days even compose and Photoshop the layout, you almost don't need to take a picture. Often I think, 'What do you need me for?'

Do you ever wish fashion photography didn't involve so much production?

I'd love it if it didn't. I did a campaign for Stüssy once where they gave

me a van full of clothes and I drove across America for twenty days and just found kids on the street, put them in the clothes and took their portrait. It was possible back then. That was a different time.

How important are personal projects to you?

For me to feel that what I'm doing has some substance, I need to do things that don't relate to fashion, that are very personal. *The Machine* was a project that came about after my brother passed away. It was a whole bunch of film that I found that I'd shot of him. It was a therapeutic process.

To me those pictures are really beautiful and they talk about so much more than the relationship I had with my brother. I also did an exhibition where I covered the walls of a gallery with Polaroids,

prints, objects and drawings, and I re-photographed the wall in sections.

What excites you most about photography?

When I first started taking pictures I was interested in focusing on something and really trying to understand it – whether that was a person, a landscape or simply the light. It was about isolating something, looking at it with a magnifying glass and then creating something from it. Now I love the act of creating a new image. When everything comes together, it feels like ecstasy. It's like a climax. I always work towards that moment. Often I'll continue shooting beyond that point because something completely unexpected might happen. I've had moments where I've felt like I was on another planet because I saw something beautiful. To me, taking pictures is being alive.

Are you interested in fashion?

I am now, but I used to hate it. I thought it was superficial. I wasn't interested in photographing clothes. I was more interested in people. I was always criticized by art directors for not being interested enough in the aesthetic of fashion. When I got older I realized I was very lucky and that fashion had been good to me. I said to myself: 'Forget trying to be an artist, make the best of this.' Ironically fashion has taken me places I wanted art to take me. There are now a lot of museums that collect my work and

I've had a lot of exhibitions. When I do shoots that don't focus on fashion, it is like creating my own art work.

How many assistants do you work with?

Heather runs my digital and computer side of things. Lars is my first assistant, and takes care of my lighting and my cameras. My second assistant, Kenny, helps out with lighting and anything else. I also have a producer, who helps organize the shoots, a studio manager, who manages me and makes sure I do what I'm supposed to and an agent, who gets me work.

How much preparation goes into a shoot?

Between two weeks and two months. I'll have meetings and telephone calls with stylists and art directors. Ideas flow back and forth.

How do you go about choosing your models?

I've got to meet someone and feel there's something there that I want to photograph. There's got to be a connection. If I take a Polaroid and there's energy, I'll work with that person. I try and build a rapport with models over the course of several shoots. The more I work with a model and get to know her or him, the better the pictures turn out. For example, I've been working with Kate Moss for fifteen years and it just gets better and better.

How do you get the best out of the people you photograph?

There needs to be a certain amount of chemistry between me and the subject. It's the nature of the photographs that I take. You have to allow that kind of flow otherwise you can kill the spirit and the feeling of the photograph. I've had shoots that have been completely wild, where a model had little boundaries and felt really comfortable with herself. For example, I did a shoot once where a model posed naked wearing a mask out of clay on her head, which was totally deformed…. But the most important thing is that the models I work with feel respected and safe, especially if they are young. I try to go with the flow as much as I can, even when I'm photographing stars. If they don't want to wear this or that, I say 'So what do you want to wear? Let's do what you want to do.' There's no point fighting somebody you want a picture of.

Mario Sorrenti, *Image of Davide [The Machine]*, 1992

Ellen von Unwerth

Having worked in the circus as a teenager, and later as a model, Ellen von Unwerth came to photography almost by chance. Despite a lack of formal training, she proceeded to create a unique visual language. Instantly recognizable, her images combine the sensual and feminine with the playful and energetic. Over the last two decades, her pictures have appeared in countless fashion magazines, including *i-D*, *Harper's Bazaar*, *Vogue* and *V*, and have been the face of numerous advertising campaigns such as Guess, Victoria's Secret, H&M and Miu Miu. Ellen von Unwerth has published several books, including *Snaps*, *Couples*, *Wicked*, *Revenge* (a photo-novella) and *Omahyra & Boyd*.

Ellen von Unwerth, *Paradise Lost* (Japanese *Vogue*), 2002

How did you first get interested in photography?

By accident. I was a model at the time and my boyfriend was a photographer. He taught me how to print because we had dark room in our apartment. Then he gave me a camera and told me, 'There's a plus, a circle and a minus, and when the circle lights up you can shoot.' That's how I started.

Did you notice early on that you were talented?

No not at all, I thought it was a really difficult profession, which it is, but it depends how you look at it. I wasn't even really interested in it, so it was great that my boyfriend bought me this camera. At first I took pictures of my model friends. I also shot pictures of kids and people in an African village, when I was there on a trip working as a model. I just went around in my free time taking pictures of people. When I had them developed, everybody said that they were really nice. I was surprised myself. Those were actually the first pictures of mine that got published. I think I'd had my camera for about two weeks at that point.

How long did it take for you to change profession?

Once I started taking my own pictures, I started giving photographers advice and would tell them, 'No, you shouldn't put the light there, you should put it over here.' They instantly stopped booking me and that was the end of my career. But I was very happy. I'm a creative person. I always have to do something. When you model, you wait all day long and people pull around on your hair. It wasn't really my thing.

To what extent did your ten years of modelling influence how you take pictures?

As a model, I felt people only ever looked at my outer shell. And I always wanted to do funny things, and they would say 'No. Don't move. Be serious.' I now do the complete opposite when I work. I love girls who have a personality, even if they are not the most beautiful, they always have something. They need to have a little devil in them. The more they move, the more I love it.

Do you always let them do their own thing?

I always have an idea for the shoot inspired by a movie, for example. It's important for me to have a story and then it's more like I tell them the role they have to play, who they are and then I direct them. But I like it when they're spontaneous and have ideas of their own.

To what extent does being a female fashion photographer affect the way you shoot and how the models relate to you?

I think the girls feel more comfortable and confident than they would with a guy. It's almost like playing between friends. It's intimate and it's much more fun.

"I love girls who have a personality, even if they are not the most beautiful, they always have something. They need to have a little devil in them. The more they move, the more I love it."

I think I just get a different feel from the girls than from the guys, maybe because a guy might be more interested in their body. I'm into expression and playfulness. But obviously I do love when the pictures are sensual and sexy, but in a fun playful way.

How do you go about choosing your models – it seems that you work with some people quite frequently?

It's difficult to describe, it's just something you feel, that this person is right for you. Then if I like shooting her I might use her over and over again. But I need a lot of fresh inspiration. But some girls like Eva Herzigova and Adriana Lima just have this thing where it clicks, and it makes for great pictures. Recently, I've been shooting Christina Aguilera quite a lot. There's something between us, which makes the pictures strong.

Do you think it's important to be technically proficient?

I'm self-taught. I think it's important to know what you want. I'm not really into setting up lights for hours, I'd rather go in the street with my camera and go click, click. For me that's more important than having the perfect lighting and perfect exposure. I'm into capturing the moment. Sometimes, I'll rip the camera out of my assistant's hands and he'll be shouting 'But there's no film in the camera!' and I think 'Never mind! Let's go.'

What equipment do you use?

I use Nikon and Contax cameras and Kodak Tri-X film. I tend to use a medium format when I shoot advertising campaigns, but I really love the 35mm Nikon.

How do you feel about digital?

I'm not into it. I'm going to use film for as long as it exists because I actually think digital isn't faster. You might have the pictures straight away but afterwards, you have to do so much retouching on it that it takes forever and it's not really less expensive either because retouching is expensive. So I don't really know why it's supposed to be so much better than film. Film is much more magical. You get that surprise element. You see your pictures and you go 'Wow!' There's the unexpected. With digital, what you see is what you get.

Does using film mean that you don't do any retouching?

I do very little. When I shoot celebrities, I might do a bit here and there. But generally I love it when a picture doesn't need retouching. Nowadays, with digital, it's always, 'Don't worry, we can remove that later, when we do the retouching.' Once when I was doing a shoot with this advertising agency, I heard someone say, 'Shit my purse is still in the picture!' and again it was, 'Don't worry, we can take it out digitally.' People get so lazy but for me the fun is in creating a picture and making it work from the outset.

Above: Ellen von Unwerth, *Claudia Schiffer* (Guess campaign), 1990
Opposite: Ellen von Unwerth, *Betty Page* (*Interview*), 1999

How did you come up with the idea of using Claudia Schiffer as a Brigitte Bardot type for that early Guess campaign?

She was totally unknown at the time. *Elle* magazine asked me to shoot a story about what a model does when she's not working, and it was Claudia. I thought she was cute, but you know ... and then

Above and opposite: Ellen von Unwerth, *In Great Shape* (Italian *Vogue*), 2006

when I looked at the pictures, I thought, 'Wow! She really looks like Brigitte Bardot.' She had the mouth, the teeth, even that slight strangeness in the eyes, which is very charming. I made her look just like Brigitte Bardot. I shot her in my little apartment at the time, and then I shot her for Guess and everyone went crazy over her.

Was that your first campaign?

No my very first campaign was with Carré Otis.

How do you come up with concepts for editorial shoots? For example, the shoot called 'In Great Shape' shot for Italian *Vogue* magazine?

I love old movies and silent movies. And I love the circus. I used to work in one when I was younger. I love movement. I love to capture girls when they're doing something. I'll have a chat with them before the shoot and tell them, 'You're a group of circus girls etc.' Whatever comes into my mind. There's always a first idea, but then it's very spontaneous.

I give them a role to play. That's why it's important to have girls with a little bit of personality, who understand what I want and have fun doing it. Not all the girls are like that.

What is your aim when you are shooting editorial? What would you like to say?

I try to create moments where people might look at the pictures and think, 'Oh I wish I knew this person', or 'I would love to live that story and be part of it.' I want to create some emotion.

How much creative freedom do you have when it comes to advertising, say with the Victoria's Secret campaign with Adriana Lima?

Usually when clients book me, they like and know what I do. They'll usually ask me to do my pictures, which are playful, where the girl is not totally concentrating on camera, but doing own thing. I get quite a lot of creative freedom. It's quite rare that people show me a layout and say, 'Do this.' I'm not good at that. It's hard for me when they show me my own pictures and say, 'Can you do it like this?' I can do it, but I'd rather have freedom.

Your shoots are often sensual and playful at the same time – do you think fashion shouldn't be taken too seriously? Is it a reflection of your own personality?

Ellen von Unwerth, *Adriana Lima* (Victoria's Secret campaign), 2003

"I collect silent movies, I just love the dramatic side to them, and the over-acting. [...] They were very naughty and in many ways much more daring than movies these days."

I think fashion is a good tool to express what you love and what you believe in. I love clothes but I'm not a fashion victim. I use fashion to tell my stories and to say something about life. I don't really take pictures thinking, 'Look at this amazing dress!' It's not what I do. But I love clothes and I love shoes. Whenever I work with a new stylist, I always look at her shoes first and I know straight away if I will like her or not. It's all about the heel.

When do you shoot black-and-white and when do you shoot colour? What's your preference?

Definitely black-and-white. When I work on my own projects, I always go for black-and-white. It has a more dream-like quality. There's something that's more unreal about it. It's more graphic and timeless. I just prefer it. Also, you used to be able to buy films that gave you strange colours. But nowadays,

everything ends up looking more and more realistic because the colour film created these days is for the mass market. These days, it's hard to find a colour film, which has a dreamy quality. Unfortunately, films are discontinued all the time. In the beginning of my career, I was using a Kodak slide film called EES, which was very difficult to expose, you couldn't trust it that much, but it became more beautiful the more you pushed it. Then they just stopped making it. It's hard for me to find film, which has the same beauty. I've tried so many films, and still not found one that's as beautiful.

How important are personal projects such as *Revenge* or *Omahyra & Boyd* to you?

Personal projects are total fun. You can do what you want and not hold back. You can let your hair down.

Is it important for your commercial work?

You have to free yourself from time to time. I also do a lot of reportage because it trains your eye and is freer. Personal work is very important. In a way it gives me more jobs than editorial work because with editorial, it's always quite safe. At the end of the day you always have to sell the dress etc. I always feel that my favourite pictures are never printed. It's great to do work for yourself. It's the most fun and rewarding. The *Omahyra & Boyd* project came about because I think Omahyra is an amazing creature.

She's really fascinating: she's very androgynous, she's got so much style, she's so elegant and full of life, you can't stop watching her. She looks boyish. And one day somebody said, 'You've got to see her boyfriend, he looks like a girl.' And I said, 'No, I can't believe it.' So then I followed them round and photographed the two together for a week, and I thought it was a very modern combination. I showed the pictures to Sam Shahid, an art director, and he put this little book together. It was more like a catalogue for an

exhibition because I had an exhibition at the same time.

Where do you get your inspiration? You said you loved silent movies, but is there an element of Bettie Page also?

I love all the old naughty pictures of spanking and I love Bettie Page. I collect silent movies, I just love the dramatic side to them, and the over-acting. No one else ever seems to want to watch them but I love them. They were very naughty and in many ways much more daring than movies these days.

What about photographers – are there any that inspire you?

Helmut Newton is one of my favourites because his women are very strong. You'll flick through a magazine and think 'Wow, what was that?' Even if it's just a shoe or a hand, there is something so strong about his pictures. And I also love Jacques-Henri Lartigue for the life, charm and lightness in his pictures. They are opposites in a way, but I love them both.

What advice would you give to a budding photographer?

You have to have your own style. There are so many photographers who come up and there's a big hoo-ha, but in the end the ones who are still working after many years are those who have a definitive style like Bruce Weber or Peter Lindbergh. You have to find something you love and find a way to create it. It's a way of seeing. For example someone might take very slick pictures or very spontaneous out-of-focus pictures like mine ... it depends what you like but you have to find something and follow that. You have to find a line.

Above and opposite:
Ellen von Unwerth, *Revenge*, 2003

Tina Barney

Not satisfied with taking pictures of skiers and picket fences as a photography student in Sun Valley, Idaho back in the 1970s, Tina Barney would go home and capture friends and family in their natural upper middle class habitat; a milieu she felt was slowly and sadly disappearing. The semi-staged photographs, published in *Theatre of Manners*, achieved great critical acclaim, as did the portraits published in her second monograph, *The Europeans*. Today many of her photographs are represented in the world's most well-known public and private collections.

Tina Barney, *Jill and Polly in the Bathroom*, 1987

When did you get into photography?

I started taking pictures when I was living in Sun Valley, Idaho. I guess I came to photography really late. I was twenty-eight years old. It all started when I made that first print in the dark room. I felt like a caged animal finally let loose. Spending so much time alone in the dark room was probably the most important thing I did in my life and also the most difficult. I'd be in there for four to five hours a day. Just sitting there watching that stupid thing agitate back and forth. It's such an important aspect of photography and yet I fear it's going to become extinct.

Why do you think spending time alone is so important?

It's the most important thing of all. When you're by yourself, you have to be able to have a discussion with yourself. You have to be able to turn your own self on. Nobody else can do it. If you can continue to do that you are going to continue to be switched on for the rest of your life.

During that time, I also began reading a lot about visual perception. That was the thing that made my heart beat most; the problems with space and scale, and what engages the viewer. I was reading Arnheim, Fried, Berger, and learning all about how the eye sees light and how the viewer responds when, for example, paint is raised from the surface of a canvas. It made me realize how difficult it is to turn the

Tina Barney, *The Trustee and the Curator*, 1991

"I also began reading a lot about visual perception. That was the thing that made my heart beat most; the problems with space and scale, and what engages the viewer."

viewer's mind on with a photograph because it's just a silly piece of flat paper.

It made me want to find out more about how an image is put together. So I decided to study Italian Renaissance painters. In my pictures I try to imitate the theory of visual perception.

What goes through your mind when you are framing a shot?

I don't know the sequence of how my brain works, but I do know that I work really fast. I always take the same amount of time to take a picture. An hour to set up. An hour to shoot. The minute I walk into a room I know what I'm going to shoot. I usually don't know what I'm seeing until I see the result, so it's a subconscious process. For example, let's take the *Jill and Polly in the Bathroom* picture. I specifically placed the hairbrush at an angle so that it tweaks your brain into paying attention to the things that are most important. It's a Dutch seventeenth-century gimmick. The viewer doesn't know it, but it works. I've always believed in the power of the centre. Seeing the radiator, the window and the picket fence draws the viewer into the space, which is also a Dutch seventeenth-century thing.

How much do you direct your subjects?

No one will ever know whether my subjects do the things they do because of how I've entered the room or because of what I've said,

how I'm dressed, or because they saw an actress doing a certain thing on TV the night before. For the picture of *Jill and Polly in the Bathroom*, taken in 1987, I placed them into that small space and set the lights up and then said, 'Come on Jill, start talking to Polly.' And I might have said, 'Move over there a little.' Most of the time it's letting them do what they want to do but just helping them a little bit for the sake of the composition and the narrative. I directed subjects in the *Theatre of Manners* because I wanted to say something very specific and I couldn't find it out there in the world.

What kind of camera do you use?

I generally use a 4x5. I only really use the 8x10 at home in Rhode Island because it's such a monster.

What about your lighting set up?

Most of the time, if I'm working on an interior shot, I'll set up lights to do an even lighting using an assistant. Sometimes, however, I don't have an assistant, like when I did the *Thanksgiving* shot. I'm so untechnical and I was in such a hurry, I dropped one of the lights and ended up loving what happened. I walked in front of the umbrella. I think that's one of the things people really like about my pictures. There are a lot of accidents. Most photographers wouldn't let accidents happen. Or they'd digitize them out. With me they happen because I work so fast and I'm

impatient. You couldn't get those pictures in a million years if you worked slowly. Another favourite accident is the extension cord in *The Trustee and the Curator*. I mean what kind of a photographer leaves her wires in the picture?

How did you manage to capture the three boys in *The Young Men*?

That was absolute luck. You can't plan that. I know these guys well. They are friends of my son, who were waiting to go to a wedding.

How many shots do you take per subject?

Twenty to thirty sheets per shoot.

What are you trying to say in your images?

Theatre of Manners is based on nostalgia, on love, on appreciation. And *The Europeans* book is as well.

Does it bother you if people interpret your pictures differently to what your intention was?

Oh no. I think people are highly narrow-minded. One thing that bothers me is that for years critics would talk about the richy-rich world of my pictures but not say one thing about the photograph and how it was put together – the things that are important to me.

How was working on *The Europeans* different from *Theatre of Manners*?

For *Theatre of Manners* I took pictures of my friends. I didn't know the people I was photographing for *The Europeans*. I found the subjects through friends or connections. I would just knock on the door of

people I'd never met and walk in. It was amazing. That body of work had to do with making portraiture, not killing myself to make people bounce around and do some kind of narrative, which is very different. The pictures in *The Europeans* are much quieter, but in a funny way also more intellectually difficult because I think the simpler the composition and subject matter, the more difficult it is to make an interesting picture.

Do you think it's important to have a philosophy?

You have to have a philosophy. I think some people have a more specific idea than others. Like Wolfgang Tillmans: what is he thinking about? Doesn't he work with a handheld camera? My philosophy is about setting up a set of rules for myself that I must abide by. For each body of work, a new set of rules. I try to formally challenge myself in terms of how I put the picture together. But I think what I want to say is so deeply rooted, I could take anything and it would be there.

What do you want people to take away from your images?

I want to make your brain work just enough so that you understand and just enough so that you don't understand. And to teach would be great. I think Thomas Ruff is brilliant, perhaps more so than Struth or Gursky, because I think there's something else that he's

thinking about each time he takes a picture and he teaches me something every time.

What made you decide to print so large?

It goes back to the late 1970s. When I went to show Anne Tucker of the Houston Museum of Fine Arts my work, she told me I could make my pictures 4x5 feet. At the time I was making what were considered big prints using wooden trays. I'd slosh the prints around in garbage bags full of chemicals. But Anne told me where I could go to have them blown up even bigger. So I had *The New York Times* picture blown up and it featured in a historic MoMA show called 'Big Pictures by Contemporary Photographers'. I think you get to see more when the pictures are bigger. I always want you to feel like you're in the room with that person. It should look like real life.

When editing, do you know straight away which one is the best shot?

Usually I know when I've taken the pictures which one it's going to be. That's the beauty of photography that you get those beautiful photographic phenomena. My theory is, the more pictures you take, the better you get. It's like a sport. I never wait to get a particular shot because wonderful accidents can happen when you shoot a lot.

Tina Barney, *Sunday New York Times*, 1982

How do you feel about doing editorial?

When I first started, I was worried that I might not be able to produce for somebody else. But I loved it so much, and then it just went. I'm pretty free in editorial. I do a lot of portraits and have worked for Dennis Freedman at *W* magazine a lot. Recently I got my first commercial job. I've been trying to get one for years, but I think people always thought I was going to be spoiled or that I'd make people look angst-ridden.

What do you make of digital photography?

I'm so angry about the digital world, I've actually gone the other way now and am taking pictures with an 8x10, like they did in the nineteenth century. My love of photography is so deep-seated that when you go up to a photograph and put your eyes a quarter of an inch away from it, I want to see that resolution. I want to see the beauty of the medium. And when you digitize, I don't care who makes that print, even if it's the greatest printer in the world, you still get that fuzzy, pointillist effect. It's like looking at polyester and then looking at silk.

What projects are you working on now?

I'm photographing tradesmen in the town that I live in, in colour using an 8x10 camera. I'm also working in black-and-white again.

Do you think people understand photography?

I think most people don't. I started taking pictures in the 1970s at a time when people were taking pictures for all the beautiful reasons photography was known for. Then all of a sudden speed comes into the arena. Speed for fame, speed for money, for getting results. Digital technology booms and dark rooms get annihilated from photography schools because students want to make their homework faster. But light is the first problem in photography. It's the root of the medium. I think when you start using a digital camera, the subject of light is out the door because it's all automated. You don't learn about the zone system or understanding shades of light.

What is the best way to learn about the medium?

You could say I'm old fashioned but I really believe in the classical way of learning about art. In other words, if you want to be a painter, you have to start out with a pencil, and then charcoal and slowly graduate. For example, I think it's good to do black-and-white printing before you move to colour. Photography students today might know about Degas and Van Gogh, but do they really understand the big fat idea behind the history of art? It all comes down to looking at a piece of art and dissecting it and understanding how it's put together. I think the most important thing is to go out in the world and see. I think everyone is so money hungry, that most art students do not want to take the time to go out and look and read about the thing they claim to be so interested in. They just want to make it and get into a gallery and be famous. Bam. Bam. Bam.

Have you got any tips for finding a subject matter?

Look at your own life. Read about art, go and see art. Some of my photography students live in New York City and never go to the Met or the MoMA. There's no excuse for that. Where do they think inspiration is going to come from?

What advice would you give to a budding photographer?

I would say sit down with a pencil and paper and think about what your life is about. What you are about. Don't even take a camera into your hands before you figure that out.

Tina Barney, *Father and Sons*, 1996

"I think that's one of the things people really like about my pictures. There are a lot of accidents."

Anton Corbijn

Photographer, designer and filmmaker Anton Corbijn eschews the world of celebrity glamour and chooses instead to focus on the raw and emotional. For over thirty years he has worked closely with artists, including U2 and Depeche Mode, taking portraits, designing album covers and directing videos. His images, which have become part of the visual language of recent generations, have been published in numerous monographs, including *Famouz*, *Star Trak*, *U2&i* and *33 Still Lives*.

Anton Corbijn, *Clint Eastwood*, 1994

How did you first get into photography?

I was born in Holland, on an island where my dad was the vicar. There was a strict religious vibe as well as a real sense of isolation. I felt that everything interesting was happening elsewhere. I was eleven when we moved to the middle of Holland and it was there that I started listening to music. Then, when I was seventeen, we moved to Groningen during the school holidays so I knew nobody. I really wanted to go to a concert that was happening in the city square, but I felt awkward about going on my own, as I was a very shy kid. So I took my father's camera as a prop. Once there, I decided to use it. The camera really helped me to get rid of my shyness. It was brilliant. I got the pictures printed around the corner and sent them to a music magazine and they actually published them. That felt fantastic. Music was always my first passion. I learned to love photography later. I didn't know the first thing about it.

Are you self-taught?

I tried to get into art school but I was turned down by three different ones. But I'm sure that not going actually helped me a lot. When you don't know how to do things, you find your own way somehow and that then is different to anybody else's. I guess you could say my style is my inability to do it any other way.

How did you initially develop your grainy black-and-white style?

I was very interested in the graphic element and I started looking at a lot of black-and-white photography books like Diane Arbus and Robert Frank. I didn't even look at colour. Also, in the 1970s in Holland there were lots of socially aware photographers doing reportage for newspapers. It was always heavily black-and-white. It's what I saw around me. When my pictures first got printed in music magazines, they were really small because I was a nobody and I photographed people who were on the edge of the scene. So I made my pictures very graphic, so that although small, your eyes would catch them before you turned the page. I also developed films slightly too warm, which was kind of by accident as I was too impatient. That gave the pictures more contrast and grain. I was using, right from the start, Kodak Tri-X film. A beautiful film.

To what degree did your upbringing influence the way you take pictures?

I think it's because of my upbringing that I've always been interested in man and his environment. I grew up with very old-fashioned Christian values. How I look at things was installed in me without realizing that initially. I didn't try to intrude too much, or put myself forward; I tried to leave my subject in their space, almost to the point of it becoming documentary style. I didn't set up

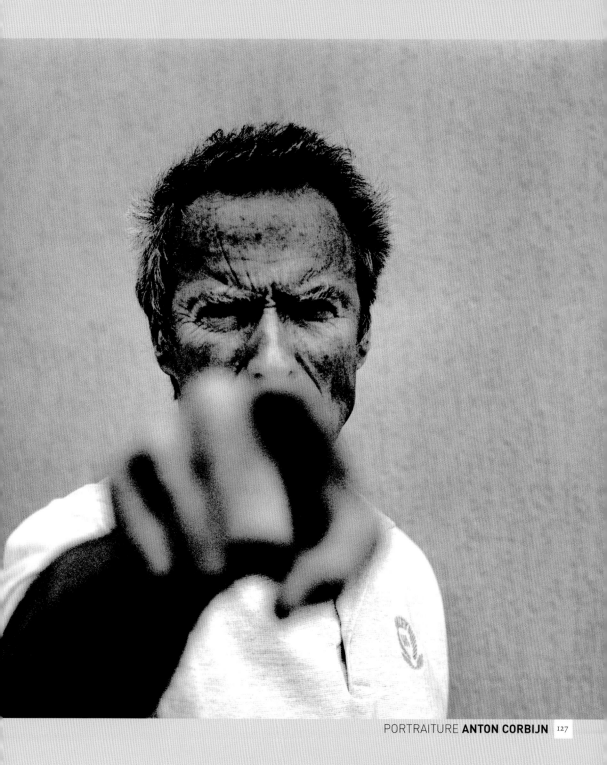

much either or come in with five assistants. The fact that I didn't interfere is a combination of shyness and upbringing. What is reflected in my early compositions is that most of Holland is flat. You see flat land and an incredible amount of sky so I took a lot of horizontal pictures.

What was your first big break?

In 1973, a year after I took my first photos, I met a musician called Herman Brood, who became the biggest singer Holland ever had. He was also a junkie and a very nice guy. We became friends. He was rock 'n' roll personified, which I never was. We would travel by train and he'd go to the toilet and shoot up and I'd photograph it. He didn't mind those pictures being published, in fact he loved it: he was an exhibitionist. Now I have reservations about this but 1970s Holland was a very tolerant place.

Do you think it's important to have a philosophy?

One main philosophy I have is that I want my photos to either be an extension of what you already know about a subject, or for them to go in a totally different direction and create something new. Only then do you actually contribute something. When I came to England in 1979 my work was published almost immediately because nobody was working the way I was – which really surprised me.

Anton Corbijn, *Tom Waits (blue)*, 1999

How did your style develop over the years?

I realized in the late 1980s that if I wanted to go on taking pictures my photography had to change for it not to become predictable. Both for me and for the audience. I had also seen a lot of photographers working with music who just got stuck.

How did you go about changing?

I moved to Los Angeles for a while to work with a different kind of natural light, namely sunshine and therefore shadow too. I also changed from a 35mm to a Hasselblad and I printed my photos on a paper that had a mix of black and brown in it when you developed it in lith-developer. So they were still kind of monochromatic but different than pure black-and-white. I started to do more close-ups, less of the subjects' environment. I also photographed other artists besides musicians such as actors, directors and painters. These photos became *Star Trak*, which was my best book commercially. The people I photograph are usually well-known artists, but I don't want that to be the only value of my pictures. That is one of the reasons I object to being called a 'rock' photographer as I feel that my photographs have a value outside of that.

How much do you research your subjects before a shoot?

I used to think I had to know all the works of the artist I photographed, but that's changed. I think it's OK to work with the knowledge that the general public has. It's not a bad starting point. Some artists like U2 or Tom Waits I've worked with for a long time. Then of course you get to know them and gain their trust, which allows you to go far further in terms of access and ideas.

How much creative input do you have?

A lot. But I'm very open to the people I photograph. I don't think you can always come in with an idea about how to photograph someone before you've even met and then ignore who that person really is.

Have you ever turned down a shoot because there was too much PR input?

Yes. One of the attractions to me of being a photographer is that photography isn't like being at school. I love that freedom as I really don't like being told what to do. That's part of the reason I don't do much commercial work. I see photography as an adventure: I like to discover where my boundaries are and what I can do with each person I meet. If someone gave me a drawing and said, 'I want you to do it like this', I'd be completely incapable of doing anything good. I'd feel restrained.

How much time do you get with people?

In the early days, sometimes less then five minutes, but these days I get offered more time. My early shoots were often done in hotel rooms so you had to be really inventive with how you used the space, and very quick. It's a great way to learn. Thanks to that experience I still photograph fast. For me, there's no adventure in arranging things too much. I usually use natural light. I don't carry any lights and hardly ever use a flash. Of course there is a difference in time offered when taking a photo of someone for your own project or for their benefit. I took a shot of Clint Eastwood, which became the cover of *Star Trak*, in two minutes. Someone introduced us and I asked straight away, 'May I take your picture?' We had our little moment together. I had no concept before I met him of how I would shoot him: the idea came to me on the spot. That can work really well but it is a bit nerve wracking, of course. My ideal way of shooting is really how I work with Tom Waits or Herbert Grönemeyer: we spend a day together, finding places while driving around, having lunch somewhere and talking a lot. The accent is not too much on the taking of the photos. The photos are a bit like my diary in that sense.

How did the picture of Bono and Salman Rushdie come about?

Normally I don't tell people how a picture comes about because I want some mystery retained.

Anton Corbijn, *Lars Von Trier*, 1997

I want all the strands of thought to remain open. But anyway, that photo was taken backstage after a U2 concert. I really like the composition because Salman has a beard but no hair and Bono has lots of hair but no beard. They've swapped glasses and are also standing in a similar way. They are, graphically speaking, like a negative of each other. I didn't even realize that until I printed it.

What about the picture of Lars von Trier with the wheelbarrow?

I had an exhibition in Copenhagen years ago and expressed an interest in photographing Lars von Trier in an interview and that was printed as a headline in the national paper. I was kind of embarrassed. But the next day, he invited me to his house for lunch and after lunch, he said, 'So how do you want to take my picture?' and I just said, 'Naked in the garden,' thinking he'd never agree – but he did. So I gave him a wheelbarrow, because a naked guy with a wheelbarrow is just weird and you can make a story. It was a photo for my '33 Still Lives' series. In my eyes, celebrity photography at the time had gotten out of hand: there was too much of it and it was totally clichéd. There was no mystery left and I wanted to go back to that, by making fake paparazzi pictures. And just to give you an example of how incapable I can be: I shot two rolls of film using the flash, to mimic the paparazzi approach. All the photographs came out over-exposed, except for that one shot. But that's all you need really, one photo.

How many shots do you do per subject?

I usually just want one picture and might shoot anything between two frames, as was the case with Bob Dylan and Robert De Niro, to six rolls of film. I know that no matter what situation I'm confronted with, I can always come back with one picture.

What do you hope to capture in your images?

Emotion I think. Emotion is a great thing. I'm very proud of that in my pictures. It's the most rare element. You can't learn that. I also hope to capture something you've not seen before. Because reality is only interesting to a degree, I try to emphasize things in reality, to make it more interesting. I don't crop my images and I always shoot handheld. By doing that I build in a kind of imperfection and this helps to emphasize reality.

There is a lot of hype around celebrities – what do you make of celebrity portraiture today?

Well, I'd like to emphasize that this is not what I do. I photograph artists whom I like, artists from various disciplines, not celebrities. I don't know any celebrity photographer whose work I'd like to follow. They don't give me anything I need. In that world, I feel pretty lonely because I have very old-fashioned values. I want pictures to give me something, to tell me something new. I feel that the American method of 'artist'

Above: Anton Corbijn, *A. Lennon, Strijen, Holland*, 2002
Opposite: Anton Corbijn, *Marianne Faithfull*, 1990

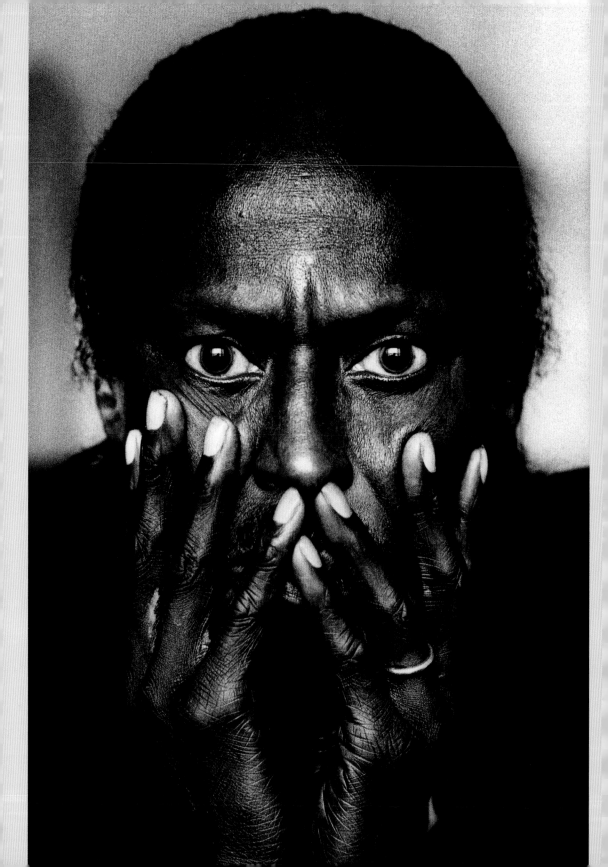

photography directs you way too much towards what you are supposed to think and feel. I guess I am the European version as I have different values and different messages in my pictures.

How would you describe your technical abilities?

Limited. But as long as you are capable of using technique to get to where you want to be, it's fine. I work using the Brian Eno school of thinking: limit your tools, focus on one thing and just make it work. For instance, by taking just one type of film with me and no lights, I have to make it work. You become very inventive with the restrictions you give yourself.

Do you think you can learn a way of seeing?

When I first started taking photographs, I am not really sure that I was seeing things. I improved, for sure, by looking at other photographers' work and by seeing the possibilities, for instance. I started seeing things from many more angles over the years. The upshot of that is that I see so much beauty around me now on a day-to-day basis as well as unfortunately a lot of what I call visual pollution. Like bad architecture here in England or carpets at airports.

Anton Corbijn, *Miles Davis*, 1985

What steps can you take to improve?

It could be very simple like trying out a new film. Right now, I go back to 35mm a lot. It makes you look at your composition in a different way. I think the problem with most people in art school is that they conceptualize what they do and then try to move towards the intuitive. I did the opposite. For me intuition was there first, and conceptualizing came a lot later.

How do you edit your work?

I usually know what picture will work once I've taken it. When it comes to selecting images though, you sometimes get influenced by what you wanted to achieve during a shoot and that can work against you. When I did the U2 book recently, I went through all the old contact sheets and I made different choices than I did at the time. Twenty years after a shoot, people don't care so much if their hair looks wrong or whether the composition is modern.

What are your views on black-and-white versus colour?

I tend to think in black-and-white – even the lith-prints and the blue prints I've done are a variation on the monochromatic. I'm still surprised what comes out when I use colour film. With black-and-white I tend to know exactly what I'm going to get, but that makes colour more attractive to me now.

> "I see photography as an adventure. I like to discover where my boundaries are and what I can do with each person I meet."

What excites you most about photography?

Meeting people like Nelson Mandela, Stephen Hawking or Miles Davis and being able to be in their space for fifteen minutes. In photography in general, it has to be where it is going as an art form. It is an incredibly visual world we are witnessing at the moment. There is too much visual information around but there are some great people working out there. I am very optimistic about the development of photography as a medium in the future.

What projects are you working on now?

I'm about to direct my first feature film. It's a movie about the life of Ian Curtis of Joy Division. So I'm taking a break from photography for the first time in a good thirty years. That is simultaneously both very scary and very exciting.

What advice would you give to a budding photographer?

In brief I would tell them to use their eyes, their brain and their soul.

Rineke Dijkstra

Dutch photographer Rineke Dijkstra tends to work in series, concentrating on individual portraits. She focuses on people in a transitional stage of their life, such as women after giving birth in 'Mothers', adolescents and pre-adolescents on the beach in her 'Beach' series and new recruits in 'Israeli Soldiers'. Her subjects stand facing the camera against a minimal background. The simplicity of the resulting image encourages us to direct all our attention towards the isolated subject. Dijkstra has published two monographs (*Rineke Dijkstra: Beach Portraits* and *Rineke Dijkstra: Portraits*) and her work is exhibited in museums worldwide.

Rineke Dijkstra, *Tiergarten, Berlin, Germany, June 27*, 1999

When did you get into photography?

I was studying to be an arts and crafts teacher, but didn't feel comfortable doing that. Then a friend lent me his camera once and I just thought, 'this is it.' I was nineteen. I did a photography course to learn the practical side of things and then went to Gerrit Rietveld Akademie, an art school in Amsterdam. I've always liked observing. Even as a kid I was obsessed with watching people that looked special to me.

Do you think it's important to be technically proficient?

It depends what kind of photography you do. It's important to know the possibilities in terms of what you can do. For example, how I use the flash and light is very important in my images. For me it was a case of learning by doing because I never understood anything they taught me at school.

What do you look for in your subjects?

It's important for me to know the location is right before I approach a subject. Then, I'll find the subject within that location and work from what the subject does. When subjects are posing for me, I don't ever want to manipulate them too much. I get excited about authenticity. I try to find people that have something special. I don't even know what it is. It's intuition. The pictures of the kids in the Tiergarten in Berlin, for example, came about because those children were actually playing a game and I was simply observing them. I'm interested in children because they don't have the feeling of self-consciousness yet and teenagers don't know how to hide it yet so it's always very much on the surface. I don't ask them too many questions. I don't need to know everything about them. I try to get to know them just by observing them when I am taking the picture. I try and look for an uninhibited moment, where people forget about trying to control the image of themselves. People go into sort of trance because so much concentration is needed from both photographer and the subject when you are working with a 4x5. Even the tiniest movement means you have to refocus. I also need to be able to relate to my subject. For example, when I took the portraits of the girls in the Buzzclub in Liverpool, England I could relate to them. I tried doing the same in other clubs, but it just didn't work.

What interests you about the transition of a person?

I think photography really lets you examine how a person is changing. When I was photographing Olivier, the Frenchman who enlisted in the Foreign Legion, every time I went to see him I thought he hadn't changed at all. But in the picture you can see the change in his eyes, in his expression. They were subtle, but you could see them clearly.

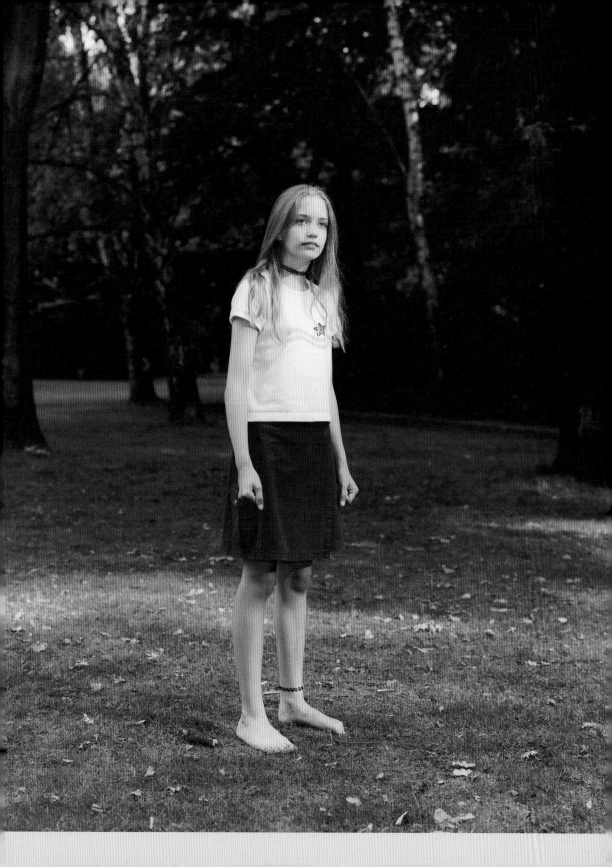

What is your aim when taking pictures?

I want to show things you might not see in normal life. I make normal things appear special. I want people to look at life in a new and different way, but it always has to be based on reality. It's important that you don't pass judgement, and leave space

for interpretation. For example, in the Almerisa series, the young Bosnian refugee, whose portrait I took for the first time in the early 1990s, it was important for me not to show any specific details of her surroundings such as the décor of the apartment. If you show too much of a subject's personal life, the viewer will immediately make assumptions. If you leave out the details, the viewer has to look for much subtler hints such as how her shoelaces are tied, or her lipstick or the state of her nail varnish. The same goes for the picture of the

boy in Odessa. You could show he is poor by including a trashcan or a stray cat in the picture. But for me it's all about subtlety and the fact that you really have to read the image to get clues about the boy. That makes it equal for everybody.

I like it when photographs are democratic. I usually find that portraits work best if you don't have a specific idea of what you are looking for. You have to be open for anything to happen. If you try and force something, there is always the danger of a picture becoming too one-dimensional.

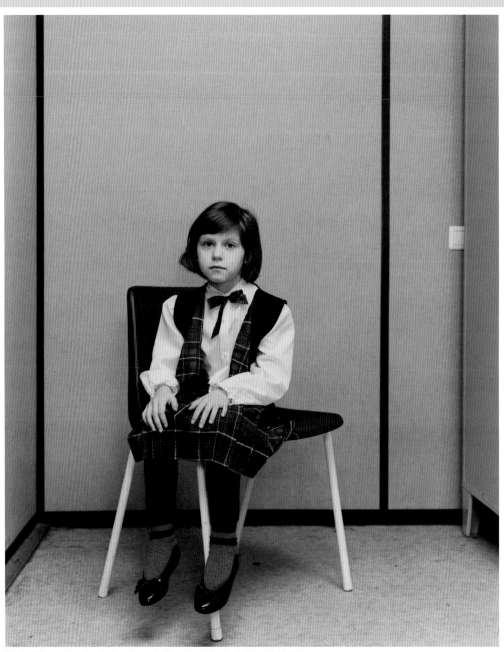

Rineke Dijkstra, *Almerisa, Asylum Center, Leiden, The Netherlands, March 14*, 1994

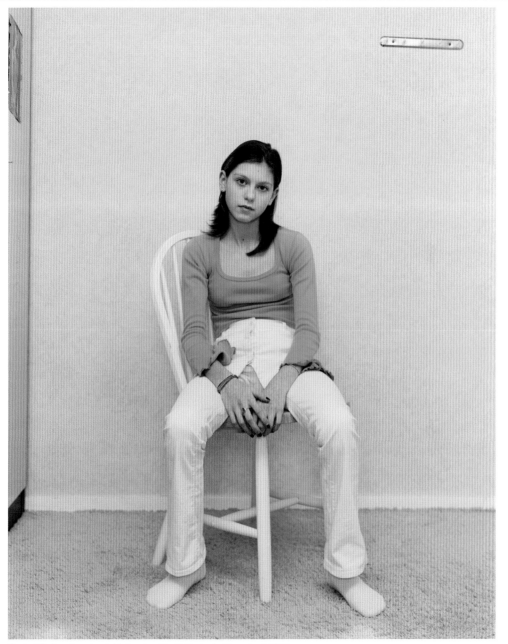

Rineke Dijkstra, *Almerisa, Leidschendam, The Netherlands, December 9*, 2000

How did you come up with the idea for the 'Beach' series?

I broke my hip about fifteen years ago and started doing self-portraits after swimming in the pool where I was doing physiotherapy. I was fascinated by capturing something unconscious and natural in a photograph, something that was miles away from the boring and predictable businessmen I had until then mostly photographed. I was interested in photographing people at moments when they had dropped all pretence of a pose. Once I began taking these pictures, I realized I would prefer to do a series because it gave me a better grip on a subject.

What equipment do you use?

I use a 4x5 inch field camera with a standard lens and a tripod. The negatives are the size of postcards, which gives you really wonderful sharp detail and contrast. The end result is that your photograph is almost more real than reality.

How do you set up your lights?

In the beginning I always had really complicated lighting set-ups because I thought: the more lights, the better the picture. Now I work with as few lights as possible. For me, daylight is the main source of light, and the flash is really only there to lighten the shadows. I use one Lumedyne flash. It works with batteries so you can use it inside and outside.

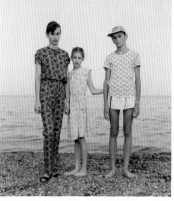

Rineke Dijkstra **Above:** *Jalta, Ukraine July 30,* 1993; **Opposite:** *Kolobrzeg, Poland, July 27,* 1992

How many frames do you shoot per subject?

I take about four or five sheets of film per subject, but I might shoot about five different people in a park on any given day. I've realized that I can't just go to a park and wait for the right person to turn up. I have to start working. Then I get into it and become part of the environment. It's a development. For example, a picture I took of a little girl in Barcelona only came about at the end of my working day. I was actually finished and packing up but then I saw her. She was there with her dad riding that scooter, looking at me like 'What are you doing?' and it's exactly the same look as in the photo. That's what I'm looking for. It's got to be emphatic. If you see the picture, it shouldn't look forced, it should

Rineke Dijkstra, *The Buzzclub, Liverpool, England, March 3*, 1995

"I get excited about authenticity. I try to find people that have something special. I don't even know what it is. It's intuition."

look like a snapshot. You're not supposed to think it's all set up. You should take it for granted and it should be totally natural somehow. I took three frames of her. That's how long her concentration lasted. But I got my picture.

How do you edit your pictures?

I scan the negatives and make them bigger so you can see more. Then I might leave them for two weeks because you need distance to see properly. It happens to me that I take a picture and I think it doesn't work at all and then I look at it three years later and I think it's a great picture. It's probably linked to having something in mind and being disappointed that your expectations weren't met, but then realizing later that it was in fact a lucky moment. But in general I make sure the light, the facial expression and the posture of the body look right.

Where do you get your inspiration?

I like the work of contemporary portrait photographers like Thomas Struth, Paul Graham and Judith Joy Ross as well as some of the older generation, in particular Diane Arbus and August Sander a lot, but generally I get more out of looking at old paintings such as the Rembrandts, Vermeers and Versproncks at the Rijksmuseum in Amsterdam. I think the light, as well as the emotional and psychological forces at play are so incredible in those paintings.

I prefer the old classics to contemporary art shows.

What art form does photography come closest to?

Perhaps sculpture. I think it's important that people understand and look at photography in a more abstract way. It's about being able to imagine looking behind the image as if it was three-dimensional.

Why do you print your images large format?

I like it when a picture is monumental – especially in a museum setting. But for me it's also important that if you stand in front of my picture, you feel the urge to come closer. If photos are too large, people tend to look at them only from a distance. I like them to be printed big enough so people view them from a distance but small enough so that they step forward and look for all the details in the picture. I think there is a whole story in all those details. It's about intimacy too.

Do you ever do editorial work?

When I first left art school I did portraits for magazines and newspapers but found it difficult because I wanted to create something more substantial that related to everybody, not just to one specific person. I learnt a lot about how to be technical, how to work with people and how to work fast, but now I'm more interested in my personal projects. Occasionally I do assignments for *The New York Times Magazine*.

Do you think people can learn a certain way of seeing?

I think everybody can do it. Diane Arbus said that you just have to choose a subject and continue photographing it for as long as something comes out of it. You always have to use your own fascinations as a starting point.

It's the same if you are in a group of people: you will always look at the people who are the most interesting to you. The same goes for photography, you have to photograph what you like. Passion is really important.

What excites you most about photography?

I love being totally in the moment, when everything comes together and is just right. You actually see things clearer. But I can spend weeks in the park without ever seeing anything interesting and I never know whether it is because it simply isn't there or because I just didn't see it.

What makes one image stand out more than another?

A photograph works best when the formal aspects such as light, colour and composition, as well as the informal aspects like someone's gaze or gesture come together. In my pictures I also look for a sense of stillness and serenity. I like it when everything is reduced to its essence. You try to get things to reach a climax. A moment of truth.

Rineke Dijkstra, *Isabel, Berlin, Germany, June 26*, 2003

Rankin

Photographer, publisher and most recently, film-director, Rankin has had everyone who is anyone – from the queen of pop, Madonna, to the Queen of England herself – in front of his camera lens. Besides launching *Dazed & Confused* magazine in 1991, he has published numerous monographs including *Celebrition*, *RankinWorks* and *Sofasosexy*.

Rankin, *The Queen*, 2000

How did you get into photography?

I was studying Accountancy at Brighton Polytechnic and ended up with loads of art students in my halls of residence. By the third term, I realized accountancy really wasn't my thing. So I took a year off and lived with my parents, which was hard to do. My friend and I started taking pictures together on a 35mm Ricoh. I really enjoyed taking pictures and found I had a talent for it. For a year, I did menial jobs like cleaning to pay for my obsession. I'd work during the day, shoot on the weekend and process and print all night in my mate's darkroom in the attic.

Would you recommend going to photography school?

By the time I went to the London College of Printing I'd pretty much taught myself what I needed to know. Nevertheless, I spent five years at the college, including two sabbatical years where I worked for the Student Union. It was during that time that I met Jefferson Hack, who owns *Dazed & Confused* with me, and we did the college magazine together. I always rebelled at college. When I got to art college, I thought they were all full of shit, so I started doing my own fashion and portraiture photography.

Do you think it's important to be technically proficient?

Yes. If you look at my broader work, you can see that I don't adhere to one style of photography. I'm not like Juergen Teller or Terry Richardson, who have hammered away at one style that is instantly recognizable. I try to keep my advertising book as varied as possible. I wouldn't be able to do that unless I was solid technically. I'm not great at lighting, but I've got great assistants.

What equipment do you use when you're shooting portraits?

I use a Mamiya RZ 6x7 with an analogue back. The majority of my work is studio-based, but I try to get out and about because I like a challenge.

What is your aim when doing portraits?

I try to come up with a new and unique approach for each of my subjects.

How did the portrait of Bono dancing come about?

That shot came about during a press session. I tend to get lots of mood boards and references going for a shoot because I find it helps me trigger how I want to do the photographs. When you meet someone, all your ideas might go out the window, but at least you've got a starting point. Sometimes I'll just chat with the subject and work it out from there. I don't like to overcomplicate, prop or do sets too often. Most of the time it's my interpretation of what I think of that person. For example, with someone like Bono, it's about encouraging him – even though he's a rock star – to do something different.

Rankin, *Tuuli*, 2006

"I think if you don't love people and aren't fascinated by them, you'll never succeed as a portrait photographer, because your pictures will look cold."

You have to make sure he's comfortable, because after all performing in front of one guy and a few assistants, is kind of embarrassing. It's about enhancing a situation for your subject and letting them trust you. I'm very collaborative. If people want to look at the Polaroids or contact sheets I'm happy to show them.

How do you deal with publicists and prima donna behaviour?

You can work with people if you talk to them. At the end of the day, it's only a photograph and if someone is going to get really upset about a photograph, then they have a lot of issues. I just roll with it and see what happens. Generally if you do that, you can push people into doing interesting things because they don't feel like you're manipulating them. I'd hate for people to come out of a shoot and feel manipulated. Of course they might come out and feel like I've been rude or offensive.

Why would they think that?

I use the technique of being cheeky and rude or asking them to do ridiculous things. For example, I might talk about my sex life, or their sex life. I cross the boundaries, but I can always gauge and see how my subjects are reacting. I rarely actually upset someone. Most people, especially the British, like a bit of naughtiness. I might say, 'I'm imagining you being fucked up the arse with a big black dildo.'

It makes them laugh. I think as long as you're making a fool of yourself and acting a bit crazy, they then think, 'Well I can make a fool out of myself too.'

What goes through your mind when you are framing a shot?

I almost defocus so that I can look at shape and composition, then I refocus. I also look away from the viewfinder and then look back. Once I've framed the shot, it's all about details.

How much do you have to know the people you're photographing?

I think if you don't love people and aren't fascinated by them, you'll never succeed as a portrait photographer, because your pictures will look cold. If, however, you love them, you don't have to know anything about them. You can just tap into them. It's a skill. Sometimes I've felt it's like photographic therapy on shoots. Every shoot is different and you have to alter your approach accordingly. You have to try to get into people's heads, so that they can open up to you and give you something. Sometimes we chat first, but sometimes it's good for everyone to be fresh and tense when you start out.

How important are personal projects to you?

They're really important to further my work. You need to be inspired and push yourself to do other things. Some things just come into my head

and I have to get them out – whether they are deep, shallow or just plain silly. It's a little bit like showing off and saying, 'Look what I can do.' Also, in terms of business you've got to keep showing the outside world what you're up to. For example, I've just worked on a book called *Tuulitastic,* which is a series of fashion and erotic portraits of my girlfriend. It really kick-started my enthusiasm to take pictures in a new way and to move my photography to another level. Commercial work is different. You have to really pull stuff out of people. It can be draining. Mario Testino said it's fifty per cent entertainment. If your subjects don't enjoy it you're never going to get anything out of them.

What was your first big break?

I got a press shoot with Björk when I was about twenty-seven. That was the first time I got £1,500 for a day's work. The picture appeared in *Dazed & Confused.* But I guess all the initial covers I did for *Dazed & Confused* really put me on the map.

What was it like shooting Tony Blair and the Queen?

The Queen was really fun. I ended up being a bit Austin Powers with her, 'Yeah baby, please ma'am can you smile for me?' What happened was that my synch lead fell out when I was shooting her and she laughed and I thought, 'I need to capture that again. I can't let it go.' I just banged on and on until she smiled. I think me acting stupid

Rankin, *Tony Blair*, 2003

Rankin, *Björk*, 1995

Rankin, *Tuuli*, 2006

"At the end of the day, photography is ninety-nine per cent business, connections and politics and one per cent creativity."

did it. I was saying stuff like, 'I know I'm supposed to say ma'am, but just want to call you mum....' I was just being really honest.

Tony Blair kept me waiting so long, I knew exactly what I wanted from him by the time it came to the shoot. I wanted a ring flash shot of him because I knew it would be hard for him to escape that kind of light. It was a crucial time. The war had just started in Iraq and they were in deep shit. He did two press photos. One with *Vanity Fair*, and one with me for *The Financial Times*. I was lower on the list of priorities and got five minutes with him. I had my flash ready to go. I shot about five rolls. I'm really quick when I take pictures. All the hotel rooms I'd photographed in over the years, doing celebrity shoots, really paid off that day. I knew how to light it and shoot it. It really worked. I chose a picture where he had a blank look.

How much time do you get with a celebrity?

I've got a reputation for photographing really fast and that sometimes works against you. For example, if I'm shooting U2 and they know I can do the job in fifteen minutes, then that's all they'll give you. An American publicist will give you a good seven hours with a star.

How do you go about editing?

I don't like editing so I always try to fob it off on to someone else, whether it's a picture editor or

someone in my office. You'll be surprised what other people can bring to your pictures. There's a great art director called Keith, who used to work at *Q* magazine. He'd see shots within shots that I'd never even thought of. I'm not fussy if someone wants to crop my pictures. Some picture editors prefer to get unedited images because they like to get a sense of the story. They might get 150 rolls of film from me. Others, especially American art directors, don't want to see contact sheets. They want to see your edit and work from that. When I do my own edit, I usually start by looking at my contact sheets at a distance. I focus on shapes and compositions.

Do you need a philosophy to do good work?

I think you need to have an endgame, and know where you're going and what you want to do with your work. Fashion, for example, is a whole different kettle of fish to conceptual photography. I tell my interns that they need to choose where they want to go in the business and work towards that goal, otherwise you'll never even break through the first barrier.

Where do you get your inspiration?

I'm much more inspired by photographers than painters. I'm into people like Avedon, Penn, Sorrenti, Teller, Knight. Whether you like it or not, you always get influenced by the work around you.

Rankin, *Tuuli*, 2006

> "You can teach anyone to take a photograph but you need more than that for a picture to be great. You need that effervescence, that untouchable thing. I can't describe what it is. It's that thing that makes people great at what they do."

So without even being aware of it, it may happen that you borrow and steal from people and sometimes they borrow and steal from you.

How do you feel about black-and-white versus colour?

I always shoot one roll of black-and-white, and then one roll of colour. It's pretty unusual. I don't think any other photographers work that way because most want to use a different kind of make-up for a black-and-white image. But I'm a bit more 'throw it against the wall and see what sticks' in my approach.

Do you ever shoot digital?

I don't really see the point of using digital photography. Film can be processed quickly now and I think you can do a much better edit using contact sheets. Also, if you're shooting digital, people stop and look at the shots every couple of frames. I hate that. It really stops the flow. With digital, an advantage is that once you've got your shot, you've got it. It's not like film, where you shoot Polaroids first and then try to recapture a moment or mood. When I worked on an erotic shoot called *Girls on Top*, I shot digitally. It helped the models get into it because they could come over and see what was happening. It was the closest to being sexual, because it was a participatory experience.

What do you hope to elicit in the viewer with your portraits?

I hope the viewer sees what I see. I hope they have an emotional response. I think two words that would describe my work well are: humour and honesty. Of course with my erotic work I hope people get turned on by it because it turns you on.

Do you think you can learn a way of seeing?

You can teach anyone to take a photograph but you need more than that for a picture to be great. You need that effervescence, that untouchable thing. I can't describe what it is. It's that thing that makes people great at what they do.

What makes one image stand out more than another?

Two things attract me to an image: how I feel about it and whether I think it's a good idea. But inherently it's an emotional reaction. I want to feel something when I see it.

What advice would you give to a budding photographer?

Don't give up, and believe in yourself. Also, work as an assistant. Make sure you choose the right kind of photographer and try to find out what it is about their work that you like. Most of all, make sure you learn about the business of photography. At the end of the day, photography is ninety-nine per cent about business, connections and politics and only one per cent about creativity.

Charles Fréger

A graduate of Rouen Art School, Charles Fréger is devoted to photographing social groups such as bakers, and ice skaters. Instantly recognizable, his images reflect on how people are different within a group. Charles Fréger has published ten monographs including *Rikishi*, *Steps* and *Majorettes* and in 2002, he founded the network of European photographers, Piece of Cake (POC) which currently has twenty-two members.

Charles Fréger, *Rikishi 15*, from the 'Rikishi' series, 2002–03

How did you get into photography?

After a degree in agriculture, I was studying painting at the Fine Arts school in Rouen. I started working on screen prints and tried to make my own photographs for that. I was immediately more interested in photography. I still admire painting as a medium, I'm just not very good at it. I came to photography when I was twenty-two years old and just had very basic knowledge. I had to teach myself.

Do you think it's important to be technically proficient?

It's important to know what you want to do and be able to execute that. You need to be able to find solutions for your dilemmas. Part of the reason I like photography is because I have systems in place I can fall back on wherever I go. Whether I'm taking pictures in a swimming pool, or in an ice rink, I know how to use my camera to get the picture I want.

What equipment do you use?

I always travel with all my equipment on my back so I am limited in terms of the quantity I can carry, but it's usually twenty to sixty kilograms. I use a medium format camera, some pairs of flashes – most of the time I work with four flashes and umbrellas. Depending on the project, I'll either work on my own, or with one or more assistants.

What attracted you to portrait photography?

I was interested in portraiture from the very beginning. All my references were in painting. I knew nothing about the history of photography. I think I first heard about William Eggleston when I was twenty-five, but I guess I managed OK without knowing anyone. I tried to do in photography what I enjoyed in classical painting – primitive painting to be exact, especially Flemish painting. I was interested in people's attitude, for example, in the Flemish paintings of Van Eyck, Petrus Christus, Memlinc.... It's that thing of being able to look someone in the eyes. It's about being distant from someone but having empathy for them at the same time. In Flemish painting, a lot of concentration is required from both artist and subject. It's a very precise, quiet atmosphere and has something religious about it. That's what I was attracted to. I wasn't interested in spontaneity. I wanted my images to exist for a while.

What moment are you looking to capture?

Something happens when I take a portrait of someone. It's not a natural attitude, but I think I'm the person who gets that attitude out of them. I always visit communities and tribes where there are strict codes and rules. For example, if I go to a sumo wrestling school and I have my equipment set up in front of the perfect wall within the space

Charles Fréger, *Water-polo 3*, from the 'Water Polo' series, 2000

"I wasn't interested in spontaneity. I wanted my images to exist for a while."

– it's usually a bit minimalist but it has to represent the environment – I'll tell someone to stand there, usually in the centre of the image and I'll say, 'Don't smile, watch the camera.' But the key is, they arrive in a space, which they think is their territory. They're thinking, 'I'm going to show you that I'm a sumo wrestler,' but when they step in front of the camera, it's like they're entering my ring, my space. There are flashes everywhere, the camera is there. It's my territory too. This creates some kind of confusion and that's what I'm looking for, when the subjects are a bit lost.

The picture I took of Etienne, one of the twelve water polo players of the 'Water Polo' series, is a good example of where everything comes together. You've got the white body, the complex background, the cap, which is reminiscent of Flemish painting, the drop of water.

How do you get what you need out of your subjects?

It's like beating a piece of metal. Over and over again. Sometimes, you get what you need in the first few shots, sometimes it takes thirty sheets. They're only ever in front of my camera for a maximum of fifteen minutes. When I was shooting the majorettes, for example, there would sometimes be up to six hundred people in the same room, with lots of music and noise. I would talk to the president of the majorette team and explain

Charles Fréger, *Lovely girls de Féchain 1*, from the 'Majorettes' series, 2000–01

what I was doing then twenty-five girls aged five to twenty-five would step in front of the camera, one at a time, or in small groups, with the rest of them behind me egging their friends on to say 'Smile!' I use gestures to tell them not to smile. They usually copy my body language like a mirror. So I if I move my head, they move theirs etc. It's like a meeting between someone who wants to catch something and someone who wants to give something. Also, eyes are always important. In the portraits I took of the horse guards for example, I took inspiration from Picasso. I really like the idea that you can have a profile of someone but that they are watching you at the same time.

What would you like to elicit in the viewer?

The main aim is to show how we are different within a group. But I would also hope that you feel empathy. I feel that my pictures are more like scalps, rather than heads. You have to look inside.

What do you think about when you are framing a shot?

I'm always thinking about the next picture. I try to keep pressure on myself. For example, recently in the small republic of San Marino, I was shooting forty guards and there was a really strong wind, a big Sirocco. It was impossible to shoot outside. I took pictures of fifteen of them, and then I had to stop and find a new location and it was impossible to find another place. There are two things that are fundamental in my work: the people in their uniform, but also the background. It has to be just right. So there were twenty-five guards there waiting for me to find a solution. It's like being a boxer and constantly trying to keep pressure on yourself.

Also, I shoot from down below. My camera is pointed up towards the subject. It's really characteristic of my work. You can recognize my pictures through that because most portrait photographers shoot face-to-face.

Why do you only work in series?

Even when I was still painting, I painted in series. Everything I made I had to paint plenty of times. So when I moved to photography it was completely natural for me to write and rewrite the same story.

Why do you shoot every single person in a group?

I hate castings. Even when I am working on assignment for a magazine, I tell them to choose the models for me. In my personal work, I shoot everybody because if you have twenty majorettes or sumo wrestlers in front of you, they totally transform when they step in front of the camera. They really start to exist. So someone might look really boring in the group, but once they're in front of the camera, they really come into their own.

Above: Charles Fréger, *Majorettes de Looberghe 2*, from the 'Majorettes' series, 2000–01
Opposite: Charles Fréger, *Libertines de Billy-Montigny 2*, from the 'Majorettes' series, 2000–01

"I feel that my pictures are more like scalps, rather than heads. You have to look inside."

Above: Charles Fréger, *Grande Escorte Royale 2*, from the 'Guards of the Empire' series, 2004–06
Opposite: Charles Fréger, *Boucher 30*, from the 'Bleus de travail' series, 2002–03

Charles Fréger, *2 Nelson 23*, from the 'Double Nelson series', 2004

"When I photograph a person, I will always find a way to feel close to them. The actual end product of the portrait is ... only the visual tip of the iceberg. It's more about an outsider trying to step into a group of insiders."

Does a photographer need a philosophy to do good work?

Yes. In my work, I am interested in a kind of morality; an attitude; an empathy. I respect my subjects and the fact that everyone has a chance to exist. Perhaps the empathy is a bit like the Stockholm syndrome, where you fall in love with your kidnapper. When I photograph a person, I will always find a way to feel close to them. The actual end product of the portrait is in a way only the visual tip of the iceberg. It's more about an outsider trying to step into a group of insiders. Every time I photograph a group, I get the feeling that I'm making my way into the group. But every time I finish, my subjects make me feel that I am in fact, a total outsider. It's very frustrating but that's the way it is.... Groups also exist to make outsiders feel that they are not part of the group.

What have you learnt about yourself by photographing these groups?

I grew up with the 1970s culture of my parents, where things like uniforms and the Church were frowned upon. Now I realize how fundamental it is to be a part of a group. In fact I created the photography cooperative, POC, four years ago, because I didn't want to work alone anymore. The idea came to me when I was driving through Norway. The sea was black, there was one metre of snow, and it was eerily quiet.

It was completely depressing. During that trip I decided I wanted to create something to ensure that photographers were never alone anywhere. For me, creating POC was like having my own tribe. Ironically, the two guys running POC – myself and Götz Diergarten – both work in series typology, where we talk about communities.

Do you think you can learn a way of seeing?

What makes one photographer better than another one is something you can't really explain. It's subtle. It's the energy behind the work, which makes it exist more than the others.

Where do you get your inspiration?

I'm not quite sure. If I arrive somewhere and I see a group of boy scouts I think 'Wow, that would be a great project. Who are these guys?' But then sometimes people contact me and say, 'I live in Russia and I have a contact at the Police Academy in Moscow,' so I jump on a plane and go for it. When I feel empty, I go to the Museum of Fine Art in Rouen and look at the *The Flagellation of Christ* by Caravaggio. I also love *The Adoration of the Mystic Lamb* by the Van Eyck brothers, in the Cathedral of Saint Bavo in Ghent. Being face-to-face with the Flemish paintings in London's National Gallery, in particular *The Arnolfini Portrait*, is fantastic.

How much do you do in post-production?

Nothing.

You are very prolific in terms of publishing your work. Why is printing a book of each series important to you?

I've done ten books to date. It's a way of clearly saying what I've done, like a manifesto. It helps me move onto the next project. If I had accumulated all those photos over the years without making a book and had to edit them now, I think I'd go crazy.

What are you working on at the moment?

I'm working on an idea for a feature film based around a community of majorettes in the north of France near the seaside. It's about how you might be accepted by a group but in the end you always stay an outsider. I've written the screenplay already, and if we manage to raise the money, I'll shoot it as well. I feel like I need to take a bit of distance from my work to feed it with a little something else.

What advice would you give to a budding photographer?

Be clever and share your contacts. It's a karma thing. It will always come back to you. Also, try to create your own network. For example, I was introduced to Gallery Kicken in Berlin through Götz Diergarten after we met via POC. Similarly, Götz had two exhibitions in France last summer thanks to me.

Charles Fréger, *Steps 17 (Dream Steps)*, from the 'Steps' series, 2001–02

Naomi Harris

Following the end of her documentary photography course at the International Center of Photography, Naomi Harris moved to Miami to photograph Haddon Hall, the last hotel in Miami dedicated to senior citizens. Thanks to her personal project she got her first assignment with *The New York Times Magazine* and has been working for publications ever since. She is the winner of numerous awards, including the Agfa Young Photographer Award in 2001 and the National Magazine Award for Photojournalism. Her first monograph, about swingers in suburbia, will be published in 2007.

Naomi Harris, *Clare and Daughter Ronda at the Rascal House, Miami Beach, Florida*, (*Heeb* magazine), 2002

When did you start taking pictures?

I never really had an interest in photography until I studied printmaking at university. A lot of my work was photo-based, using other people's pictures. So I thought it would be worth me taking a photography course myself. I took a basic photography class at uni and then went to Europe with my camera. When I returned I saw the contact sheets and thought, 'Oh dear, I think this is what I want to do.' On my trip I'd hung out with the owner of a kosher deli in Paris, a little old lady in Italy, who let me stay with her and I'd met a whole heap of interesting people. I used photography as a way of meeting people I'd normally never talk to. Most people think you're crazy if you walk up to strangers, but that's what I was most interested in and photography allowed me to do that. After uni I applied to do the documentary photography programme at the International Center of Photography and somehow managed to get in.

Do you think it's important to work on a personal project?

I wouldn't be doing anything today if it wasn't for my personal projects. My very first job for *The New York Times Magazine* was because the picture editor Kathy Ryan had seen the project I did at Haddon Hall, the retirement hotel in Miami. That project showed my

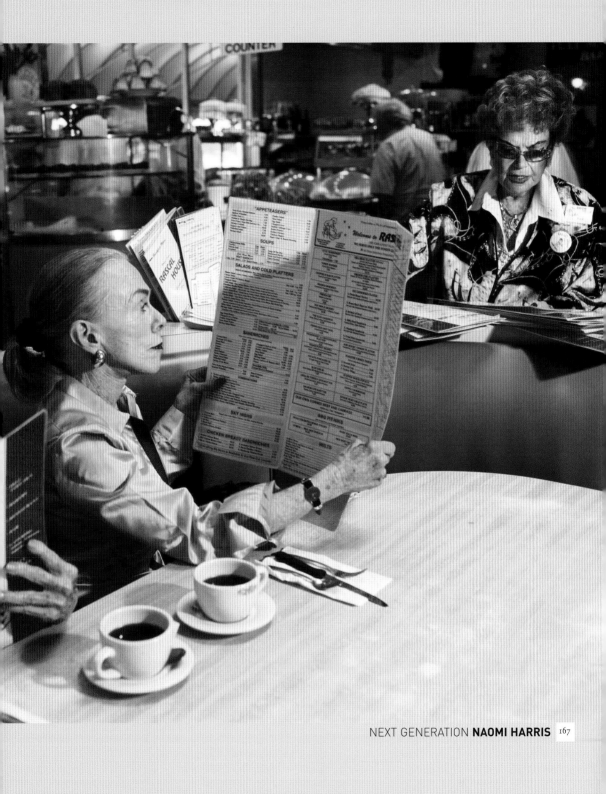

"I'm just innately curious. Whenever I photograph someone, I'll ask him or her a thousand questions."

Above: Naomi Harris, *Marie and Sonja by the Pool, Miami, Florida*, 2000
Opposite: Naomi Harris, *Leigh Smoking, Haddon Hall Hotel, Miami Beach, Florida*, 1999

"When I pick a project it has to be something where I can learn something about myself or the world around me. If I'm going to work on it for numerous years, it must excite me for a while, not just be a hot, trendy topic."

consistency and my ability to create a project with a beginning, middle and end. It allowed me to develop a style and helped me to develop a way of seeing. Today, a lot of the assignments I get are linked to the project I'm currently working on, swingers in suburbia.

How did you come up with the idea for those projects?

Haddon Hall was a very personal project for me. I only had my paternal grandmother who I wasn't close to growing up, so I needed to do that for myself. I wanted to feel

the love of seniors and experience something I never had. The swingers idea came about after going to a nude beach in Miami, when I was living there. A sixty-year-old friend of mine invited me to a swingers party and it just cracked me up. There was an all you can eat buffet, with big hunks of meat. People would just go to town on the food and twenty minutes later disappear to the back room to have sex. When I eat steak, I unbutton my pants, but I don't want to go and have sex. As we were leaving, they were

putting the breakfast buffet out and people were standing around naked eating pastry. I was mortified. I thought the whole scene was hilarious. At first I thought, what a bunch of freaks. But since working on the project, my opinion has changed a lot. I've explored my own sexuality. When I pick a project it has to be something where I can learn something about myself or the world around me. If I'm going to work on it for numerous years, it must excite me for a while, not just be a hot, trendy topic.

How do you get the best out of your subjects?

I'm always very honest with the people I photograph, whether that's a swinger for my book or an American football player for *ESPN* magazine. I always tell people about my own experiences and if people ask me questions, I'll answer them honestly. I open up a lot. At the end of the day, I'm asking my subjects for something, so I want to give something in return. The least I can do is be a decent human being. Also, I try to become part of the community as much as possible, whatever that community is. When I go to a teenage event like the Rubik's Cube World Championships, I'll wear jeans and sneakers. If I'm going to a sex party, I won't dress up like a nun, but wear knee socks and put my hair in pigtails. Using a medium format camera and pulling out

lights also helps because it makes people feel special; more important. Sometimes if you treat something like a bigger production, it helps you get better pictures.

Do you think it's important to be technically proficient?

Yes. Regardless of whether you actually use lights or not, you should know what the effect would be and then you can still decide not to use them. If you are technically proficient, you can have a concept and know exactly how to execute it. I wish I'd had more technical training at school because if you really know what you're doing you can make miracles happen.

Do you think a photographer needs a philosophy to do good work?

Most good artists are a bit on the crazy side. Most of my photographer friends are either on medication, in therapy or they should be. It's the off-kilter quirkiness that allows you to see people in a different way. I think it's the strange way you view the world that makes your pictures different. If you viewed it like everyone else, you wouldn't be taking pictures. I'm not sure you can call that a philosophy, perhaps it's more a way of seeing. For example I'm fascinated by what makes people tick.

With the swingers story, I think, 'You look just like my neighbour,

Naomi Harris, *Drinking Franzia, Swingstock, Wisconsin, July*, 2003

Right: Naomi Harris,
Ribs, Swingstock, Wisconsin,
July, 2003
Opposite: Naomi Harris,
Viking And Girlfriend,
Swingstock, Wisconsin,
July, 2003

what makes you a raging sexoholic?'
I try to give people a voice.

Where do you get your inspiration?

I don't look at other people's work
much. I think young photographers
often look to their heroes and try to
emulate the style, but that's a bad
idea. You really need to find your
own voice and do your own thing.
I get inspiration from the people
I meet and the experiences I have
meeting those people, for example
spontaneously attending a swingers
party with my sixty-year-old friend.

**Do you see yourself as a
photographer or a journalist?**

I don't see myself as one or the
other. I think I'm part of a new

breed. I use the internet a lot to
research projects, and then it's all
about word of mouth and finding
out about quirky events or people.
Because almost everything has
been done already you need to
find new subjects. Whenever I do
a story, I report back to an editor
with the five Ws (who, what, where,
why when) and all the relevant
names and contact numbers. Also,
I'm just innately curious. Whenever
I photograph someone, I'll ask him
or her a thousand questions.

**What thoughts go through your
mind when you are framing a shot?**

I try not to think. It's really just a do.
I'm always looking behind me and

around me to see if I'm missing anything. When setting up a portrait I often look for a specific spot, so that there is something your eye can go to. For example at a swingers party recently, I was trying to make sure this *Star Wars* poster was in the frame because I thought it was really important for the picture. It was a kid's room and there was an orgy going on in the bed. So often I'm sweeping a space or room to see if there is anything that needs to be in the shot to improve it visually, but when I'm actually shooting, it's a moment of meditation.

Do you think you can learn to have an eye?

You can take all the classes you want, and read all the books about lighting you can get your hands on, but at the end of the day, it has to come from within. No one can teach you how to connect with your subject. You can't teach a vision. You have to ask yourself, what am I trying to say? What is my vision? That can't be taught.

What makes one image stand out more than another?

It's the moment when it all comes together: the light, the colour, and the expression on someone's face. It just jumps out. You shouldn't even have to ask yourself.

What kind of equipment do you use?

I use a 645 medium format Contax, and usually carry a 35mm Nikon. I also usually use Profoto lights. I like the results of fill flash.

Above: Naomi Harris, *Harem Nights, Niagara Entice, Niagara Falls, New York, October,* 2004
Opposite: Naomi Harris, *New Years Eve, Live Oak Resort, Washington, Texas, December,* 2005

Naomi Harris, *Red Glove Fan, Michael Jackson Trial, Santa Maria, California*, June, 2005

"I wish I'd had more technical training at school because if you really know what you're doing you can make miracles happen…"

I'm a big fan of pictures popping out. Outdoors, if the background is not so important, I'll give more importance to the subject by using fill-in flash and darkening the background.

What advice would you give to a budding photographer?

Only you can make it happen. There are no free rides in this business. Have a vision and a focus and then make that portfolio. If you want to work for magazines, don't have puppy dogs on one page of your portfolio and landscapes on the next. Be specific. Be critical about your own work and don't use an image simply because taking it was a memorable experience. Consider moving to a different location to get work. Why be in New York where you are competing with thousands of other photographers? Editors are looking for people based in the mid west right now for example because they can't afford to send people out there anymore. Make appointments with editors, and advertising agencies, or at least work on your own project when you're not shooting for an assignment as that way, when things are slow, you know you've used that down-time wisely. No one is going to come and see your pictures if they are just sitting at home in a box. These days it's not enough to be a talented photographer, you have to be a good promoter and business person too.

Naomi Harris, *Number 1 Fan, Michael Jackson Trial, Santa Maria, California, June,* 2005

Alec Soth

An avid traveller, Magnum nominee Alec Soth spent three years taking pictures along the Mississippi river documenting the places and people he encountered with an 8x10 camera. *Sleeping by the Mississippi* was published to critical acclaim by Steidl Publishing, as was his second monograph, *Niagara*. Nominated for the Deutsche Börse Prize in 2005, Alec Soth continues to create images infused with a deep sense of lyricism and melancholy.

Alec Soth, *Rebecca*, 2005

When did you become interested in photography?

In high school I had an art teacher, Bill Hardy, who was all encouragement, which I needed at the time. I studied painting. Thought I was Pablo Picasso. That's when my interest in art exploded. But deep down I knew I wasn't a painter because I was interested in going out of the studio and into the world. The thing that really got me excited was going to a Joel Sternfeld lecture in college. He was talking about *American Prospects*. I'll never forget, he showed an image of his little car in the vast landscape and it was so exciting to me. I thought, 'God, I could drive around America. That really sparked something and I ended up getting into one of his classes. During spring break I took a trip down the Mississippi. I went from Minnesota to Memphis. I didn't take great pictures on that trip but the excitement of travelling started then. When I graduated, I knew that the work I'd done in college wasn't of any significance. I knew that I wasn't fully cooked. One of the things that was really lacking was the ability to photograph other people.

How important do you think it is to have formal training?

Not very. At my school, Sarah Lawrence College, we mostly sat around and talked about pictures. I don't think technical training is essential. There are plenty of other good ways to learn photography.

One thing college did do was open my eyes. It eventually helped me find my own way of seeing. But when I was in school I ran away from influence. It's a common thing. I think most art students want to be the greatest thing ever but in order to do that they feel they must create something entirely new. But in doing something new you don't end up communicating to anyone because it's not part of a language. You're making up a whole new language. I think you need to work out of an existing language in order to communicate – you need to work *with* those influences, not run away from them.

What did you do after art school?

I went back to Minnesota. I felt comfortable there because there was no art world I had to deal with, no community of critics. That was really important for me, because I could do work and show it and no one cared. If I'd gone to Yale and then moved to New York, and someone had exhibited my early work – it could have defined me. But I knew I wasn't ready. I felt like I was hiding out in Minnesota while I developed.

How did you overcome your fear of photographing people?

I knew that the most powerful thing in photography is photographing people, specifically the face. Diane Arbus, August Sander....I just responded to those pictures and to avoid it would just be sad, so I had

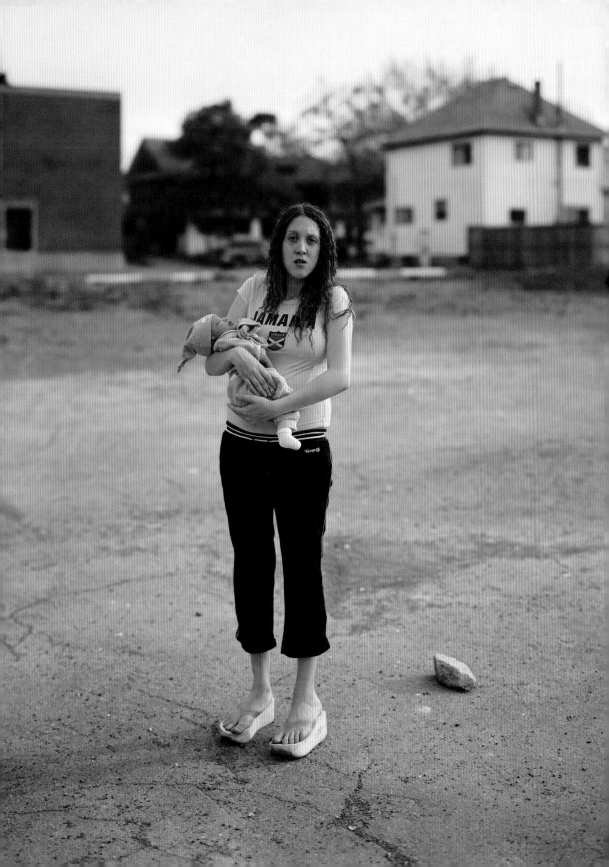

to confront it. I started out with kids because that was less threatening. I eventually worked my way up to every type of person. At first, I trembled every time I took a picture. My confidence grew, but it took a long time. I still get nervous today. When I shoot for assignments I'm notorious amongst my assistants for sweating. It's very embarrassing, I did a picture for *The New Yorker* recently and I was drenched in sweat by the end and it was the middle of winter. It's ridiculous.

How did your book *Sleeping by the Mississippi* come about?

When I was living in Minnesota I started working on a project called 'From Here To There.' The idea was that one picture would lead to the next. For example, if on one day I photographed someone cooking eggs,

the next day I might photograph a chicken. Along the way I'd taken some pictures along the Mississippi river and then thought: why not say it's about the Mississippi river? It was never a case of 'I'm going to document the Mississippi.' It was more about wandering, and one thing leading to the next and serendipity. Even today the 'From here to there process' informs my work. But I'm not limited to those tricks.

The Mississippi project was the first project I did that I felt worked for me because the whole world was my subject matter. I devised a system so that I was free. I gave myself little rules, for example, not going more than half an hour away from the river. It was essential for me to travel alone and also to drive. You need the separation and the interior space.

How do you find your subjects?

With people, it's usually an instantaneous thing. It might be the colour of someone's shirt, like with *Rebecca*, the girl holding the baby in *Niagara*. Often it is a colour response. Also with that particular picture, the girl's face just had a quality that I responded to.

What kind of equipment do you use?

I use a large format 8x10 camera and Kodak colour negative film. It's expensive. Each time you click the shutter, it's $20. On a technical front, the camera has very limited depth of field, so I always need more light. It's incredibly slow; you have to set it up on a tripod. I use a studio-style flash when I'm indoors. I'd prefer not

Top left: Alec Soth, *Two Towels*, 2004
Top right: Alec Soth, *Michele and James*, 2004
Opposite: Alec Soth, *The Voyageur*, 2004

Alec Soth, *Charles, Vasa, Minnesota*, 2002

"Whatever you're interested in, go for it. You can only find your voice if you're not intimidated by doing stuff that's been done before."

to because it slows the process down even further, but I have to. I guess I could do it without using a flash but then I'd never get that sharpness I love so much. The *Mississippi* prints were all traditional C-prints. With *Niagara*, we scanned the negatives and produced digital C-prints because it gives me more control over colour correction and more consistency in output.

How many shots do you shoot per subject?

When I was doing the Mississippi work, I didn't have a lot of money. I was very stingy. If something was very good I'd shoot two negatives just to be safe. In a way that was good because you're pre-editing. With *Niagara* it was harder to find my subject matter. I would go days without taking a picture and go crazy with frustration. So when I finally found find my subject I'd take a lot – sometimes a dozen sheets.

What do you ask yourself when you're framing a picture?

When I'm taking a picture, all thoughts leave my head. It's the nine hours of driving around beforehand where I'm thinking. And I think right after I've taken the picture about how it is going to fit into the series. Inevitably when you're taking the picture there are issues of light and how much time the person has. I always feel rushed and panicky. One of the concerns I had with having any sort of success was how it would affect my taking pictures. Would I

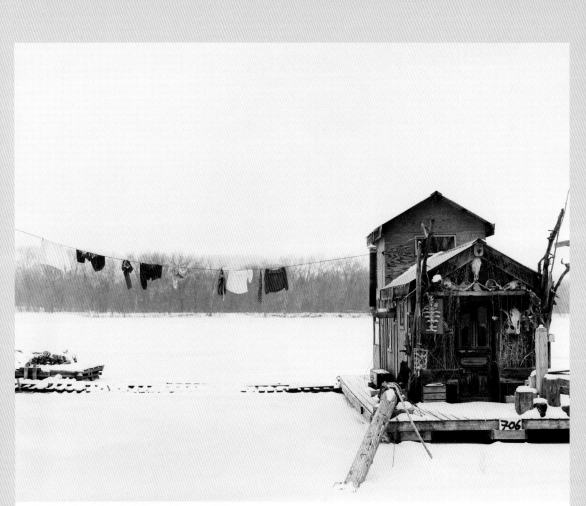

Alec Soth, *Peter's Houseboat, Winona, Minnesota*, 2002

think 'this will look really good on the west wall of the such and such gallery.' But all of it drops away. **Are you ever in the situation where you think I'm not sure that was in focus but you have to let it go?** All the time. It's the bane of my existence. I miss pictures all the time. It kills me. But I'm technically better now and I also shoot more

film, so I have better odds. I also have this problem that I try to get too much into a picture. For example, one time when I was shooting *Niagara*, there was a motel where the light was really gorgeous. I hadn't found anyone to photograph for ages so I was struggling terribly. I set up a picture and I'm completely bored of it and this woman comes up

and I think 'perfect, you look perfect.' I take a million sheets of film and when I get back and show the work to my dealer he says to me 'It's an OK picture, but it would be great if she wasn't in it.' I never even took one without her in the picture because I was so excited to have her in it. It's that desire to fill up the picture. But I have to remind myself

that photography is about limitation. It's about *not* having everything there.

What is your 'big theory' on photography?

It's kind of a joke to call it a big theory, but part of it goes back to Joel Sternfeld and his little car. Or Robert Frank and the last picture of *The Americans* with his wife and child in his car. When I look at that picture I revisit all the other pictures in the book. I'm imagining the process. The art of photography is imagining: 'I could have had this encounter with the world.' That's what I get excited about. That's what photography does. It's very related to poetry. It's suggestive and fragmentary and unsatisfying in a lot of ways. It's the art of limitation. Framing the world. It's as much about what you leave out as what you put in. With photography you have one little moment and you allow everyone else to fill it in.

Talk me through your editing process?

At the beginning of a project I'll have all these different pictures, because I don't know what I'm doing and the themes haven't emerged. The more trips I make, the more pre-editing goes on. I might see something that's interesting but it won't fit in. That's when taking a picture becomes difficult. I think in terms of a book and try to assemble it in my brain. I might take a couple of hundred and then edit that down

Alec Soth, *Helena, Arkansas*, 2002

into a series. In the end it's about creating a mood.

How much do you do in post-production?

Not much at all. I like the look of a conventional print.

What excites you most about the medium?

I love the act of taking a picture. I love that I work on the poetic side of the spectrum and that my pictures can be read and responded to in different ways. Sometimes it can be powerful, but I struggle with the individual picture because I take pictures as a series. I just don't know how much one picture can do.

Do you think a photographer needs a philosophy to do good work?

You need to find your own voice, as corny as it sounds. I do have that feeling that you need to know the tradition and find your little voice in that tradition in order to bring a little glimmer of newness to it.

How would you advise someone to go about finding his/her own voice?

You need to do the work. It's a long process. People often ask me what they should do to get published? In some cases, they haven't done the work or worked through their crappy pictures yet. You're not going to get your novel published based on a one-page treatment. You need to write it first. You have to make a bold jump, even if it's expensive. I think first books are often so great because it usually took a photographer a decade to do it.

How important is it to you to have your work looked at by peers?

It's important to be able to present your work as a condensed thought. Presentation is so much of what it's about. I think about it constantly. You have to articulate your ideas, especially to raise funds. So having commercial drive is not a terrible thing. It forces you to edit. It's not about *pleasing* an audience but *speaking* to an audience. So much contemporary art happens in this small world where it doesn't have to communicate. But if something doesn't communicate, it doesn't move us. Also, I often can't trust my own feedback. I'm always so aware of the experience I had taking the picture that I can't see it. But I'll show people towards the end as too much feedback in the early stages screws with your head.

How do you approach a much-photographed subject without doing it in a clichéd way?

I rub right up against clichés. Like, photographing the Falls. But I didn't want to be scared off by it. If you want to take pictures of kittens, do it. Whatever you're interested in, go for it. You can only find your voice if you're not intimidated by doing stuff that's been done before. With *Niagara* I thought of love songs. They always have clichés, but at some level it's going to move you. There's this thing that the art world always has to be new, new, new. But you don't have to reinvent the wheel.

What makes one image stand out more than another?

If there's one thing I've learned it's that it's really hard to know what people are going to respond to. Why does one song become a hit and another one doesn't? It's almost an innate thing when I choose a picture. A chimp can make a great individual picture, it's not that hard, it just involves luck. It's a weird combination that makes for a great picture. It's a complete mystery to me.

Where do you get your inspiration?

I don't know. I haven't had an editorial assignment yet that has led onto a bigger project; say like Larry Sultan and his pornography work, which I heard was inspired by a *Maxim* magazine shoot. When I'm thinking about what I want to do, I close my eyes and imagine I have a museum in my basement that no one else can go in besides me. I think about what kind of pictures I see on the wall. Then I make those pictures. If I was going to photograph something related to reality TV, I wouldn't photograph it from the outside, I'd photograph the people and try and figure out, 'Who are these people who long for fame?'

How do you feel about doing editorial work?

I like it, but it makes me anxious. I once asked Robert Polidori whether he was ever afraid that doing editorial would hurt his art-world standing and he said: 'doing editorial work is like being on road with a band. You don't do your best shit, but you raise the quality of your mediocrity and it makes you ready to do your best work when the opportunity comes along.' I totally agree with that. It's great practice all the time.

What was it like to publish your first book with Gerhard Steidl?

He is amazing. He's like a god to me. The greatest thing about him is he's all about art and not about money. The whole thing about Steidl is that there's not this committee you have to deal with, just one guy. If he says he'll do it, he'll do it and he'll do it like you want it. Also, because he's doing it on site in Germany and because he knows so much about technology and you're not sending it off to China, the quality control is great. It's every artist's dream.

What have the last ten years of taking pictures taught you?

I've learned to keep myself open to the whole world. There's a real problem with photographers who say, 'I'm going to do a project about this.' If you're a novelist you wouldn't say, I'm going to do a novel about grape jelly and show it over and over again. You'd show who makes it, tell different stories and show different elements. You'd create a rich world. Now if I come up with a clever idea, I realize I have to open it up.

Alec Soth, *Charles Lindbergh's boyhood bed, Little Falls, Minnesota*, 1999

"I have to remind myself that photography is about limitation. It's about *not* having everything there."

Neil Stewart

Famous for his energetic fashion campaigns for brands such as Tretorn, Puma and Folk, Neil Stewart combines freedom with great precision. He has an uncontrollable energy, thereby creating a unique, fresh perspective in his imagery. His work has been published in numerous magazines including *i-D*, *The Face* and *Arena*. More recently, Neil Stewart has worked together on projects with his brother, a director of photography, and is becoming increasingly interested in the moving image.

Neil Stewart, *Tretorn-bike in motion*, 2004

When did you first become interested in photography?

My mother used to shoot loads of Super8 footage when I was young and we used to have projection nights at the house. I've been obsessed with the visual arts ever since. I actually went to arts college to study painting. I was given a camera at the start of the course and I went around photographing the things I wanted to paint. As soon as I got involved with the mechanics of holding a camera, I fell in love with the medium. I felt, and still do, that I can paint with a camera. Although I was taking pictures in view to painting them, the photographs stood up on their own. Even today, I still take pictures in the hope that I will be able to paint them one day.

Do you think it's important to have formal training?

Depends on what you're like, but for me, the course at the Surrey Institute of Art and Design was the best thing I could have done. The woman who ran the course just let us go out and create. We were left to our own devices and if we wanted help we just asked for it. I learnt a lot. But on the other hand, if you've got half a brain cell and you understand a bit of maths and chemistry, then photography is easy. No one can teach you how to be creative though. You might be able to learn the order, but you have to progress it.

Did you ever assist?

I assisted big studio photographers for two and a half years and learnt everything about 'the business'. It's an invaluable time. Probably the best job in the world. Where else can you shadow someone who is at the top of their game? As an assistant you get paid to learn, travel and work in a creative environment. Apart from Youth Training Schemes there aren't many careers that have such a good filter system.

How did you get your first big break?

I used to sit in the surf shop Low Pressure in London making my scrapbooks of surf/snowboard trips, faces and places. One day an agent borrowed one for a few days and the next thing I know I have to take a few days off work to shoot a Levis-look book. After that I went around to any magazines, who'd give me a look. Picture editors and art directors always want to discover new talent, so usually it's not that hard to get an appointment.

How much creative freedom do you have on a shoot?

I get a fair bit because I tend to warn people what I'm like. I like to show my imagery my way – without too much compromise. The deal is, 'If you give me freedom, I'll give you great imagery.' That's the way I work best. Art directors should be like managers of a football team. They should manage the photographers well, rather than control them.

The brand Folk – a proper menswear label from the UK – gives me the most creative freedom. I've been involved since the launch and it's a privilege to create for them. Cathal McAteer, the owner and designer, and I have a similar sensibility and energy, so when we collaborate it's pure goodness. We had lots of conversations before we started the campaign. The imagery had to be timeless but fresh, and we had to give it an identity and a history. Whether the people were having a cup of tea or back-flipping into the ocean, we make the everyday fantastic. Keeping the crew at a minimum and energy levels at maximum, we achieve more in three days than most fashion campaigns in two weeks. The understanding allows for a special pace. This shows in the imagery, more so than in my other work. Take the picture of the three guys standing in front of a chapel. I just saw the three crosses, stopped the car, put the camera on the car on self-timer, stood in the picture with the other boys and we took the shot. There is always so much energy on the shoot and in the people. It works perfectly for the brand.

For me the best kind of photoshoot is when everybody, from the stylists, the hair and make-up artists, through to the models, is involved

Neil Stewart, *Folk One – Cathal laugh*, 2003

and concentrating on the one thing. When the atmosphere is vibrant and pulsating, it's impossible not to get a good picture. That's when I get really creative.

How do you make that 'pulsating' atmosphere happen?

I allow the models to be themselves and be free. It comes naturally if you just allow them to move. When the models feel like I'm not there, when the photographer almost becomes invisible, that's when you capture something special. The way I like to start a shoot, is to get up early and rather than telling people what to do because I don't like to be told and models don't like it much either, I might say, 'Right. We've got these bikes today. Just make sure you stay where I can see you.' I won't talk to the models apart from trying to get them to where the light is. That's when you get an honest and natural image. My set-ups are quite randomly set up....

How do you go about casting?

Because of the way I work, choosing models with the right energy is really key. Everyone always says that movie directors cast a better-looking version of themselves in main roles; it's kind of the same in photography. I try to choose people that will represent all sides of me. You are trying to show your emotions and ideas through these people. They should mirror and complement your style.

Neil Stewart, *Folk One – Original Crew*, 2003

How do you come up with concepts for your shoots?

They come up in a variety of ways but I always concentrate on things I'm really into. The only way you can ever get your style across is if your personal touch is there. For example, for an editorial I did for an Italian magazine called *Sport & Street*, which was a music issue,

I did a shoot inspired by the ska movement in England because I've always been obsessed with it. The mixture of people and their style was visually stimulating. I tried to recreate the energy so that you just want to be there when you look at the pictures. That's what I try to achieve with all my pictures – that notion of sharing the moment.

I always try to shoot like I'm part of the gang. I'm the invisible man between the viewer and the subject.

How would you describe your signature style?

All my work is about capturing the atmosphere of natural surroundings in the best light. I think the magic light in my pictures sets me apart. Motion is

Neil Stewart, *Folk One – Football Heads*, 2003

"When the atmosphere
is vibrant and pulsating,
it's impossible not to get
a good picture. That's
when I get really creative."

Neil Stewart, *Tretorn – 70s girls*, 2004

"As soon as I got involved with the mechanics of holding a camera, I fell in love with the medium. I felt, and still do, that I can paint with a camera."

also extremely important in my images. I don't work well when I'm confined to standing still. In fact, I work best when I'm thinking off the cuff, when I'm just completely involved in the moment. I'm always looking for that special atmosphere that you might get when you are documenting a conflict, a band on tour or a film star on set. If you have those scenarios, that energy is a given. My job is to create that same 'alive' imagery with the people and places I have. Freezing motion allows the viewer to keep up with the image, therefore keeping up with me.

What equipment do you use?

Have photographers actually revealed that? I use a Contax 645 and a 35mm point and shoot. I have to use a medium format camera these days because of the size the image gets printed and it allows me to do more technically, such as synch up flash or shoot digital.

What do you think about when you are framing a shot?

Composition is what separates us. Broken down into three things: the light, the subject and the framing.... There are very strict rules in photography in terms of what works visually, I like to learn the rules and then break 'em.

What do you want the viewer to get from your images?

To be involved on every level. I want them to be there and feel it. Art is about stimulating emotion.

Neil Stewart, *Brasil – Capoeira Kids*, 2002

Where do you get your inspiration?

Everywhere I can. The reason I love travelling and doing outdoor shoots in good light is because I wanted to get away from mundane England. I grew up in Manchester, a place where the energy is electric but it isn't that stimulating visually: all the houses look the same and the light is flat. When I left, I longed for the opposite. I like to be around water, surf, snow and mountains. I also look at lots of photography, architecture and film books.

What photographers have influenced you?

I like the work of Paul Fusco. I think I have a similar eye to him. I also love the work of the surf photographer and film maker George Greenough. He custom-built his own equipment, body harnesses and surfboards out of fibre glass, which allowed him to take pictures nobody had taken before. Certainly, I'm influenced by my heroes but I learnt pretty quickly that repetition is the death

of art. I try to do something I've never done before on every shoot and try to technically advance my work – whether that's by using new filters or different flashes etc. For example for the first Tretorn shoot, they wanted the brand to be hugely influenced by the Björn Borg era. Because I've always loved the printing side of photography, which is an art in itself, I decided to experiment with the washed-out and faded light you get in those 1970s pictures you might see at the

hairdressers window. Printing can really influence a style and you can actually replicate that look in the printing process.

Have you ever gone to extremes to take a shot like Greenough?

I've definitely taken pictures where no one else would think of doing them: hanging off the side of a high building in San Francisco. Gaffer-taping myself to quad bikes. I'm not a stranger to danger. I actually get hurt quite frequently on my shoots because I push both myself and the models to the limit. For example, I might be hanging out of a people-carrier with the boot open and it's going at full speed and I'm not holding onto anything as I need my hands to hold onto the camera.

What else sets you apart?

I study visual communication, colour theory, architecture and body movement. Stylists and designers have an important role and influence over the photography. The details in the clothes, the colours they use, the way models are restrained or can feel free all affect the image. Equally, whether or not a photographer knows the principles of their own field can affect an image. I like to learn about successful retail stories. After all, if you don't know what sells, how are you going to sell it? If you have the choice to shoot a red, blue and yellow dress and you

Neil Stewart, *Editorial – ska band*, 2005

haven't studied Bauhaus, how are you supposed to know how to make your image have the most impact? The same goes for the models you choose. Some people have more presence, but if they've studied the Alexander technique it's going to help the image. Then you have to know how you work best and where all those elements can be brought together. Generally, I prefer working in outdoor environments with natural light. It represents me more than the four bare walls of a studio.

When do you produce your best work?

I like adversity. I think I've always cut a different line. When most people are sitting in a Winnebago on a commercial shoot because of rain, talking bullshit drinking bad American tea, I'll be out in a poncho and getting everyone to turn their car lights on, shooting through the storm. There is no such thing as bad weather, just the wrong clothes. Billy Connolly said that.

Are you interested in fashion?

Course. Fashion gives people an individual style. It's things like that, which make life more interesting. Before I became a photographer I worked in the rag trade for years. Still do I suppose.

How do you go about editing your pictures?

On my beautiful big wooden table in my studio. Editing's the good bit too. I'm not a percentage photographer. There are a lot of producers out there in the business, who can take a well composed picture and with the right girl and the right team, if they press the shutter enough times, they'll get a picture out of it. I don't work that way. I might take two frames or two rolls. On the Folk shoots for example, I never repeat myself. I move on after every frame. The best feeling is when you have too many images that you like at the end of an edit. For our first Folk shoot, editing was really hard because we had so many good pictures. It then went down to how many pages we could afford, which was twenty-six.

What makes one image stand out more than another?

It has to visually stimulate me and make me think or feel something. I have to not want to flick the page. It has to keep my attention.

Do you think you can learn a way of seeing?

No. Technically speaking, anyone can take a picture. But to create an image that stimulates other people is difficult, that's where art comes in. I always feel that good photographers have that inbuilt. You can't teach people that.

What excites you most about photography?

The feeling you get when you know you've got a good shot.

What advice would you give to a budding photographer?

Be a good businessman as well as a good photographer. You have to be cut-throat and incredibly determined to do well in this business. It's a very creative business but it's also an industry. You have to learn all the mechanics that go with it such as people skills, dealing with clients, managing your team, deciding which images you want to show the world. That's where lots of young photographers fuck up. They don't know or develop their style before they start showing their work.

Neil Stewart, *Editorial – ska band*, 2005

"An image has to command attention and reward you with something when you stare it down. It should either give you a deeper understanding of a subject, or allow you to appreciate something in a completely new way, to let you see the world anew."

PART 2
IMAGE TAKERS, IMAGE MAKERS

CURATORS AND GALLERISTS
AGENCY DIRECTORS, EDITORS AND PUBLISHERS

Camilla Brown

Senior Curator, The Photographers' Gallery, London

Camilla Brown was first introduced to the role of the curator while doing an internship at the Whitechapel Art Gallery in London. Following the completion of her MA at the Courtauld Institute, London, she became exhibitions curator at Tate Liverpool and later took on a curatorial role at The Photographers' Gallery, London, where she has been for six years.

Above: Gary Lee Boas, *Gary Boas with Frank Sinatra at Jilly's restaurant, NYC,* late 1970s
Opposite: Bettina von Zwehl, *Alina, no.8,* 2004

How do you go about choosing an artist?

You just get a sense when it's right to show someone's work. One thing I ask myself before deciding upon an artist is, can that work hold the space? For example, is that person ready for the show? Some artists might have one or two images that are absolutely stunning, but if you put twenty-five of those images in one space, it isn't really going to work. Also, sometimes people aren't quite ready for their work to go on display and to deal with the reactions of the public. As a temporary publicly funded gallery we tend to only show an artist once, certainly in a large solo show. So timing is really critical.

Would you ever choose an artist upon first viewing of their work?

It's very unusual to show someone's work if you haven't been aware of it for a number of years. One of the things I'm involved in is going to see students' work and doing talks and portfolio reviews. We do try to go to student end of degree and MA shows. You spot people whose work you like and keep an eye on them. But it would be quite unusual for someone fresh out of college to be shown at the gallery, certainly in a solo show.

Would you ever show work by someone who was new to the medium?

As a gallery, we are not averse to showing work by photographers who have never shown their work in a gallery context before and who do not see themselves as artists. For example, we did an exhibition with Los Angeles-based photographer Gary Lee Boas who is an amateur 'fan' who has produced an amazing body of work taking photographs of celebrities in Hollywood. When you look at the work from across the 1970s to the 1980s you simply can not believe the people he had been able to get on film – Michael Jackson; Muhammed Ali; Elizabeth Taylor; Ronald Regan – the list goes on. Having seen his work in a book, we brought the work together in a show with his letters and other paraphernalia that illustrated this obsession. He was amazed that we were showing his work in a gallery. Our interest was in many ways the social story his work could tell – our culture's obsession with fame and celebrity.

Don't you also have a responsibility to show work by people who aren't famous yet?

David Spero, *Brigyn's, Tir Ysbrydol (Spiritual Land), Pembrokeshire, Oct*, 2004

"My job is to be responsive to contemporary practice, not to make trends. If shows try to force a theme that is not appropriate they become contrived and self-conscious. I would, however, fight quite ferociously for something I believe in."

Absolutely. The gallery has in fact built its reputation by showing artists and photographers who have not had significant shows before and have become regular art circuit fixtures. I'm not reluctant to taking risks, and there are examples of people who have not shown before who have produced the most marvellous set of images having just picked up the camera. But we also have to think about whether or not this person is going to make another body of work that's equally interesting? Or is it just an amazing thing to show right now because it's really powerful?

What is frustrating is that there are so many good artists out there, and in a year we only have a few opportunities to hold solo shows. Some people, even the quite experienced, at times expect to show you their work and for you to say: 'we'll give you a show tomorrow' when that is not the way it works, not least as we have to plan our shows a long time in advance. I would expect someone who wants to show at our gallery to think about the types of shows we do and whether their work makes sense. Just wanting to show your work and gain recognition is not enough and for photographers, often an exhibition is not the best outcome for their work.

Sometimes a book is better than a show and many a photographer's reputation is built through this form of output.

David Spero, *Communal kitchen, roundhouse and chicken coop, Tinker's Bubble, Somerset, Feb*, 2005

What kind of shows do you put on at The Photographers' Gallery?

We break the exhibitions down into five different strands: firstly, there is the vernacular, or photography that isn't produced for a gallery context, like Gary Lee Boas. Secondly, we try to offer a contemporary perspective on historic work. I curated a Walker

Evans show several years ago, for example, which brought his colour work to the fore, juxtaposing it with his more well-known black-and-white work. Thirdly, we do solo exhibitions of established international figures, who haven't been shown in the UK before (we were the first to show Rineke Dijkstra and Boris Mikhailov's work).

We also hold first solo shows by British artists like David Spero or Bettina von Zwehl. Every eighteen months we aim to hold a group show, to tap into something that we think is of the moment. And finally, we have our annual Deutsche Börse Prize, where four nominated photographers get exhibited, one of whom will take the prize. We also

have a remit to look beyond Europe and the USA to Asia, Africa, Central and South America. I am presently co-curating a show of Colombian artists' work with Pippa Oldfield from Impression Gallery (York) for a group show in 2007. We recently met Milena Bonilla who has made a lot of good photography and moving image work. We were taken with her

work on buses in Bogota, where she stitched up slashed bus seats, which becomes almost a metaphor for healing the wounds of violence in this troubled country. It is very poetic and resonant work.

How important is presentation to you?

I really urge photographers to think about that. And sometimes they don't. When I worked at Tate Liverpool I worked with video artists and sculptors and they were much more aware, as part of their training, how to install work and how to connect different pieces. At the end of the day it's all about editing,

scale and presentation. And that is as important as taking the photograph in the first place.

Have people learned to really look at photography?

We are living in a society where we are continually bombarded with visual images to the point of saturation, and I think that this has in some ways made us all quite immune to reading images and particularly photographs. We want to be able to instantly understand what a photograph is saying. So the challenge with photography when you put it on a gallery wall is to get people to spend more time looking

at the images. To consider why images are placed next to each – why they are part of a series – and think about what the photographer might be trying to say. Context and captions can also totally change the way an image is interpreted, and become an integral part of the work in an exhibition.

Do you welcome artist portfolios?
Although we're a very small team, we're always looking at work. There is a huge demand for people who want either a show or often simply feedback on their work. I try to see on average six artists one-to-one every month. I will – if this is at the gallery – spend an hour with them but a studio visit will take longer. This is alongside all the shows I see and publications and magazines I am looking at. I also spend a lot of time researching shows both nationally and internationally. For one-to-one sessions I tend to see artists I've picked up on through all the above means, or those who are recommended to me. We used to have an open submission process but many people who applied were not at a stage where they would be ready for a show. So we recently stopped this process as we were inundated with inappropriate work.

Due to the response we had from photographers, we are now developing 'folio forum' sessions where we as curators, or other photographers or art editors, give selected people feedback on their work. We felt this was more useful than suggesting to photographers that sending in their work would lead to a show – which it rarely did. We realize this might not be right for everyone's work, but there is no fool-safe system. To be taken seriously as an artist you have to put time and effort into a proposal and the presentation of your work. We've had people apply who don't know

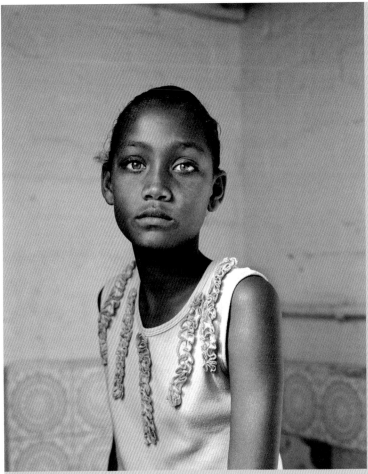

Adam Broomberg and Olivier Chanarin, *Naema Erasmus, 11, Mannenburg, South Africa, 2004*

anything about the gallery and who have submitted completely inappropriate work. I do not wish to discourage people because I know there are very good photographers out there who aren't sending their work in because they think 'what's the point?' So we are aiming to work to improve the systems we have in place to make it more effective for us and also more productive for photographers.

Who have you discovered in recent years that you have found particularly exciting?

The artists I mentioned above from Colombia interest me. There are a number of good people but some who spring to mind immediately are Bettina von Zwehl and Adam Broomberg and Oliver Chanarin. I could not claim to have discovered any of them but certainly they are young artists and I worked with them on their first significant solo exhibitions at the gallery. Bettina's work excites me as I think she is challenging the traditional notions of portraiture exploring both the outer public persona of her sitters whilst also revealing moments of inner contemplation. Adam Broomberg and Oliver Chanarin work together in a very interesting way and have developed a methodology that they used previously to focus on taking images of people often in socially isolated environments such as in prison and psychiatric hospitals.

"So the challenge with photography when you put it on a gallery wall is to get people to spend more time looking at the images. To consider why images are placed next to each – why they are part of a series – and think about what the photographer might be trying to say."

Now their work seems to be moving more to explorations of place focusing on historically loaded and politically volatile locations such as Israel.

Do you consider what the public reaction might be before putting on a show?

My perspective is that if you show interesting contemporary and historic work and it's a good exhibition, it will be publicly accessible. If I were to try and pick something that I thought was potentially publicly accessible, I'd probably end up being patronizing. It's like going for the lowest common denominator. You should always aim for quality.

What do you make of the 'curators as tastemakers' debate? How much power do you have?

I think that as a curator you are obligated to make qualitative judgements – you have to put yourself somewhat on the line and decide between what you think is good and what is not. However it is certainly not all about our own tastes. My job is to be responsive to contemporary practice, not to make trends. If shows try to force a theme that is not appropriate they become contrived and self-conscious. I would, however, fight quite ferociously for something I believe in and I've been very lucky that I've been able to champion work that I think is very strong and hopefully helped artists in key

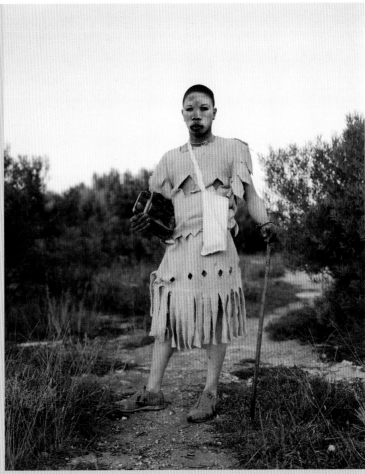

Adam Broomberg and Olivier Chanarin,
Mandlenkosi Nopqhayi, 19, Motherwell, South Africa, 2004

Ori Gersht, *The Clearing. Trace 1*, 2005

"At the end of the day it's all about editing, scale and presentation. And that is as important as taking the photograph in the first place."

points of their career. That is how I see myself, however I am sure the artists whose work I have not included in shows would have a different view on this debate. You cannot, as a curator, keep everyone happy all of the time.

If you are working eighteen months to two years in advance, how do keep your finger on the pulse?

When we move to our new location we would love to have a quicker turn around of shows and one-off projects, so that we can take more risks with younger artists, who have a good few images but don't have that whole body of work yet.

What advice do you have for young photographers who would like to see their work exhibited in a gallery?

Discussing work with other photographers at the early stages is really useful if you ever want to present your work to a curator, photo editor or publisher. Of course there are also portfolio reviews photographers can attend in the UK and abroad but they should bear in mind that if they see ten people they may get ten different opinions. I don't think there's any problem with showing someone you trust a body of work before it's in its final stages. I personally find it a lot more interesting as a curator.

Why do images need to be contextualized?

I think visitors to our shows need something to help orientate them around a space. They find it much more inaccessible if they don't have something to read. But you can make that as brief as possible to open up as many different interpretations as possible. Ori Gersht is a good example. There are two dialogues about his work. One is the personal history and story behind it and the other is how his work is experienced by the viewer. The most common question I get asked about his work is: 'are they paintings?' because they look so painterly. So I couldn't really write a text about his work without mentioning that, which I did by relating the work to the painters who had influenced Ori.

What are your views on digital photography?

If you've got something to say and it's the right format for you to produce work in, then great. Otherwise, Adam Broomberg and Oliver Chanarin are two fantastic photographers who use large format cameras to take portraits and landscape shots. Digital production is so good now that they can print their work using digital prints and they have the depth of field they need. So I am increasingly seeing photographers like them using a digital output to print their work but not so many using digital cameras to take their work with. As digital camera

technology improves and as photographers get used to using them, this will change.

Where do you think photography is going?

Because we are moving into a new space, we really have to ask ourselves this question. But it's like looking into a crystal ball. One of basic questions is whether prints are going to get bigger or not. Because of digital printing, you can suddenly make photos much bigger. I think it's inevitable that they will increase in size. But there might also be a backlash and people might produce smaller work. One trend we've noticed is a return to black-and-white photography. Who could have predicted that?

When can something be called art?

For me, given my art history background, it's very much about the viewer. For example, if you think it's art, it's art. But people always want a label. More than anything, my aim as a curator is to try to get people to engage with work and the ideas behind it. If it makes you think and it's interesting to you, then it has value. A well-curated exhibition should be thought-provoking and ask as many questions as it answers. It's not about saying 'be a sponge and I will show you what contemporary art is,' because there is plenty of contemporary art that I have issues with and don't enjoy.

Katherine Hinds

Curator of Photography, Margulies
Collection at the Warehouse, Miami

Owned by the collector
Martin Z. Margulies and
housed in a converted
warehouse near Miami,
the Margulies Collection
at the Warehouse is a
wide-ranging collection
of photography, video,
installation and sculpture.
The photography collection
includes work from 1910 to
the present, and traces major
movements in twentieth-
century photography,
including Social Realism,
New Topography, American
Street Photography and
the School of Düsseldorf.
A curator of the collection
since 1982, Katherine Hinds
functions as its custodian
and is in charge of installation
and educational programming
as well as networking with
galleries, artists and museums.

Jackie Nickersen, *Chipo, Farm
Worker Zimbabwe*, 1997

**What does curating a significant
private collection involve?**

We spend a lot of time developing
relationships with galleries and
artists for future purchases and
curating the exhibition space at the
Warehouse. At any given time, we
have over 1,500 works of art on
display at the Warehouse plus a
myriad of works out on loan to
national and international museums.

How do you select photographers?

A photographer has to fit into
the rhythm of the collection.
At present, the collection has
a great bone structure as we
have worked hard to develop an
extensive collection of photography,
from Lewis Hine up to the present.
When we are looking at new work,
we are looking to see how that
work will fit into the established
rhythm of the collection, and we
also aim to enhance the collection's
educational properties. A piece
of work does not have to be beautiful
or important in the marketplace,
but it might be a moment in time
when photography shifted or
changed because of a certain
photographer. For example, it was
important to acquire a photograph
by Walter A. Peterhans. He taught
photography at the Bauhaus. We
now have his photograph hanging
next to a portfolio of Bauhaus
photography to demonstrate the
history of the Bauhaus as a school.

**Where do you go to view and buy
work?**

We're in a position now where
galleries and dealers come to us and
keep us informed about new artists
and upcoming shows, but on top of
that, Mr Margulies goes to all the
art fairs and travels prodigiously,
visiting galleries worldwide. The
Margulies Collection is interested
in buying bodies of work, or
portfolios, rather than individual
images. Part of the reason for
doing that is that we have a large
exhibition space where we develop
exhibitions by rotating new works
on an annual basis and one of our
key aims is to give the collection
an educational aspect. We feel
that people coming to view the
collection can get a better idea of
an artist's philosophy if they can
see a photographer's extensive
body of work.

**How did you manage to have the
seminal moments of the history
of photography?**

There was never a game plan.
The collection evolved through
Mr Margulies' instinct. He has
an uncanny eye to seize work.
On top of that, we're always in
conversations with gallery owners.
We ask ourselves, when purchasing
a piece of work: how does this
apply? Where was the artist in his
or her development? For example,
when we saw Cindy Sherman's
Untitled (Bus Riders) from 1976, we
felt it was important to add it to the
collection because it predated the
film stills. The photographs help us

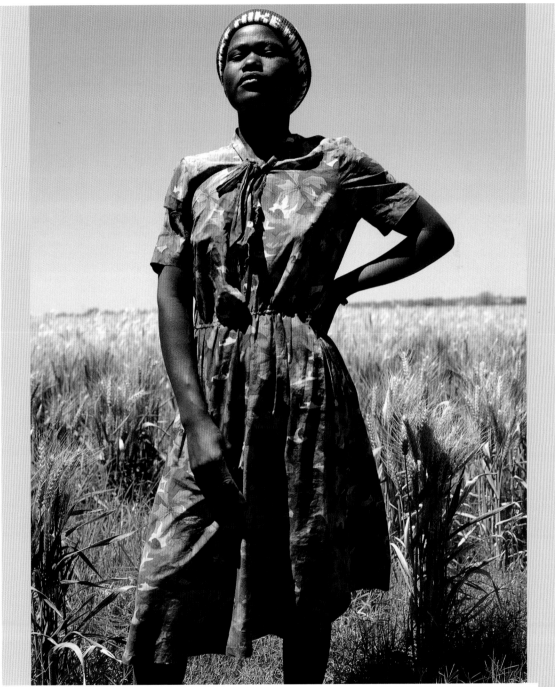

Cindy Sherman, *Untitled (Bus Riders)*, 1976–2000

Hajo Rose, *Self Portrait from the Bauhaus I portfolio (1910–1989)*, 1932

show young art students who visit the collection a body of work of an important American artist shortly after she herself was in school. It illustrates where Cindy Sherman was and where the students are now so they can relate to it and be encouraged.

Who would you like to see in the collection that you don't own at present?

There are artists Mr Margulies just can't get enough of. Alec Soth is someone like that, as are Justine Kurland and Jackie Nickerson. I think the collection could have additional pieces by those artists. Then there are always areas we would like to explore further in the German Photography section,

especially the mid-century era. But we don't have a wish list. That's not how the collection grows. It's not about representing a historical time line. We don't have the same mandate as a museum collection might have.

Is your selection criteria based on investment, on aesthetic sensibility or something else entirely?

It's not about possessing works of art or holding things for investment. That is not part of the thinking. Mr Margulies never sells work from the collection. The collection is about surrounding oneself with art and sharing art in order to learn about new things. It's about being engaged in this very interesting unorthodox world that is the art world. Also, the educational aspect of the collection is very important and has been ever since we lent the outdoor sculpture collection to the Florida International University. It was very rewarding to know that 35,000 students were viewing the art work every day and especially rewarding to get letters from students saying, 'Thank you for introducing me to art. It's changed my life.' Also, we often give pieces on loan to universities. It's wonderful to see the work in a new setting as you can experience it in whole new way by lending it. Eventually, parts of the overall collection, including paintings, sculptures and photography, will be donated to university-based museums. Every year we make decisions about

Ed Ruscha, *Phillips 66, Flagstaff, Arizona from Gasoline Stations*, 1962

"Sometimes we look at work by young artists and they are all over the map so to speak. It's a disparate body of work. What we're interested in when looking at young work, is that a photographer has taken an idea and really explored it."

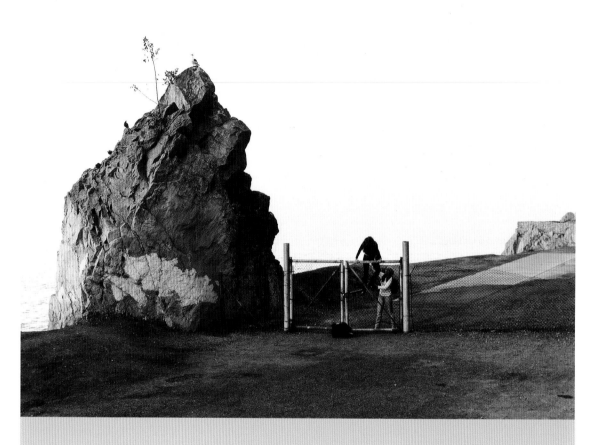

Above: Justine Kurland, *Gibraltar (Highway 1, California)*, 2000
Opposite: Albert Renger-Patzsch, *Machine Detail*, c. 1950

"We feel that people coming to view the collection can get a better idea of an artist's philosophy if they can see a photographer's extensive body of work."

where we will be donating works from the collection.

Do you welcome portfolios?

It's difficult for us to view unsolicited work due to a lack of administrative resources and time structure. We might ask to see an artist's portfolio if we've seen a book of his or hers or seen a piece of their work in a magazine. Generally, we're more likely to go to see shows following an invitation from a gallery. We're

very tenacious about seeing new shows and reading specialist photography and art magazines.

Do you only buy through galleries?

We rarely buy directly from artists. Primarily we buy through galleries such as Laurence Miller Gallery, Arndt & Partner, Galerie Ernst Hilger, Kicken Berlin, Tanya Bonakdar, Marian Goodman, 303, Jack Shainman, Sperone Westwater, Cohan and Leslie to name but a few.

Sometimes we buy through auctions and private sales. For example, we recently bought several portfolios from the Ruttenberg Foundation.

What makes one image stand out more than another?

That's a difficult question because there are so many diverse areas within photography. An image has to have a certain presence in terms of how it fits into the whole dialogue of photography.

Do you think a photographer needs a philosophy to do good work?

I don't know about philosophy, but an artist must have a good eye and a feeling for what he is doing whether it is photography, sculpture or painting. As Motherwell said: feeling is the very essence of art.

In terms of young art students, I think they need to develop a point of view and then fully work through that idea. Sometimes we look at

work by young artists and they are all over the map, so to speak. It's a disparate body of work. What we're interested in when looking at young work, is that a photographer has taken an idea and really explored it. We want to see that someone has put time and effort into fully developing a point of view, or philosophy if you will. Take the young Russian photographer Anastasia Khoroshilova, for example,

Andreas Gursky, *Prada I*, 1996

"It's not about possessing works of art or holding things for investment.... The collection is about surrounding oneself with art and sharing art in order to learn about new things. It's about being engaged in this very interesting unorthodox world that is the art world."

who takes beautiful colour photos of rural Russia; the photos give you a *feeling* of rural Russian communities. You don't have to go there in person to feel what this is about. The photos give you that. Walker Evans exemplifies this genre of capturing the feeling of a location through photographing mundane subject matter and somehow making it great.

Who are some of your recent discoveries and what attracted you to them?

Jackie Nickerson's photographs have been mesmerizing. She fits into the area of the collection that represents African people in their work setting. Her images never cease to captivate.

Ivan Karp once said that a great work of art is like looking at a fresh

vase of flowers every time you see it. It's like that with Ms Nickerson's work. You always get that great feeling, that thrill when you look at them.

Do you buy work from photographers worldwide?

Most continents are included in the collection. Amongst countless others, the African photographer Malick Sidibe and the South African photographer Zwelethu Mthethwa are represented in our collection. If a body of work fits into the collection and goes with the flow, that's when we strike. We don't go into it thinking, 'We need to enhance this aspect of the collection.' In the case of Zwelethu Mthethwa, Mr Margulies was fascinated when he first saw the very large colour photographs. They just had a certain humanism, like the picture of the woman standing in her kitchen. It's a very global image, which was particularly interesting to Mr Margulies.

Where do you think photography is going?

I couldn't answer that question. Exploring that question is the best thing about the art form, so why answer it?

Anastasia Khoroshilova, *Maria Iwanov*, 2004

Dr Inka Graeve Ingelmann

Head of the Department of
Photography and New Media,
Pinakothek der Moderne, Munich

Following a PhD in art
history and an internship
at the Metropolitan
Museum of Art in New
York, Dr Graeve Ingelmann
worked as a freelance
curator for the Berlinische
Galerie in Berlin, the
Folkwang Museum in
Essen and the Sprengel
Museum in Hanover.
A curator for photography
at the Pinakothek der
Moderne since 2002,
Dr Graeve Ingelmann is
in charge of expanding
the museum's permanent
collection, as well as
organizing yearly
photography shows.

Eva Leitolf, *Youth in their parent's bedroom,
Rostock – Lichtenhagen* (from the 'German
Images – Evidence in Rostock, Thale, Solingen
and Bielefeld 1992–94' series), 1993

**Why do you think there is an
increased interest in photography
at the moment?**

There's always been photography
booms. For example, in the 1920s
there was a big photography boom,
when people first started saying
photography was an art form.
Then during the Third Reich,
photography was used as a tool
for propaganda in Germany. Sadly,
a lot got lost in terms of the belief
in photography and what it's good
for after that. It wasn't until the
1970s really that artists had
a renewed interest in the medium
– whether that's Joseph Beuys,
Katharina Sieverding, Jürgen
Klauke or Bernhard and Anna
Blume. But to my mind the ones
who really managed to break
through by working in colour and
in large format were the Becher
students. It was the most cheeky
step they could have taken to use
a very straight, documentary-style
approach and print in a tableau
format. However, digitilization
has brought about the biggest
revolution in photography and
it brings with it a new sense
of awareness in terms of what
photography meant in our history.

**How do you decide who to exhibit in
any given show?**

I'm always thinking about themes
for shows that could show the
collection in a new light. For
example, I recently curated
a small show about landscape
in contemporary photography
using works from the collection by
Jeff Wall, Axel Hütte, Lewis Baltz
and some work on loan by the
photographer Beate Gütschow.
Borrowing work for a specific show
is a good way of seeing whether you
would like to buy a piece of work by
that artist, as you can test whether
the picture holds the viewer over a
couple of months and whether it fits
into the collection or links up with
other artists.

**How do you go about choosing
artists for the permanent
collection?**

I try to enlarge the existing
collection by completing important
portfolios that are already in the
collection. I also try to see what
artists might tie in with the works
we have already, such as the
Becher School or the Americans
in the 1970s and develop it into
something new. Being a German
museum, I also think it's really
important to promote German
photography. We have a very
modest budget to buy new work.
Fortunately we are supported by
PIN, the Friends of the Pinakothek
der Moderne, who help us acquire
works by internationally known
artists like Andreas Gursky, Boris
Mikhailov, Wolfgang Tillmans,
Teresa Hubbard, Alexander Birchler
and others. We also use funds from
the Bavarian Ministry for Culture
to promote young artists based
in Bavaria.

Eva Leitolf, *Following the arson attack 20 May 1993, Bielefeld* (from the 'German Images – Evidence in Rostock, Thale, Solingen and Bielefeld 1992–94' series), 1993

"Getting recognized as a serious artist is not a sprint race, it is a life-long marathon."

Which young local artists have you invested in recently?

Two recent examples would be Eva Leitolf, a very talented photographer who did a series at the beginning of the 1990s on xenophobia in Germany and also Elias Hassos. As our means from the Bavarian State are very modest, we can only buy work by young emerging artists. But even in this case I tend to study someone's progress over the course of several years before I make a purchase.

What do you make of the 'curators as tastemakers' debate?

It might sound naïve but I try to stay away from the art market as much as I can. The art market is very entertaining but also short-lived. Something that is hip now might be forgotten about two years later. I always try to do exhibitions based on the importance of the actual work and if something is timely. For example, last year I showed the work of the unjustifiably forgotten avant-garde photographer Moï Wer. I tried to bring his work back to the consciousness of the public.

Where is German photography at the moment? Is a post-Becher School emerging?

The Becher School was never a real movement. Photographers like Gursky, Struth and Candida Höfer were linked because they worked in large format, had a documentary approach and studied with Bernd and Hilla Becher. It was such a

Ricarda Roggan, *Bett, Tisch und Eimer*, 2002

dominant form of photography, that we're currently seeing the third generation of Becher-style photographers emerge on the art scene. It's becoming a bit dull now. Internationally, there's always been a big focus on the Becher students, but the spectrum in German photography is much richer than that. Michael Schmidt,

for example, is from Berlin and has a completely different approach, but is equally important. Thomas Demand, who remodels recognizable interiors, like airport security checkpoints out of cardboard and then photographs them, has also taken a different path in photography, as has Wolfgang Tillmans.

What young German photographers are you currently keeping an eye on?
I get the feeling that the young photographers coming through now have a much broader approach. On the one hand you have someone like Ricarda Roggan, a young artist from Leipzig, who photographs installations she makes from objects she finds, through to Loretta Lux,

Sabin Hornig, *Rear Window*, 2004

"In photography the important thing is to see whether someone can reinterpret a well-known way of seeing or invent a complete new one."

who makes digitally enhanced portraits, which end up looking like a weird in between world that is hard to grasp. At first Loretta Lux's images made me feel uncomfortable because I wasn't sure whether her work wasn't just well-executed kitsch. But then I realized it's not that at all, it's very sophisticated. Sabine Hornig is

Sabin Hornig, *Radikal Reduziert*, 2004

another German photographer who has caught my eye. She takes pictures of Berlin shop windows and the reflections therein. In terms of education, the most interesting school of photography in Germany is the Academy of Visual Arts in Leipzig. Potentially that's going to be a hotbed of talent in the near future.

Who excites you on the international scene?
The Moroccan-born photographer Yto Barrada, a 2006 Deutsche Börse Prize finalist, is very exciting. Her photographs explore issues of migration in the Strait of Gibraltar in a very poetic way. Korean photographer Nikki S. Lee, who takes pictures of herself in various group settings such as 'the college girl', the 'rapper' or 'dinner with the banker boyfriend' is also inspiring. I am also keeping an eye on the Belgian artist David Claerbout who works with photography and film.

Does a photographer need a philosophy to do good work?
I don't think you can take pictures without having one. The artist

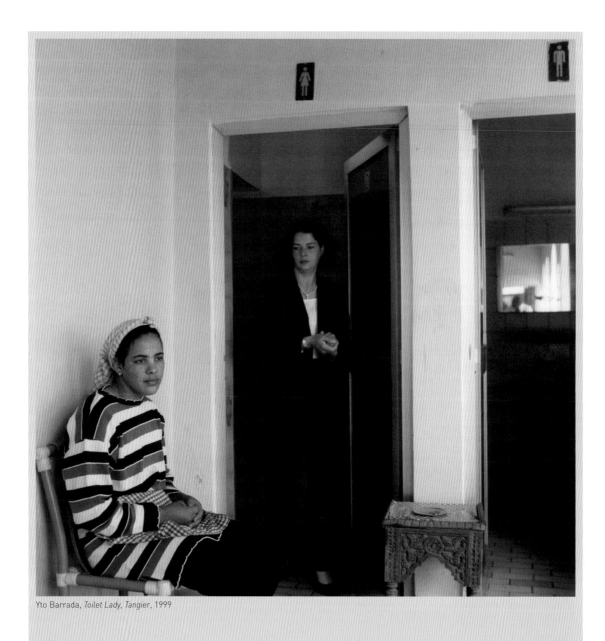

Yto Barrada, *Toilet Lady, Tangier*, 1999

might not be aware of it, but you notice it when you look at the sum of their pictures. Every photographer has something that Rudy Burckhardt called an 'instant vision'.

Are trends in photography important for the medium?

Trends have always existed in photography. For example, Wolfgang Tillmans started a trend and many photographers tried to take pictures like him but nobody managed. Or at the beginning of the 1990s, everyone was taking pictures of children and youth and yet nobody reached the quality found in the works by Rineke Dijkstra. Every time I stand in front of one of her pictures I'm breathless because she creates such an intensity between herself and her models. I'm sure galleries often say to the photographers they represent, 'Why don't you take pictures a bit like so and so?' because it sells. But good artists would never imitate, they try to do their own thing.

In photography the important thing is to see whether someone can reinterpret a well-known way of seeing or invent a complete new one. For example, if you look at the trend of taking pictures of children, no one came close to Rineke Dijkstra, and then someone like Loretta Lux comes along, who reinterprets the idea in a completely different way and it becomes really exciting. Recently

a photographer said to me, 'Anyone can steal the theme I'm working on, but no one can steal the way I'm looking at it.'

A perfect example of that is an exhibition that's on in Munich right now, which shows photographs taken by both Boris Mikhailov and his students during the same trip to Odessa. Although they were all in the same town, and saw the same things, no one else saw the world like he did. His students might have been standing right next to him, but only he saw the world that way. That's what makes someone like Eggleston or Mikhailov.

Do you think people have learnt to really look at photography?

Lots of people say they don't understand contemporary art, but it's not like people actually understand the religious and symbolic background of paintings from the seventeenth and eighteenth century. Just because something is represented in a figurative way, people think they understand it. It's also a big mistake in photography. People generally think 'I can judge this image because I can see what's on the picture and I could take this picture myself', but it doesn't happen that often that people actually figure out what it is that the artists want to show us or that they develop a sophisticated way of seeing. In Germany, people aren't really taught how to read

photography or art in general, as art education in schools is becoming a bit of a joke. You can only learn to see by really looking at images and dealing with the impact they have. You have to engage with a photograph, even if you can't explain it properly. It happens to me that I'm fascinated by a piece of work but can't explore it all the way. In fact, the best works are often the ones that make you feel uneasy, or uncertain.

How would you define art?

I'm not sure I can define what art is. For me it's always changing, with every piece of art I see. In photography it's a learning process. I think there's always a very definite reason why an artist uses a certain colour or material or printing method. It's in observing the method, that you see if someone is good or not. How well does the artist know the properties of his or her chosen material? Is he just holding the camera up to it or is he looking at it with a photographic eye? Great artists are always reinventing their media. When I curate an exhibition I have to be fascinated by the subject, it has to grab me and not let me go. With me, it's always a good sign if something actually makes me angry upon first viewing, that the art work has hit a nerve and is making me think. It might have addressed something that's a taboo for me and stretched it to its limit.

Yto Barrada, *Girl in Red, playing jacks, Tangier*, 1999

"It's always a good sign if something actually makes me angry upon first viewing, that the art work has hit a nerve and is making me think."

Do you accept portfolios?

I set aside one day every month to see photographers one-to-one. Once an artist has made an appointment with me, they can come and discuss their work. It's not really about looking at potential artists for an exhibition or acquisition; it's more about giving photographers the opportunity to have someone to talk to about their work. Most photographers aren't even represented by a gallery, as there are so few in Germany. We might discuss possible forms of presentation, whether the images should be printed big or small, how to frame it, etc, which is all crucial.

In order to get an appointment, photographers have to send me some biographical information and at most ten samples of their work. If someone says they can't edit their images, I normally refuse to see them. I also prefer to see images from a project the artist is actually working on, rather than images from ten different projects. Artists from the States are very good in presenting themselves, they are trained. They have their ten images, they do their fifteen-minute speech, they are not interpreting but presenting their work and their concept. No German artist I've seen can do that, mainly because they don't get taught how to. But it's really important that art schools prepare their students to be able to present their work.

At the end of the day, if I'm going to have to convince the museum's Development Association to invest money in a specific artist, they have to be able to convince me first. They are their own best spokesperson.

What kind of advice would you give to a budding photographer?

I know how hard it is to be recognized so it's a case of building a reputation step by step. An artist should use any good offers to exhibit their work or have it published. It will help them develop a reputation slowly, over time. I would advise photographers to not be shy and write to galleries and curators to introduce their work. It's often tiring and mostly frustrating but it's important to be involved in a dialogue. For example, I saw Yto Barrada's work for the first time at an art fair in 2002. I never spoke to her, I never acquired any of her pictures or showed her work in one of my exhibitions but three years later when I was asked to give a recommendation for a special stipend I remembered her work, its strong impact that I still felt, and suggested her to the jury who finally chose her. I know it is a very long exhausting road. Photographers must trust in their own work even when nobody seems to be interested. Getting recognized as a serious artist is not a sprint race, it is a life-long marathon.

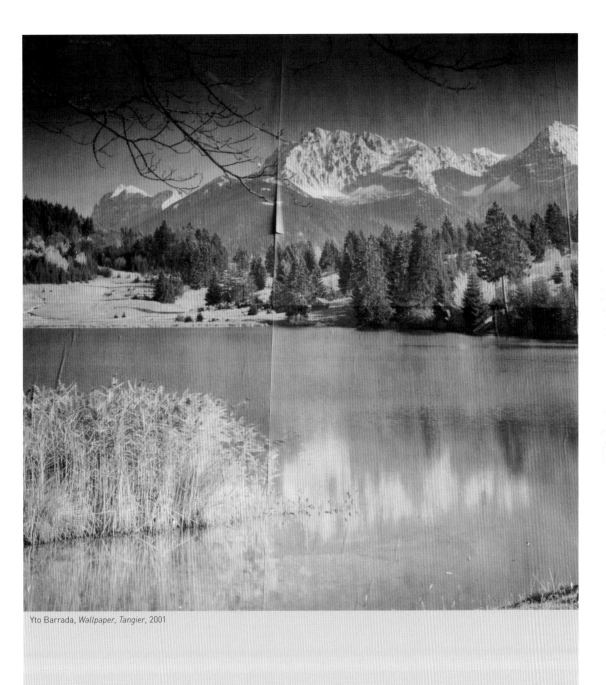

Yto Barrada, *Wallpaper, Tangier*, 2001

Rudolf Kicken

Founder and Co-owner,
Gallery Kicken, Berlin

One of the first private
gallery owners in Germany,
Rudolf Kicken has worked
in the art world for over
thirty years, representing
photographers such as
Helmut Newton, Diane
Arbus, Stephen Shore
and Bernd and Hilla
Becher. One of Gallery
Kicken's main strengths
is its diversity. Indeed,
it represents almost
all the great names in
art photography from
the beginning of the
nineteenth century up
to the present.

Above: Josef Sudek,
Bread, Egg and Glass, 1950
Opposite: Albert Renger-Patzsch,
Farbenkasten/Paintbox, 1925

How did you start Gallery Kicken?

I was supposed to take over my
father's construction company, but
I loved photography. Even though
I was studying economics at the
time I decided to apply for Otto
Steinert's photography class at the
Folkwang School in Essen. Steinert
accepted me but suggested that
I should finish my economic studies
first. I earned my degree in
economics and then went to study
photography at the Visual Study
Workshop in Rochester, NY for two
terms. One day during this time,
I met the director of the Light
Gallery in New York City. I asked
whether we could represent the
Light Gallery photographers in
Germany. In 1974, Wilhelm
Schürmann and I founded Galerie
Lichttropfen in an old bookstore in
Aachen. The real Schürmann and
Kicken gallery didn't start until 1976.

How did Kicken develop as a gallery?

We were lucky because we had
some of the great collectors such
as Werner Bokelberg, Volker
Kahmen, Manfred Heiting and
Thomas Walther among our first
clients. Without the Amercian
market, however, we could have
never survived. In the beginning,
it really helped that we were
associated with the Light Gallery
and that I'd met people in
Rochester who became leading
curators, such as Anne Tucker
and Peter Galassi.

After the Art Basel Fair in 1977,
we realized it wasn't enough to
just represent the Light Gallery
photographers. We had to find our
own stock. So we started thinking
about who was important and
forgotten in the history of
photography. German photography
from the 1920s was very important
and we started to work with this
material. We knew Werner Mantz,
so we represented him. We also
bought the dummy of Albert
Renger-Patzsch's famous book
The World is Beautiful. We met
Umbo and showed his photographs.
 Parallel to that we decided to go
to Prague, where we met Josef
Sudek. Soon we got in touch with
other artists of the Czech avant-
garde or their estates and from
there we developed a collection
of Czech avant-garde photography
and introduced it to the

"A good work of art is something you always remember, where you wake up and think of that image."

international art market. The
gallery has worked internationally
from the very beginning and
exhibited at international art fairs.
After a couple of years Wilhelm
Schürmann and I ended our
partnership and the gallery moved
to Cologne. And then in 2000 it
moved again, this time to Berlin.
My wife Annette and I run the
gallery together there.

**When did you start representing
new blood?**

Heinrich Riebesehl, *Schillerslage, Hannover*,
1978

We have always shown
contemporary artists and classic
photography simultaneously.
Among the contemporary artists
we have worked with in the last
decades are Dieter Appelt, Anna
and Bernhard Blume, Axel Hütte,
Jürgen Klauke, Klaus Rinke. Götz
Diergarten is one of the young
photographers we have recently
started to represent. He suggested
another artist from the photography
cooperative POC (Piece of Cake),
he was a member of and that
person was Charles Fréger.
Other contemporary artists in

our programme are Hans-Christian
Schink and the Japanese
photographer Ryuji Miyamoto.
And two years ago, whilst looking
at a book about Struth, Schürmann,
Michael Schmidt and Riebesehl,
we rediscovered the very interesting
German photography from the
1970s. That's when we decided to
show works by my former partner
Wilhelm Schürmann and Heinrich
Riebesehl, whose work we had
exhibited already in the early days
of the gallery.

**What do you look for when choosing
new photographers?**

Hans-Christian Schink, *A20 Peenebruecke Jarmen*, 2002

"Artists always want to show their latest work, but it's important to see early work to see where they came from. By looking at where someone came from and where they are now you can gauge the potential."

Götz Diergarten, *Untitled (Gouville) 5*, 2002

Artists always want to show their latest work, but it's important to see early work to see where they came from. By looking at where someone came from and where they are now you can gauge the potential. When starting out many photographers imitate their great masters. It's important to see how they find their way out of that dilemma. It gives you a real flavour of their talent. Then of course there is also the tummy feeling you have about an artist.

How can you tell if something is a great photograph?

The vintage photography collection at Eastman House in Rochester was like a training ground for me. I looked at and stored as many photographs in my head as possible. Now when I see a new photo I compare it to what I've seen in the past. Even today, when I'm buying something new, I put it up on the walls in the gallery next to a work of art we've been looking at for a long time and we see if it holds up. For example, we did a show of German photography recently and installed a typology by Götz Diergarten in the same room as a work by the Bechers, his tutors. And he held his own.

Do people bring in portfolios to show you?

Yes, a lot of artists approach us to present their work to us. Some artists who come and see us have not focused on any kind of theme

yet. They are all over the place. We always suggest they should try and concentrate on one theme. Just look at Edward Steichen. He spent a whole summer photographing some pears. At the end, he approved only very few photographs from this series.

We ask an artist to first send us a selection of his or her works by email so that we can get an idea if the work would be interesting for us and if it fits the programme of the gallery at all. If we then invite an artist to show us his original work we expect him to bring in good quality prints. They should be mounted or over-matted. If someone comes in carrying their dog-eared prints in a plastic bag, it makes me think that he does not have any respect for the work. You have to be able to choose the right image and quality of print in order for a gallery to judge your potential.

Do you think photographers these days are impatient to get famous?

Some are but it's the fault of the art market. There is a lot of bad quality art out there that is selling at high prices. One of the problems is that some of the people who buy, just buy because of a name. I call this phenomenon 'buying with your ears instead of your eyes'. It's that 'oh so and so is good now' syndrome. For some people it's a fashion statement like buying a new handbag. But what really counts is good quality and consistency.

Götz Diergarten, *o.T. (Borrstadt 1)*, 1998

"Now when I see a new photo I compare it to what I've seen in the past. Even today, when I'm buying something new, I put it up on the walls in the gallery next to a work of art we've been looking at for a long time and we see if it holds up."

What makes someone an artist?

A good work of art is something you always remember, where you wake up and think of that image. And it has to be more than just the one image. If I gave someone a camera and one hundred rolls of film, anyone could make one good photograph. But that wouldn't make him an artist. Consistency and persistence is key. A picture should grab and hold your attention. It doesn't matter whether that's on an intellectual or an emotional level. One of the problems today is that young artists haven't really done their history homework. They haven't seen much yet. Of course you can say 'everything has been photographed' but it's the way in which a theme is approached that's exciting.

In the long run, if something is merely beautiful or merely shocking, it becomes boring. It needs to be more than that. We all agree that, for example, Ansel Adams's *Moonrise* picture is fascinating but I'm not sure it will still be considered a masterwork in the history of photography two hundred years from now.

How do you know if someone is going to be successful or not?

Nobody can predict whether or not an artist will run out of ideas or not. Renger-Patzsch, for example, produced very important work in the 1920s. Then in the 1950s, he started to concentrate on a new theme: pictures of trees. It took me a long time to see that these pictures were also magnificent.

As a gallerist, if you take someone on, you have to believe in them very intensely. For example, I worked with Helmut Newton for twenty years and brought him into focus as an artist. Apart from Penn and Avedon, it was one of the first times that a fashion photographer was shown in museums and was being collected. I strongly believed in his work and it finally succeeded in the art market.

How would you describe your relationship with the photographers you represent?

I believe in handshakes, not contracts. In German the word *Vertrag* (contract) comes from the verb *Vertragen* (to get on). I think there has to be a personal relationship between the gallerist and the artist.

How much do you influence new projects?

The photographers we represent pretty much know what they want. But they often show us new projects and we'll have long conversations about this. A gallerist has an obligation to maintain a constant dialogue with the artist.

How do you keep yourself informed about new or up-and-coming photographers?

There are three strategies. Firstly, we look at a lot of specialist magazines and go to a lot of exhibitions, art fairs and galleries. Secondly, we have people who come to the gallery to present their work and thirdly, artists we represent may point out another artist, because they have the finger on the pulse all the time.

How much power do you have as a tastemaker?

First and foremost, it's the quality of a piece of art, which is the determining factor. At the end of the day, even if you've created a trend, it'll be gone after a while if the quality is not there.

Do you think a photographer needs a philosophy to do good work?

An idea or philosophy is certainly necessary otherwise you can't work continuously.

What kind of advice would you give to a prospective client?

Before you buy something, always be sure to see the original print. I say that to all my collectors. Don't buy from a publication or auction if you haven't seen the original.

An image has to have an aura and you can't see that from a reproduction. Also, one should not be too afraid to make mistakes in collecting – mistakes teach us a lot.

What do you make of digital photography?

As long as the image is not too manipulated, unless it is done intentionally so, I don't care what system is used. Technological development has always influenced

the history of photography. The fact that the Bechers could do large prints for example, was only due to the fact that a system had been devised for advertising purposes, but it was artists who took advantage of it. In that respect it's not surprising that photographers are embracing the digital revolution.

What excites you most about the medium?

I love the fact that you can still discover unknown treasures. You can still put together an incredible collection with a fairly small budget. You don't have to go out and buy a big name for over £100,000. For example, at the Basel Art Fair, we sell prints ranging from 1,500 Euros to over one million. Photography as a medium has many facets.

Where do you think photography is going?

I have no idea. But I don't believe that analogue photography is over.

What advice would you give to a budding photographer?

Believe in your work. If someone turns you down, don't let that discourage you, just keep on working. Also, ask people you trust for advice. And finally, look at as much art work as you possibly can. You have to be able to compare yourself to the best artists.

Wilhelm Schürmann, *Verviers*, 1976

"Believe in your work. If someone turns you down, don't let that discourage you, just keep on working."

Diane Dufour

Bureau Chief, Magnum,
Continental Europe

Founded in 1947 by Robert Capa, Henri Cartier-Bresson, George Rodger and David Seymour and created to reflect their independent natures both as people and photographers, Magnum is perhaps the world's most prestigious photographic agency. With its four offices in London, New York, Paris and Tokyo, it has fifty-five members and provides photo essays to the press, publishers, advertising agencies, galleries and museums across the world. Fascinated by the notion of witnessing history in the making, Diane Dufour started working for Magnum in 1988. She has been Bureau Chief of the Continental Europe office for six years.

Magnum Collective, *Magnum Stories*,
published 2004

How do photographers become members of Magnum?

Any photographer can apply to become a member of Magnum. They have to send in a portfolio, either as slides, prints or digital files. The portfolios should be sent to any of our four offices in either London, Paris, New York or Tokyo, towards the end of May. The Magnum members review the portfolios collectively during the first day of the annual general meeting, which takes place at the end of June. Magnum members take a vote on applicants, and if applicants are successful they become 'nominees' – the first stage of collaboration with Magnum.

They must then present a new piece of work or project two to three years later to prove they are not a one-hit wonder, but capable of renewing their vision and applying it to a new subject. If members vote in favour of the nominee, the photographers reach the second stage of membership called 'associate'. Two to three years later another vote occurs to establish whether the associate can become a full member. Once a photographer becomes a full member, his or her vote and voice has the same weight as any long-time members such as Raymond Depardon or Martin Parr. It's a true cooperative system. The new photographer has to bring a new vision and an ability to relate to the community of photographers and to the Magnum staff.

Besides Magnum's reputation, what is it about the cooperative that makes photographers want to join? How would you describe its philosophy?

The main reason photographers join is because Magnum is fully independent and allows absolute freedom. This independence is at the core of the Magnum structure with the photographers being the only shareholders. It is also fundamental to Magnum's philosophy. There is a team of about ninety staff world-wide, who work for you and who respect your choices, no matter what subject you decide to cover and in what form you want to express yourself. Magnum merely adapts its capacity to fundraise and promote photographers' new projects through books, editorial sales, print sales or exhibitions. It is a fully *à la carte* system.

The second important aspect is the fact that Magnum has been the most creative group in the history of documentary photography. It means a lot, especially to young photographers, to be able to exchange views with key figures such as Josef Koudelka, Rene Burri, Gilles Peress or Lise Sarfati. And finally, photographers like the sense of community they gain by becoming a member of such a group of strong characters.

> "We don't solely work with the concept of a story anymore. We work with the idea of a 'project', meaning that it could turn into editorial, a book, an exhibition or all of the above."

Above left: Raymond Depardon, *7x3*, published 2004
Above right: Magnum Collective, *Euro Visions*, published 2005

When choosing a new member, do you only assess quality of work or also whether a nominee's personality fits into the framework of the cooperative?

First and foremost it's about a photographer's singularity of vision. You have to be able to differentiate yourself from other Magnum photographers and what they have done. Though you might have been inspired by Martin Parr or Susan Meiselas, you have to bring your own distance and judgment on the world, as well as your own set of values regarding aesthetics and political thinking. Your personality is secondary. During your time as a nominee and associate, members can evaluate whether and how you fit into the collective. But I don't remember a single case where a major, talented photographer didn't become a member because he was deemed unsociable. At least seventy-five per cent of the associates become members.

Is it important that each new photographer has his or her own style or way of seeing? Must he or she complement Magnum as a whole?

It's important to have a singularity of vision, yes, but Magnum members are not proactively looking for a photographer, who can do X, Y, Z, because it's missing in the cooperative. If a photographer is striking and outstanding, no doubt there is something special about him or her that hasn't been seen before.

Do you think it's important for a photographer to have a philosophy to do good work?

Being a photographer is not just about taking a picture but knowing why you are taking it. It's about how you position yourself towards the real and towards other photographers who shoot in a similar or opposite way. Some photographers are not good at expressing it, but the notion is always there, and that's enough.

Do you think you can learn a way of seeing?

I think you can learn about certain aesthetic or political criteria to help you position your work. But whether you can learn to have 'a vision', I don't know. I doubt it. It has to come from within you. But you can structure what's inside you, by getting inspiration from

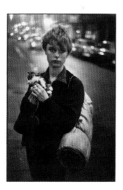

Bruce Davidson England / Scotland 1960 Steidl

de qui
s'agit-il ?

Henri Cartier-Bresson

Gallimard/Bibliothèque nationale de France

other artists and having a sense of commitment and a notion of history.

What makes one image stand out more than another?

When photographers are voting in new nominees and associates, they are not looking for the single image. Anybody can do a single masterpiece. They are looking at an entire process and also the commitment, aesthetic qualities and 'guts' behind a project. They are looking to identify a sense of coherence; a uniqueness in a body of work.

Can you talk me through the editing process at Magnum?

When Robert Capa and Henri Cartier-Bresson first founded the

Above left: Bruce Davidson, *England / Scotland 1960*, published 2006
Above right: Henri Cartier-Bresson, *De qui s'agit-il?*, published 2006

agency, one of their key aims was to give photographers complete control over choice of form, subject, text and captions. They were keen to ensure that all photographers maintain the copyright to their negatives and also control their own edit. The philosophy remains the same today.

Can photographers work on personal projects at Magnum? Does Magnum help finance these?

Magnum photographers work mostly on personal projects. That is what Magnum is about. That said, there are different ways we help a photographer finance a personal project. The most common way is through grants, partnership, museums, collectors or magazines, or a combination of all of the above. We also have something we call

"It doesn't matter how you present your work as long as it's coherent with the meaning. Every aspect of your work, from concept to execution, has to make sense."

THE NEW LIFE LISE SARFATI

Lise Sarfati, *The New Life*, published 2005

"Being a photographer is not just about taking a picture, but knowing why you are taking it."

'indirect financing', which involves the sale of reproduction rights of the images from the library, as well as advertising assignments. A third type of income is what we call 'speculation'. This is when a photographer decides to pay for part of the project with his or her own money. It's rare to get all the funding from one unique source. For example, at the moment Raymond Depardon is doing a five-year project on the political landscape in France and we have raised money by approaching public and private partners and by selling some of his work to magazines. We are like project coordinators and fundraisers.

On average how many times do you syndicate a story?

We don't solely work with the concept of a story anymore. We work with the idea of a 'project', meaning that it could turn into editorial, a book, an exhibition or all of the above.

Do photographers get commercial jobs through Magnum?

Yes. Often it's used to finance personal projects. Martin Parr is a good example of a photographer who does advertising campaigns, in order to raise money for personal projects. It allows him to work in a completely free way. Josef Koudelka, on the other hand, is someone who has always refused to do commercial assignments. So for him we find other ways to fund his projects.

In the post-*Life* era, which publications these days give the most space to photo-essays?

Very few these days take the risk to commission a photographer to do a long-term personal project. The money and space devoted to the presentation of photographers' work is extremely limited, which we regret.

Why would someone like Eugene Richards choose to leave Magnum?

Very few photographers have left Magnum in the sixty years since its conception. There could be any number of reasons for someone to leave. It could be financial or due to the fact that they didn't feel part of the community....

What kind of advice would you give to a budding photographer?

Be very demanding in terms of what you want to achieve. It doesn't matter how you present your work as long as it coheres with the meaning. Every aspect of your work, from concept to execution, has to make sense.

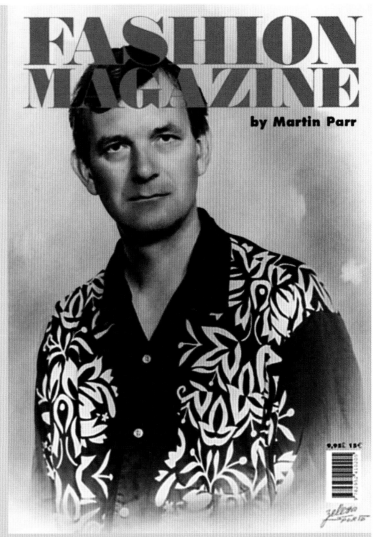

Martin Parr, *Fashion Magazine*, published 2005

Kathy Ryan

Picture Editor, *The New York Times Magazine*, New York

Kathy Ryan began her career at the photo agency Sygma in 1978. While there, her responsibilities included researching and sending images to Peter Howe – photo editor of *The New York Times Magazine* at the time. Impressed with her eye, he called her in for an interview and gave her a job shortly thereafter. Twenty years later, Kathy Ryan is still at *The New York Times Magazine* and approaches each project with as much enthusiasm as if it was her first.

Katy Grannan, 'In The Shadow of Wealth' cover (*The New York Times Magazine*), 2000

What makes working at *The New York Times Magazine* so exciting?

The best thing about working at *The New York Times Magazine* is the huge variety of photo stories we run. It's probably more varied than any other publication. We cover topics that allow me to engage in all genres of photography from documentary to high-concept portraiture through to building sets in a studio.

How do you go about choosing a photographer for a story?

The choice of photographer is the single most important step in the process. With any given project we try to decide what kind of eye, what kind of thinking and attitude we want behind the pictures. Sometimes we match photographers according to their strengths, at other times we aim for the opposite, like hiring someone to do a fashion assignment who has never shot a fashion story before. In some ways, that's my favourite thing.

What is your vision for the magazine?

One philosophy I adhere to is that I always try to think about how we can break out of what's gone before. There are so many magazines out there. I think: 'what's the point of doing something if you're not going to try and doing something different?' I aim to do something more adventurous, more unexpected.

Can you think of a story where that was the case?

One of the most satisfying things I've done was commissioning Taryn Simon to cover the Exonerated. It was just when the story was coming to the USA before DNA testing was a big deal. A lot of criminal cases were reopened and lo and behold there were large numbers of people serving long prison sentences, whose names were ultimately cleared. Taryn was doing really beautifully lit, controlled large format photography at the time. I was thinking, rather than just using a photographer with a 35mm journalistic approach, why not use someone like Taryn, whose work is connected by an overriding philosophy and interior dialogue. Her approach was very literary. All the facts of the story were in the pictures: the subject, the background, the environment, and the person's history. Every single decision she took was purposeful. There was no happenstance. She did deeply moving portraits – sometimes at the scene of arrest – that were so emotional because of the lighting. It brought out the stress in the men's faces. It became a huge thing because she made it her life's work for the next three years. It was rewarding because, in certain ways, that one phone call changed her life and we ended up with fabulous images.

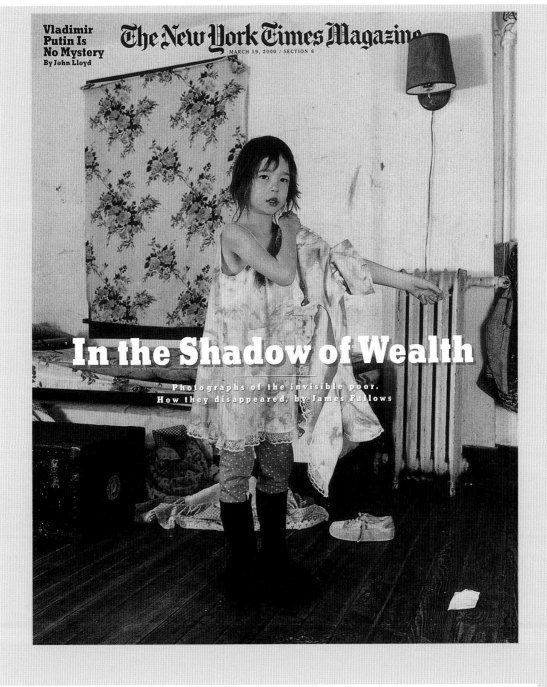

Life
After Death Row
For these men, sentenced to death and then freed, the outside world has offered more misery than happiness.

By Sara Rimer Photographs by **Taryn Simon**

It has been 20 months since Ronald Keith Williamson was exonerated and freed from death row in Oklahoma, where he spent the better part of nine years pacing back and forth in his 9-by-11-foot cell, screaming that he did not rape and kill a young woman in a town called Ada. Ravaged by mental illness and the anguish of his time in prison, he is unable to hold a job and lives in a group home in Oklahoma City.

The state made no reparations for the mistake that turned him from a high-school baseball hero into a condemned man, No. 134846, other than to mail him the standard $50 check given to all inmates who are destitute upon release. Now Williamson recreates his old prison boundaries in the group home by pacing back and forth in his room. His one solace is playing the guitar. Death row, he says, taught him how to play the blues.

There are 3,682 men and women on death row in America. While 98 people were executed last year, only 88 men and one woman have ever been exonerated and

released because of evidence of their innocence. Almost half of these exonerations have occurred since 1993, and nine of them were a result of DNA testing.

This modest surge in exonerations has prompted a new awareness about the risk of executing innocent people. Several states have ordered their legislatures to study the death penalty. Illinois went so far as to declare a moratorium on executions. Other states have expressed confidence in the efficacy of the system. Texas, for example, has executed more than three dozen people this year. But while the death-penalty debate has intensified, the fate of those freed from death row has gone largely undiscussed.

The men who look out from *Text continued on Page 108*

Earl Washington, released from Virginia's death row in October 2000.

100

"The choice of photographer is the single most important step in the process. With any given project we try to decide what kind of eye, what kind of thinking and attitude we want behind the pictures."

How important is it for you to commission big names?

Part of my philosophy is that there should be a range of photographers in the magazine, from big names to unknowns. I believe really strongly in that. We are constantly seeking out new talent by looking at portfolios, graduating classes at the School of Visual Arts, the International Center of Photography, Yale, MFA schools. For me, a big part of the creativity and excitement of my job is discovering someone. It's

Taryn Simon, Photo from 'Life After Death Row' (*The New York Times Magazine*), 2000

recognizing something amazing in somebody's early, unpublished work before anyone else does and giving those people a meaningful start. I think young photographers often lose sight of the fact that it's a big part of what editors do.

Name some of your discoveries?

I don't want to make any claims but we ran a picture by Katy Grannan in our portfolio 'Poverty in America' years before she was a big name for example. Similarly with Malerie Marder, I had her do assignments before she went to Yale and wrote her letter of recommendation. Sometimes I might also use a

Scientists
ARE CONDUCTING PERSONALITY
TESTS ON
ANIMALS AS VARIED
AS CHIMPS,
HYENAS AND GIANT
OCTOPUSES.

When
IT COMES TO A CAPACITY FOR
CHARACTER,
WE MAY
NOT BE ALONE.

PHOTOMONTAGES BY ERWIN OLAF

photographer who is well-known in Europe but not yet in the USA. For example, I recently commissioned the Dutch photographer Erwin Olaf to do a story about animals and personality because researchers are now saying that all kinds of animals, including octopuses have personalities. I thought if we're doing hyped up photo-illustrations with animals, I don't want it to be corny. Olaf does funky stuff in post-production on his computer. There's an eerie,

Erwin Olaf, Photo from 'The Animal Self' (*The New York Times Magazine*), 2006

surreal, slightly edgy and dark tinge to his images. They came out brilliantly.

How do you research new talent?

I go to a lot of the shows in New York, I look at catalogues of books coming out, I try to get sneak peeks at stuff, I talk to graduating classes, I do portfolio reviews and I make an effort to look at photographers' books when they come in because it would horrify me to reject something that turned out to be great.

Do you think it is important for photographers to have a philosophy?

Yes. They need to have a sense of what matters most to them and a

driving force that gets them up in the morning. What are they after? What are they looking to do? They have to be able to reflect on what's meaningful to them and what isn't and have the discipline to pursue the meaningful. Invariably the best photographers are trying to say something about the world. They have a mission that goes beyond the aesthetic. Eugene Richards, for example, has a very specific mission in life. His stories are always deeply human stories about loss, devastation, humanity and all of the emotions within. Right from day one, he knew what it was that

made his heart beat. Ultimately, you have to make a decision about what you want your pictures to add up to.

What is your view on black-and-white versus colour?

We publish everything. Some months I'm deeply in love with black-and-white and feel that no matter what, I'll always have it over colour, and other months I think that colour, in the right hands, has an incredible, emotional current running through it. Most months I think film is better than digital but I think 'oh, that's just my age....'

How do you feel about cropping?

I'm the chief anti-cropper. I figure what's the point of putting tons of thought into who would be the right photographer, and hiring someone with a highly-tuned vision of how to fill the frame, both graphically and in terms of content, if you're then going to crop that?

What excites you most about photography?

Doing something new. Trying to reinvent something. Breaking new ground. After that, it's the photographers themselves. They are creative, interesting, wonderful people and I love that they are all wildly different, personality and creativity-wise.

What advice would you give to photographers who would love to see their work published?

Eugene Richards, Photos from 'The Global Willowbrook' (*The New York Times Magazine*), 2000

*Steele, second
from right, and
Adnan, seated
at left, share
in a communal
lunch at the
general's
headquarters in
Samarra.*

Continued on Page 56

PHOTOGRAPH BY GILLES PERESS/MAGNUM, FOR THE NEW YORK TIMES

THE NEW YORK TIMES MAGAZINE / MAY 1, 2005 47

I think the key thing is to decide exactly what you want to say. Try to find something that's newsworthy or timely that others aren't doing. But be aware of the work that's being done by your generation of photographers, and if you can, find a hole or something unseen, then that's great. If everybody is doing large Gursky-esque landscape-driven, larger than life images, walk away from that.

What do you look for in an image?

If it's a documentary picture, I'm

Gilles Peress, Photo from 'The Salvadorization of Iraq' (*The New York Times Magazine*), 2005

looking for a great scene. I'm looking for a moment where you see something revealing happening or something unfolding. Gilles Peress and Eugene Richards, for example, are two photographers who see magnificently. Their ability to isolate, with framing, what they want you to see in the picture is superb. It's about great seeing and authority. It's something that transcends reality at times. Last year, for example, we published an amazing picture by Peress where American soldiers and their Iraqi counterparts were diving into a big carcass of meat in their lunch

break. This is a moment most photographers would not have deemed worthy of shooting, because it was 'only' their lunch break, but it was the best picture in some ways because it was like a warriors' feast. He saw something that had a symbolic meaning.

I'm looking for pictures that resonate, that tap into something, that transcend the literal meaning. The pictures people remember resonate on an emotional level. An image has to command attention and reward you with something when you stare it down. It should either give you a deeper

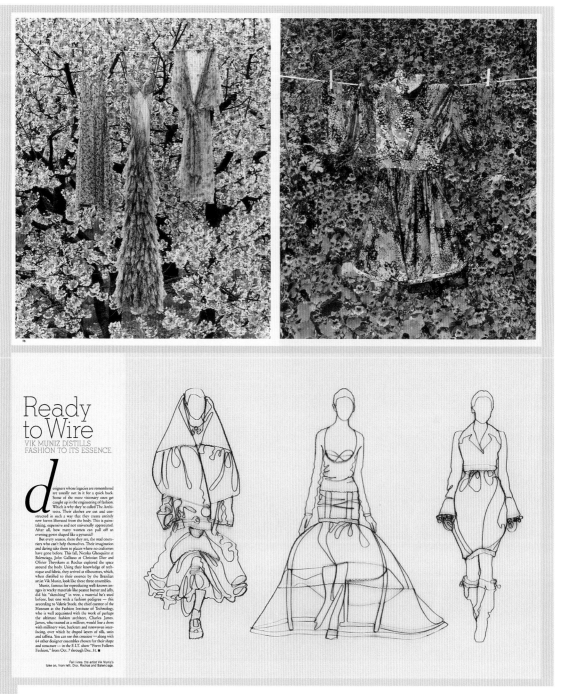

Ready to Wire
VIK MUNIZ DISTILLS FASHION TO ITS ESSENCE.

*d*esigners whose legacies are remembered are usually not in it for a quick buck. Some of the more visionary ones get caught up in the engineering of fashion. Which is why they're called The Architects. Their clothes are cut and constructed in such a way that they create entirely new forms liberated from the body. This is painstaking, expensive and not universally appreciated. After all, how many women can pull off an evening gown shaped like a pyramid?

But every season, there they are, the mad couturiers who can't help themselves. Their imagination and daring take them to places where no craftsmen have gone before. This fall, Nicolas Ghesquière at Balenciaga, John Galliano at Christian Dior and Olivier Theyskens at Rochas explored the space around the body. Using their knowledge of technique and fabric, they arrived at silhouettes, which, when distilled to their essence by the Brazilian artist Vik Muniz, look like these three ensembles.

Muniz, famous for reproducing well-known images in wacky materials like peanut butter and jelly, did his "sketching" in wire, a material he's used before, but one with a fashion pedigree — this according to Valerie Steele, the chief curator of the Museum at the Fashion Institute of Technology, who is well acquainted with the work of perhaps the ultimate fashion architect, Charles James. James, who trained as a milliner, would line a dress with millinery wire, buckram and nonwoven interfacing, over which he draped layers of silk, satin and taffeta. You can see this creation — along with 64 other designer ensembles chosen for their shape and structure — in the F.I.T. show "Form Follows Fashion," from Oct. 7 through Dec. 31. ∎

Fall lines: the artist Vik Muniz's take on, from left, Dior, Rochas and Balenciaga.

understanding of a subject or allow you to appreciate something in a completely new way, to let you see the world anew. Or it could be the 'wow' effect if a picture was created in the studio.

Do you think a picture should ask questions more than answer them?

I think photography is one hundred per cent about asking questions. Photography at its best is often ambiguous. The most memorable pictures make you pause and think: 'wait a minute, is he happy or sad? What does that mean? Warriors diving into meat? Why?' Pictures with the most staying power transcend literal meaning. They have some other presence. There's poetry.

Would you say the same about fashion photography?

In fashion photography, I think the challenge is to be as inventive as possible. There's no reason not to be wildly imaginative because it's not tethered to the real world. Fashion is fantasy. The news on the runway repeats itself, so you might as well be as imaginative a possible. Fashion photographers should make it their mission to shake off the ghosts of the past, people like Helmut Newton and Guy Bourdin, and break free. For

Opposite above: Alfred Seiland, Photos from 'Style: Hanging Gardens' (*The New York Times Magazine*), 2004
Opposite below: Vik Muniz, Photos from 'Ready to Wire' (*The New York Times Magazine*), 2004

example recently, when the news on the runway was that some of the designers were showing clothes with dramatic shapes, I thought it would be cool to have Vik Muniz interpret several of the dresses as 'wire sculptures' and then photograph them. He does a lot of conceptually based photography and one of his prior bodies of work depicted simple, elegant sculptures of common objects made out of wire, which he then photographed. The results were exquisite. We published them in our 'Women's Fashion Fall 2006' issue.

Or another example was in a special issue about landscape architecture in May 2004 called 'Hanging Gardens'. Here the news on the runway was that designers were showing lots of chiffon and silk dresses with small flowery prints. So I commissioned the landscape photographer, Alfred Seiland, to take these dresses into beautiful pastoral environments and shoot the dresses hanging on clotheslines, juxtaposed against flowering bushes and trees. They are wonderful.

What do you make of the statement that everything has been done before, given that your main aim is to find something new and different?

I'm really optimistic in that sense. People do succeed. For example, last year Paolo Pellegrin, who normally does 35mm black-and-white, artful photojournalism, did

"I'm looking for pictures that resonate, that tap into something, that transcend the literal meaning. The pictures people remember resonate on an emotional level."

something incredible. When he covered the Pope's funeral in Rome, he worked with a flash and it added a whole other drama to those faces experiencing real emotion and grieving. I'd never seen anything like that. So there you are, right there in the documentary genre, he managed to reinvent. It's always possible.

Where do you see photography going?

There'll be more and more digital. Once the tools exist…. Photography has always been driven by the tools, by changes in technology, in cameras, in film.

What have you learned during the last twenty years of being a picture editor?

Don't take no for an answer. Just because a subject or a photographer says no the first time, it doesn't mean they won't come round in the end. You learn with time that even things that look like they can't be done, can be. I guess it's a certain kind of stubbornness.

Gerhard Steidl

Founder and Publisher,
Steidl Publishing, Göttingen

Based in the German town of Göttingen, Steidl is renowned for producing photography books to an exceptionally high standard. Publisher Gerhard Steidl has developed a unique philosophy which revolves around the idea of artist as king and the publisher as servant. Steidl publishes approximately 120 books per year, including monographs by some of the world's most famous photographers such as Joel Sternfeld and Robert Polidori.

Joel Sternfeld, *American Prospects*, published 2003

When did you first become interested in publishing?

I wanted to be a photographer and started taking pictures at weddings when I was twelve years old. I'd print the photos in my darkroom, do the layout, arrange the photos in a book, then sell the finished album to the newly-weds for 10DM. Later, because I was interested in learning about artificial light, I asked a local theatre company whether I could take pictures of their rehearsals one day. They liked the pictures so much they asked whether they could use them as a poster. I agreed under the condition that they let me do the layout, typography and design of the poster and also let me be present at the printers. The printers got the colours and the contrast completely wrong. So I said, 'we're not doing it like this. If you can't give me more colour, why don't you run it through the printers twice?' They looked at me like I'd gone crazy, but it worked. Or just about. That was the point when I realized if you want to reproduce something, it's best to make sure you control every stage of the creative process yourself.

How did you learn about printing?

Shortly after the poster printing experience, I heard that an American artist was coming to Cologne to exhibit his screen-prints in Germany for the first time. He was part of a whole new art direction. It was called Pop Art and the artist was none other than Andy Warhol. When

I went to the show, I fell in love with the prints. The colours and contrast were so strong. So I went over to Andy and asked him what exactly screen printing was and how it worked. He drew a little sketch for me and explained how you did it. It's a simple technique for which you essentially only need silk and colour. I then taught myself how to print using those sketches and managed to reach a high level of competence in a very short time. When I felt ready, I went to artists such as Joseph Beuys, Marcel Broodthaers, Nam June Paik and asked whether I could work for them. They entrusted me with their sketches and somehow liked me. I realized it was great to work with artists directly.

Why did you give up photography?

After printing for several years, I looked at what I'd done and was never really satisfied with myself. I thought I wasn't talented enough and didn't want to end up as a third rate artist in some hicksville town and only ever look up to others better than me. I thought it would be much more exciting to work with and for those great artists. That's how the concept of Steidl Publishing came about.

What exactly is the concept of Steidl?

I see myself as the artist's servant. I help the artist turn his vision into reality by offering the technical know-how in terms of photography, design, printing and publishing.

JOEL STERNFELD AMERICAN PROSPECTS

"I rely on my instinct. If I like something on impulse, I'll grab it. It's an emotional reaction, at times linked to burning curiosity."

Robert Polidori, *Zones of Exclusion: Pripyat and Chernobyl*, published 2003

"I see myself as the artist's servant. I help the artist turn his vision into reality by offering the technical know-how in terms of photography, design, printing and publishing."

MITCH EPSTEIN FAMILY BUSINESS

ROBERT POLIDORI HAVANA

Most publishers think in terms of a series. They'll have a little format, and a standard format because that's the cheapest way to produce books, but we don't work that way. Every book is produced *à la carte* and developed individually according to the artist. I would never say to an artist that he or she has too many pages or that their format is too expensive. I'm not interested in knowing how much a book costs; I just want to do it the best possible way.

Also, at Steidl everything from the layout to the printing happens on site. At a normal publishing company, they might give something to a scanning studio and then the

Above left: Robert Polidori, *Havana*, published 2001
Above right: Mitch Epstein, *Family Business*, published 2003

whole thing gets sent off to China to be printed, so the people working on the book might never see the end product. At Steidl, the artist walks around and discusses details with the designer, the pre-press people and the printer. For example, when Robert Frank was here, he reminisced about his 1956 Chevy trip through America. An art historian would cut their hand off to get first hand information like that, so a designer is bound to work on a book differently after being privy to such information.

How do you go about choosing the photographers?

I rely on my instinct. If I like something on impulse, I'll grab it. It's an emotional reaction, at times linked to burning curiosity. For example, if something attracts me on an instinctive level, but I haven't

fully understood what it's about, I'll usually go with the project because I feel like I can learn something or discover something new. But there is less and less space for new artists as the photographers that have become regulars over the years like Mitch Epstein, Robert Polidori, Joel Sternfeld, make up two-thirds of my client-base. We can only dedicate thirty per cent of our time to new photographers at present.

Have you thought about expanding the business?

I don't want to expand the business. I currently have one printing machine and I want to keep it that way because I only ever want to concentrate on one book at a time. If for example, I'm working on a book with Nan Goldin, I want to be totally focused on that. Printing is

Arnold Odermatt

Karambolage

Steidl

a really intimate process because all the years of work come together in that instant. If someone has been working on a project for ten years, they'll obviously be nervous and thinking, 'Is this going to work? Will it come out how I envisaged it?' It's very tense – almost like a birth. Even today I still get stage fright before I start a new book, because I'm so excited.

Above left: Arnold Odermatt, *Karambolage*, published 2003
Above right: Hiromix, *Hiromix*, published 1999

Do people approach you with their portfolios?

We get sent about fifty portfolios a week but they usually get sent back because the standard is generally not good enough. Often, they are merely imitations. For example, when we printed *The Other Side*, one of Nan Goldin's first books, we got inundated with portfolios that were direct rip-offs featuring a masturbating man or a woman smoking dope. The same thing happened when we published Hiromix's book. We're not interested

in publishing bad imitations. You can flick through a portfolio like that and realize in an instant that you've seen it before.

Photographers also approach us at the Frankfurt Book Fair. They'll come up to our stand with their book dummies of a selection of nudes and say, 'It's all laid out, it just needs to be printed.' If I say I'm not interested, they'll dig around in their suitcase and pull out a portfolio of portraits. And so on. The only time I ever took on a book presented to me at the Book

Fair was when Arnold Odermatt, the Swiss photographer, presented me with his portfolio, which resulted in *Karambolage*.

Generally, photographers end up at Steidl because I've heard about them by word of mouth. A photographer I'm working with might say to me, 'you should check out this guy in Finland. He's been working on a project for five years and is doing amazing stuff.'

Is it important that a project is new and different?

We also publish books on classical photography. I've just done a wonderful book with Bruce Davidson, for example, called *England / Scotland 1960*. Or just today, I was talking to David Bailey

about his experience of the East End of London and that he still has rolls of film no prints have ever been made from, from 1959–64, which we're hoping to turn into a book. It's not just about working on projects that are 'trendy', or funky'. It's also about working in the realms of classical photography and figuring out how to show the work of established photographers in a new context.

How much say do photographers have in terms of the edit and design of their book?

What I love most is when a photographer comes to me with a box of photos and we just sit down at the table and dream up the future book. I always ask right from the start, 'how do you see your book? What is your dream vision?' I usually have my vision of things but I never enforce it on anyone. There are some photographers,

like Mitch Epstein, who may have a really strong vision but want help designing the book. In that case, I'll try to help the artist develop a custom-made style that fits in with their way of seeing. Then there are artists who know exactly what they want, all the way through to the typography on the cover. If an artist can come to me with reasons for wanting paper of a certain quality, I'm happy to oblige. I'd never interfere by saying it's too expensive or there are too many pages. Cost is never part of the thinking process.

If money is never part of the thinking process, how do you finance Steidl?

Some years ago, I bought the world rights to Günter Grass's oeuvre. That's money easily made. I also make money printing books, fashion show invitations, press kits and catalogues for Chanel and

Joel Sternfeld Sweet Earth - Experimental Utopias in America

JENS F.

COLLIER SCHORR

Karl Lagerfeld. So much effort and expenditure is put into some of our photography books that you'd never recoup the money in the sale anyway. We did a book with Collier Schorr for example, which cost 120,000 Euros to produce. Even if it sold out, we wouldn't make more than 30,000 Euros. I'm lucky – I own the business and can invest any money I make back into printing books, without asking anyone's permission. If it was a shareholder company, someone might object because they'd rather buy a Porsche. And then you'd be in trouble.

Above left: *Sweet Earth – Experimental Utopias in America*, published 2006
Above right: Collier Schorr, *Jens F.*, published 2006

What does a weekend at Steidlville feel like?

The artist generally arrives on Friday and we'll sit down and have a chat – a bit like being in a café with a friend – and then we might spread out their pictures and start sliding them around. After they retreat to their Steidlville apartments, I'll lay out the pictures in a way I think might work. It's usually highly intuitive. The following morning, we're ready to start working on a sequence. We then discuss it and the pictures get pushed around some more. By Sunday you have a layout and by Monday the scanning starts. Artists come back a month later to do the final corrections and on the third and final visit, we do the printing. On any weekend, there will be three

photographers at Steidlville, all at different stages of production. Sometimes I feel like a youth hostel manager. We've got a restaurant, apartments, a lounge and a library. It's fun for the artists because we eat and hang out together. Everybody gets treated the same, whether you're Robert Frank or Alec Soth coming to do your first ever book.

How would you describe your workday?

It's like being a child at play. I play all day long to the point of oblivion. Sometimes people might have to wait a couple of hours to speak to me, but it's not because I'm arrogant, it's because I'm so engrossed in the work I actually forget. Artists have that childish playful instinct too, so the collaboration works really well.

What excites you most about photography?

The scope for interpretation. With paintings you have to stick to the original colours. If Turner used a certain yellow, you have to reproduce that same exact yellow in a book. Photography is much more fluid. A case in point is when I was working with the Magnum photographer Richard Meier, who had photographed the Siberian forest. On the Ektachrome film and on the print, the snow came out blue, but Richard said, 'That colour is wrong. I remember the snow being purple.' So we added some magenta and held back on the cyan and the snow became purple. You need only look at Bill Brandt's prints. There's that famous picture of the stairs, which he did where one print is almost pitch black and another print almost white but both pictures are from the same negative. That kind of room for interpretation is only possible in photography.

What advice would you give to a budding photographer?

I am a craftsman, not a teacher. I wouldn't want to give any advice because I rely heavily on instinct. It could well happen, for example, that a photographer sends me something under the name Bob Miller one year and I reject it and then he or she sends me something the next year under the name Norman Appleboim

and I agree to run with the project. Marketing or the selling potential of a book is always the last thing on my mind.

What has working so closely with artists taught you?

I feel fortunate that I am able to witness the intimate procedure that's involved in the creative process. I feel very comfortable in the role of a student. Every artist that works with us teaches me something new, whether it's about colour, framing or design.

Art historians might spend ages analysing why, for example, Andy Warhol used pink for a certain screen print, but I was lucky enough to witness that he just saw a bucket standing around the factory and he kicked it and said, 'What is this shit? Pink paint? Let's use it.'

It's the subtlety and little experiences that emanate from the creative process and lead to the understanding of art, that fascinate me.

Robert Frank, *New York to Nova Scotia*, published 2005

Dan Torres

Picture Editor, *Libération*, Paris

Launched in 1973 with the help of Jean-Paul Sartre, *Libération* is France's most forward-thinking newspaper and was the first daily to turn its front page into a poster-like advert. It used full-sized images and striking headlines at a time when the dry and academic establishment press in France had failed to address the mood of a nation inspired by the student uprising in 1968. Sartre wanted writers to use a *parler-écrit*; the language actually spoken by its readers. Picture editor at *Libération* from 1994 to 2006, Dan Torres was in charge of commissioning photographers, editing pictures and designing the legendary and much-imitated front-page, referred to as 'La Une'.

'Bravo l'Artiste!' cover (*Libération*), 9 May 1998

What did you do before you became picture editor at *Libération*?

I was a photographer for seventeen years, doing everything from reportage through to portraits. I really feel like I know how difficult life can be as a freelance photographer. I know how hard it is to pick up the phone and call an editor to convince him or her to look at your work if you're not famous. I've been there.

Was it difficult to go from being a photographer to being a picture editor?

It was a very difficult transition for me and I really miss taking pictures. As a photographer, I became my camera. It was like an extension of me. Everything I saw, I saw through the lens. Now, although I hold nothing in my hands, I am confronted with other photographers' work on a daily basis. This has allowed me to open up to other points of view – a truly enriching experience.

How would you describe the visual language of the photography in *Libération*?

The newspaper has a very definitive style. When covering political events, for example, we don't want photographers to follow the traditional codes of political reportage. Politicians are actors, especially during electoral campaigns and in meetings. They put themselves centre stage. We're not interested in those rehearsed moments. We're interested in those brief instants, which are completely out of the control of the politicians. It could be a look or an attitude and it will tell you so much more about the power games at play. You have to be a good photographer to read those subtle situations, and have a keen interest in politics and psychology. It's the little moments that end up being unforgettable pictures because they are the ones that really tell a story. We don't want pictures that merely mirror what's written on the page. Each individual picture should open a window onto a whole new world. It should be able to convey a new level of understanding. We don't always get it right, but at least that's our ambition.

How much work is commissioned? How much bought in?

We commission about seventy per cent of the images on a daily basis and we run about seventy to eighty images in each edition. Most productions are done in France because we have a limited budget. Nevertheless, I love commissioning photographers from, for example, Russia, China, and America. I'm not exactly going to send a French photographer to do a reportage in California. That would be absurd. And that's not just a financial decision. It's an editorial choice as well. I think you can learn a lot by looking at a variety of photographic styles – especially foreign ones.

5F • LUNDI 9 MAI 1988

NOUVELLE SERIE N° 2166

Libération

RESULTATS PARTIELS

communiqués par le ministère de
l'intérieur à 23 heures:
Inscrits: 31 318900
Votants: 26628761
Exprimés: 25658506
Abstentions: 14.98 %

Mitterrand: 13970799 54.45 %
Chirac: 11687707 45.55 %

BRAVO L'ARTISTE !

Premier président de la V^e République élu deux fois au
suffrage universel, François Mitterrand peut
continuer à bouleverser le paysage politique français.

Are you more likely to use an up-and-coming photographer or an established one?

Libération has always welcomed up-and-coming photographers. My aim is to discover new talent. For this I go to festivals such as Visa Pour L'Image, the Beijing Biennale or the photography festival in Bamako in Mali, Africa. We do a lot of hunting around. Sometimes we come across a gem. Many photographers were discovered after being published in Libération. I enjoy commissioning well-known photographers, but that's not my aim.

Above left: '48 Hours' cover
(Libération), 18 March 2003
Above centre: 'Chirac dissout Juppe'
cover (Libération), 27 May 1997
Above right: 'La Guerre' cover
(Libération), 20 March 2003

With a day-rate that is lower than average, why do photographers choose to work for Libération?

Photographers work with us because they're interested in the story. It's usually out of passion. Also, they know that their images are never going to be cropped, that they're going to get the space they deserve and be well laid out. We have absolute respect for each photographer's style. If a photograph has been shot a certain way it's because the photographer intended it to be framed that way. It's not up to us to override his photographic aesthetic by recropping his shot.

Do you ever look at portfolios?

It's my job to assess portfolios. It takes a lot of time and effort but it's a necessity if you want to find new talent.

In the editing process, how do you ensure that your final story reflects what the photographer had in mind?

It's not just about what he or she wanted but what we're after as well. We work very closely with our photographers. When we produce a story, the editing is done by us because that's our job, but we'll always consult with the photographer. We have immense respect for each photographer's style. We don't have any staff photographers. We only use freelancers, so for each individual assignment we make sure we choose a photographer whose style works well for that particular project from the outset.

What was the idea behind 'La Une' (the front page) when it was first launched in the poster format?

Libération started with its poster-like front pages in 1981. It was an editorial decision that came about because editors were keen to use photography as a journalistic tool and demonstrate that it's an instrument which can help us to understand the world. It also coincided with a certain mood in France. *Libération* represented a craving for modernity, a longing to find a new way of reading things. A lot of publications in France have since copied the format. It's difficult to get just right, but a successful 'Une' has to be

Above left: 'Il était une fois l'Amérique' cover (*Libération*), 17 May 1998
Above centre: 'Marchons!' cover (*Libération*), 30 April 2002
Above right: 'Pourquoi la France tire son épingle des Jeux' cover (*Libération*), 5 August 1996

beautiful to look at, even if it isn't pretty, or even instantly readable.

Has the digital era brought with it an onslaught of new talent?

Absolutely not. Digital technology has progressed immensely, but most of the photographers I work with still use film. It's not a dictate of mine, it's simply what they prefer. Film is still very important to us. Not because of its tradition, but because there are many photo-shoots, such as fashion shoots and some portraiture, which demand that kind of quality. I must be the only editor in the world who has recently invested in enlarging the office darkroom. Digital technology is here and that's a fact. It has to be embraced. But what interests me at the end of the day is the content. After all, I'm not a gallery owner.

What's the most exciting aspect of your job?

I get a kick out of working to extremely tight deadlines. There's nothing more exciting than when the entire layout has to be changed at 7pm because of something major happening like Le Pen coming second in the preliminaries of the presidential elections in 2002. Everyone starts working so efficiently and with such precision. It's extraordinary and extremely fulfilling to be a part of that. You're so full of nervous energy. It's such a crazy rhythm working on a daily. It's like being on crack. Although you're wiped out at the end of a ten-hour day, you begin to start needing that rush. That is what's addictive about my job.

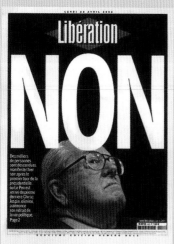

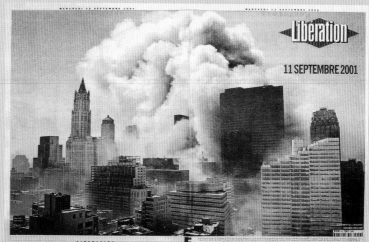

What advice would you give someone interested in becoming a picture editor? Can you learn to train the eye?

Go to the Louvre. You have to learn to train your eye by immersing yourself in the greats. And I don't just mean photographers. Editing pictures is all about aestheticism, culture ... it's about everything. You can't be a picture editor without having an interest in culture, and that includes music, cinema, dance etc. You have to soak up the world around you. There's no point in focusing only on photography. You have to wade in, literally drown yourself in it.

It's about ambience, it's about mood. Take jazz for example. That's not at all the same as hip hop, which isn't the same as opera, which in turn, is still different to pop. They're all emotive, but they're different. Exactly the same goes for photography. You don't have to start at the beginning of the nineteenth century, just steep yourself in the modern greats such as Mapplethorpe, Avedon, Eggleston and McCullin. In order to really acquire an eye, and in order to really appreciate a photographer, you have to be cultured.

Above left: 'Non' cover (*Libération*), 22 April 2002
Above right: '11 Septembre 2001' cover (*Libération*), 12 September 2001
Opposite: 'Fillon vend sa potion' cover (*Libération*), 25 April 2003

"Editing pictures is about aestheticism, culture ... it's about everything. You can't be a picture editor without having an interest in culture and that includes music, cinema, dance etc. You have to soak up the world around you."

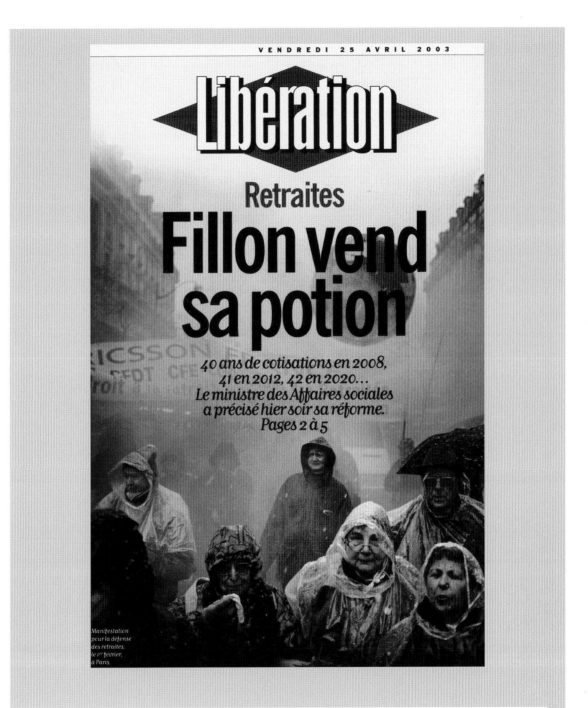

VENDREDI 25 AVRIL 2003

L'Libération

Retraites
Fillon vend sa potion

*40 ans de cotisations en 2008,
41 en 2012, 42 en 2020...
Le ministre des Affaires sociales
a précisé hier soir sa réforme.
Pages 2 à 5*

*Manifestation
pour la défense
des retraites,
le 1er février,
à Paris.*

Bibliography

Barney, T., *Tina Barney: Photographs: Theatre of Manners*, Scalo, 1997

Barney, T., *Tina Barney: The Europeans*, Steidl, 2005

Boot, C. (Ed.), *Magnum Stories*, Phaidon Press, 2004

Bright, S., *Art Photography Now*, Thames & Hudson, 2005

Capa, R., *Slightly Out of Focus*, Random House, 2001

Corbijn, A., *Anton Corbijn U2 and I: The Photographs 1982–2004*, Schirmer/Mosel, 2005

Corbijn, A., *Star Trak*, Schirmer/Mosel, 2005

Corbijn, A., *Famouz*, Schirmer/Mosel, 2005

Corbijn, A., *Anton Corbijn – Innocence: Stern Portfolio (37)*, Stern Gruner + Jahr AG & Co, 2005

Corbijn, A., *Anton Corbijn – 33 Still Lives*, Te Neues, 2000

Cotton, C., *The Photograph as Contemporary Art (World of Art Series)*, Thames & Hudson, 2004

Cotton, C., *Imperfect Beauty: The Making of Contemporary Fashion Photographs*, V & A Publications, 2000

Demand, T., *Thomas Demand*, Museum of Modern Art, New York, 2005

Demand, T., *Thomas Demand: Phototrophy*, Schirmer/Mosel, 2005

Demand, T., *Catalogue*, Serpentine Gallery London and Schirmer/Mosel, 2006

Dijkstra, R., *Rineke Dijkstra*, Hatje Cantz, 2001

Dijkstra, R., *Rineke Dijkstra: Portraits*, Schirmer/Mosel, 2004

Eggleston, W. and Szarkowski, J., *William Eggleston's Guide*, Museum of Modern Art, New York, 2002

Eggleston, W., *William Eggleston*, Foundation Cartier, 2001

Ewing, W. A., *ReGeneration: 50 Photographers of Tomorrow*, Thames & Hudson, 2005

Fréger, C., *Bleus de Travail*, Distributed Art Publishers, 2006

Fréger, C., *Steps: portraits photographiques et uniformes*, Le Point du jour Editeur, 2003

Fréger, C., *Majorettes*, Léo Scheer Beau, 2002

Fréger, C., *Le froid, le gel, l'image: Merisotakoulu*, Léo Scheer Beau, 2003

Fréger, C., *Charles Fréger: Double Nelson*, Piece of Cake, 2005

Fréger, C., *Charles Fréger: Rikishi*, Piece of Cake, 2004

Fréger, C., *Légionnaires*, Sept-Cent Soixante Dix Neuf, 2002

Hill, P. and Cooper, T., *Dialogue with Photography*, Dewi Lewis Publishing, 2005

Knight, N., *The idealising vision – The art of fashion photography*, Aperture, 1991

LaChapelle, D., *Hotel Lachapelle*, Bulfinch, 1999

LaChapelle, D., *LaChapelle Land*, Channel Photographics, 2005

Lovatt-Smith, L., *Fashion Images de Mode*, Steidl, 1997

Mark, M. E. and Naef, W., *Mary Ellen Mark: Exposure*, Phaidon Press, 2005

Mark, M. E., *Mary Ellen Mark: Twins*, Aperture, 2003

Mark, M. E., *Streetwise*, Aperture, 1992

Mark, M. E., *Indian Circus*, Chronicle Books, 1993

Mark, M. E., *Passport Mary Ellen Mark*, Lustrum Press, 1976

Mark, M. E., *Mary Ellen Mark: Falkland Road: Prostitutes of Bombay*, Steidl, 2006

Mark, M. E., Folger Jacobs, K. and Forman, M., *WARD 81*, Simon and Schuster 1979

McClure, R., *Schweppes Photographic Portrait Prize 2005*, National Portrait Gallery, London, 2005

McClure, R., *Schweppes Photographic Portrait Prize 2004*, National Portrait Gallery, London, 2004

Mikhailov, B. and Williams, G., *Boris Mikhailov (Phaidon 55S)*, Phaidon Press, 2001

Mikhailov, B., *Boris Mikhailov: Case History*, Scalo, 1999

Mikhailov, B., *Boris Mikhailov: A Retrospective*, Scalo, 2003

Mikhailov, B., *Boris Mikhailov: Look at Me, I Look at Water … or Perversion of Repose*, Steidl, 2004

Mikhailov, B., *Boris Mikhailov: Salt Lake*, Steidl, 2002

Panzer, M. and Caujolle, C., *Things as They Are: Photojournalism in Context Since 1955*, World Press Photo, 2005

Parr, M. and Chesshyre, R., *The Cost of Living*, Aperture, 1991

Parr, M. and Heiferman, M., *Martin Parr: Autoportrait*, Dewi Lewis Publishing, 2000

Parr, M. and Walker, I., *Last Resort: Photographs of New Brighton*, Dewi Lewis Publishing, 1998

Parr, M. and Williams, V., *Martin Parr*, Phaidon Press, 2002

Parr, M., *Think of England*, Phaidon Press, 2004

Rankin, *Rankin: Spezial Fotografie (Stern Portfolio S.)*, Gruner + Jahr AG & Co KG, 2003

Rankin, *Celebritation*, Vision On Publishing Ltd, 2000

Rankin, *Rankin Nudes*, Vision On Publishing Ltd, 2001

Rankin, *Rankin: Male Nudes*, Vision On Publishing Ltd, 2001

Richards, E., *Cocaine True, Cocaine Blue*, Aperture, 1996

Richards, E., *The Knife and Gun Club: Scenes from an Emergency Room*, Atlantic Monthly Press, 1995

Richards, E., *Dorchester Days*, Phaidon Press, 2000

Richards, E., *The Fat Baby*, Phaidon Press, 2004

Salgado, S., *Workers: An Archaeology of the Industrial Age*, Aperture, 1993

Salgado, S., *The Children: Refugees and Migrants*, Aperture, 2000

Salgado, S., *Migrations: Humanity in Transition*, Aperture, 2000

Salgado, S., *An Uncertain Grace*, Aperture, 1992

Shore, S. and Badger, G., *Stephen Shore: Uncommon Places, 50 Unpublished Photographs 1973–1978*, Edition Mennour, 2002

Shore, S., *Stephen Shore: American Surfaces*, Phaidon Press, 2005

Shore, S., *The Nature of Photographs*, The Johns Hopkins University Press, 1998

Shore, S., Tillman, L. and Schmidt-Wulffen, S., *Uncommon Places: The Complete Works*, Aperture, 2004

Sims, D., *Visionaire #40: David Sims Roses*, Visionaire Publishing, 2003

Sontag, S., *On Photography*, Penguin, 1979

Sorrenti, M., *Mario Sorrenti: The Machine*, Steidl, 2001

Soth, A., *Alec Soth: Niagara*, Steidl, 2006

Soth, A., *Alec Soth: Sleeping by the Mississippi*, Steidl, 2004

Szarkowski, J., *Looking at Photographs: 100 Pictures from the Collection of the Museum of Modern Art*, Little, Brown & Company 1999

Teller, J. and Sherman, C., *Juergen Teller, Cindy Sherman, Marc Jacobs*, Rizzoli Publications 2006

Teller, J., *Juergen Teller: Nurnberg*, Steidl, 2005

Unwerth, E. von, *Omahyra and Boyd*, Edition Mennour, 2005

Unwerth, E. von, *Revenge*, Twin Palms Publishers, 2004

Unwerth, E. von, *Spezial Fotografie Ellens Girls: Portfolio No 28*, Te Neues, 2002

Unwerth, E. von, *Wicked*, Te Neues, 1998

Picture Credits

Images are referred to by page number. Measurements are given in centimetres and inches, height preceding width.

[2] Top down, left to right
Stephen Shore
Lobsters, 1974. Chromogenic print, 50.8 x 61 cm (20 x 24 in). © Stephen Shore
Naomi Harris
Number 1 Fan, Michael Jackson Trial, Santa Maria, California, 2005. C-print, 50.8 x 61 cm (20 x 24 in). Courtesy Naomi Harris
Rineke Dijkstra,
Almerisa, Asylum Center, Leiden, Netherlands, March 14, 1994. C-Print, 25 x 105 cm (49 ⁹⁄₁₆ x 41 ⁵⁄₁₆ in). Rineke Dijkstra courtesy Marian Goodman Gallery, New York
Eugene Richards
Photos from 'The Global Willowbrook' (*The New York Times Magazine*), 16 Jan 2000. Courtesy Eugene Richards and *The New York Times Magazine*
Charles Fréger
Rikishi 15, from the 'Rikishi' series, 2002–03, Chromogenic colour print, 72 x 58 cm (28 ⅜ x 22 ¹³⁄₁₆ in). Courtesy Charles Fréger
Tina Barney
Jill and Polly in the Bathroom, 1987. Chromogenic colour print in an edition of ten, 121.9 x 152.4 cm (48 x 60 in). Courtesy Janet Borden, inc
Robert Polidori
Zones of Exclusion: Pripyat Chernobyl, 2003. Steidl Design at Steidl Publishers /Gerhard Steidl Druckerei und Verlag GmbH & Co.OHG
David Sims
Raquel Zimmerman in gold trousers with cigarette in her mouth (French *Vogue*),

2005. Colour print, dimensions variable. Courtesy David Sims
Anastasia Khoroshilova
Maria Iwanov, 2004. C-print, 100 x 72 cm (39 ⅜ x 28 ⅜ in). Courtesy of Galerie Ernst Hilger
Mario Sorrenti
Shannon with Hand in Mouth, 1996. Colour print, dimensions variable. Photographer: Mario Sorrenti. Originally published in *Art Forum*
David LaChapelle
My House (French *Vogue/ Couture Story Icons*), 2001. Digital c-print photograph on paper, dimensions variable. © 2006 David LaChapelle
Alec Soth
The Voyageur, 2004. C-print, 127 x 101.6 cm (50 x 40 in). Courtesy Alec Soth
Eva Leitolf
Following the arson attack 20 May 1993, Bielefeld (from the 'German Images – Evidence in Rostock, Thale, Solingen and Bielefeld 1992–94' series), 1993. C-print, 66.5 x 53.5 cm (26 ³⁄₁₆ x 21 ¹⁄₁₆ in). Courtesy Eva Leitolf
Mary Ellen Mark
Ram Prakash Singh with His Elephant Shyama. Great Golden Circus, Ahmedabad, India, 1990. Platinum print, 48.3 x 48.3 cm (19 x 19 in). © Mary Ellen Mark
Thomas Demand
Copyshop, 1999. C-print /Diasec, 183.5 x 300 cm (72 ¼ x 118 ⅛ in). © Thomas Demand, VG BildKunst/ DACS, London
Boris Mikhailov
From the 'Case History' series, 1998–99. Colour print, 187 x 127 cm (73 ⅝ x 50 in). Courtesy Barbara Gross Galerie, München
[7] **Rineke Dijkstra**
Shany, Herzliya, Israel, August 1, 2003. C-print,

126 x 107 cm (49 ⅝ x 42 ⅛ in). Rineke Dijkstra courtesy Marian Goodman Gallery, New York
[8] **Ricarda Roggan**
Vier Stühle, Tisch und Bank, 2002. C-print, 100 x 125 cm (39 ⅜ x 49 ³⁄₁₆ in). Courtesy Galerie EIGEN + ART Leipzig/Berlin
[9] **Mario Sorrenti**
Goya, Men Feeding (*Another Magazine*), 2004. Colour print, dimensions variable. Photographer: Mario Sorrenti. Originally published in *Another Magazine*
[10] **William Eggleston**
UNTITLED, DUNKERQUE, 2005. Light Jet print, 40.6 x 50.8 cm (16 x 20 in). © 2007 Eggleston Artistic Trust, courtesy Cheim & Read, New York. Used with permission. All rights reserved.
[11] **Robert Polidori**
Metropolis, 2004. Steidl Design at Steidl Publishers/Gerhard Steidl Druckerei und Verlag GmbH & Co.OHG
[12] **Boris Mikhailov**
Case History, 1998–99. Colour print, 187 x 127 cm (73 ⅝ x 50 in). Courtesy Barbara Gross Galerie, München
[15] **Thomas Demand**
Gate, 2004. C-print/Diasec, 180 x 238 cm (70 ⅞ x 93 ¹¹⁄₁₆ in) © Thomas Demand, VG BildKunst/ DACS, London
[16–17] **Thomas Demand**
Lichtung/Clearing, 2003. C-print/Diasec, 192 x 495 cm (75 ⁹⁄₁₆ x 194 ⅞ in). © Thomas Demand, VG BildKunst/ DACS, London
[18–19] **Thomas Demand**
Archiv/Archive, 1995. C-print/Diasec, 183.5 x 233 cm (72 ¼ x 91 ¾ in). © Thomas Demand, VG BildKunst/ DACS, London
[22–23] **Thomas Demand**
Copyshop, 1999. C-print

/Diasec, 183.5 x 300 cm (72 ¼ x 118 ⅛ in). © Thomas Demand, VG BildKunst /DACS, London
[25] **William Eggleston**
UNTITLED, DUNKERQUE, 2005. LightJet print, 40.6 x 50.8 cm (16 x 20 in). © 2007 Eggleston Artistic Trust, courtesy Cheim & Read, New York. Used with permission. All rights reserved
[26–27] **William Eggleston**
UNTITLED, GREENWOOD, MISSISSIPPI, 1973. Dye-transfer print, 38.7 x 52.7 (15 ¼ x 20 ¾ in). © 2007 Eggleston Artistic Trust, courtesy Cheim & Read, New York. Used with permission. All rights reserved.
[28] **William Eggleston**
UNTITLED, NEAR JACKSON, MISSISSIPPI, c. 1970. Dye-transfer print, 60.3 x 48.9 cm (23 ¾ x 19 ¼ in). © 2007 Eggleston Artistic Trust, courtesy Cheim & Read, New York. Used with permission. All rights reserved.
[29] **William Eggleston**
UNTITLED (BILOXI, MISSISSIPPI), 1974. Dye-transfer print, 40.6 x 50.8 cm (16 x 20 in). © 2007 Eggleston Artistic Trust, courtesy Cheim & Read, New York. Used with permission. All rights reserved.
[30] **William Eggleston**
UNTITLED (HUNTSVILLE, ALABAMA),1972. Dye-transfer print, 50.8 x 40.6 cm (20 x 16 in). © 2007 Eggleston Artistic Trust, courtesy Cheim & Read, New York. Used with permission. All rights reserved.
[31] **William Eggleston**
UNTITLED (MORTON, MISSISSIPPI), c. 1972. Dye-transfer print, 63.5 x 47 cm (25 x 18 ½ in).

© 2007 Eggleston Artistic Trust, courtesy Cheim & Read, New York. Used with permission. All rights reserved.
[32–33] **William Eggleston**
UNTITLED (MEMPHIS, TENNESSEE), c.1975. Dye-transfer print, 40.6 x 50.8 cm (16 x 20 in). © 2007 Eggleston Artistic Trust, courtesy Cheim & Read, New York. Used with permission. All rights reserved.
[35] **Boris Mikhailov**
From the 'Case History' series, 1998–99. Colour print, 187 x 127 cm (73 ⅝ x 50 in). Courtesy Barbara Gross Galerie, München
[36] **Boris Mikhailov**
From the 'SOZ-Art/SOTS ART, USSR' series, 1975–78. Photograph, hand coloured, dimensions variable. Courtesy Barbara Gross Galerie, München
[37] **Boris Mikhailov**
Superimpositions from the 60s–70s, 2005. Colour print, 129 x 169 cm (50 ¹³⁄₁₆ x 66 ⁹⁄₁₆ in). Courtesy Barbara Gross Galerie, München
[38] **Boris Mikhailov**
From the 'Salt Lake' series, 1986. Black-and-white photograph/Gelatine Silver Print, 30 x 40 cm (11 ¹³⁄₁₆ x 15 ¾ in). Courtesy Barbara Gross Galerie, München
[39] **Boris Mikhailov**
From the 'Salt Lake' series, 1986. Black-and-white photograph/Gelatine Silver Print, 30 x 40 cm (11 ¹³⁄₁₆ x 15 ¾ in). Courtesy Barbara Gross Galerie, München
[40] **Boris Mikhailov**
From the 'By the Ground' series, 1991. Black-and-white photograph/sepia toned, 15 x 30 cm (5 ⅞ x 11 ¹³⁄₁₆ in). Courtesy Barbara Gross Galerie, München

[41] **Boris Mikhailov**
From the 'Case History' series, 1998–99. Colour print, 187 x 127 cm (73 ⅝ x 50 in). Courtesy Barbara Gross Galerie, München

[42 l] **Boris Mikhailov**
From the 'Case History' series, 1998–99. Colour print, 187 x 127 cm (73 ⅝ x 50 in). Courtesy Barbara Gross Galerie, München

[42 r] **Boris Mikhailov**
From the 'Case History' series, 1998–99. Colour print, 187 x 127 cm (73 ⅝ x 50 in). Courtesy Barbara Gross Galerie, München

[43] **Boris Mikhailov**
From the 'Case History' series, 1998–99. Colour print, 187 x 127 cm (73 ⅝ x 50 in). Courtesy Barbara Gross Galerie, München

[44–45] **Stephen Shore**
West Market St and N. Eugene St, Greensboro, NC, January 23, 1976. Chromogenic print, 50.8 x 61 cm (20 x 24 in). © Stephen Shore

[46] **Stephen Shore**
Zugspitze, 2006. 4 colour offset book, 21.6 x 27.9 cm (8.5 x 11 in). © Stephen Shore

[48] **Stephen Shore**
Landscapes – Brewster County, 1987. Chromogenic print, 91.4 x 114.3 cm (36 x 45 in). © Stephen Shore

[49] **Stephen Shore**
Landscapes – Brewster County, 1987. Chromogenic print, 91.4 x 114.3 cm (36 x 45 in). © Stephen Shore

[50] **Stephen Shore**
Lobsters, 1974. Chromogenic print, 50.8 x 61 cm (20 x 24 in). © Stephen Shore

[52–53] **Stephen Shore**
Telephone, 1972. Chromogenic print, 12.7 x 17.8 cm (5 x 7 in). © Stephen Shore

[55] **Mary Ellen Mark**
Ram Prakash Singh with

His Elephant Shyama, Great Golden Circus, Ahmedabad, India, 1990. Platinum print, 48.3 x 48.3 cm (19 x 19 in). © Mary Ellen Mark

[56] **Mary Ellen Mark**
Amanda and Her Cousin, Amy Valdese, North California, 1990. Silver Gelatin photograph, 40.6 x 50.8 cm (16 x 20 in). © Mary Ellen Mark

[57] **Mary Ellen Mark**
Kamla Behind Curtains with a Customer, Bombay, India (from the 'Falkland Road' series), 1978. C-print, 40.6 x 50.8 cm (16 x 20 in). © Mary Ellen Mark

[58] **Mary Ellen Mark**
Relatives, Tunica, Mississippi, 1990. Black-and-white print, 40.6 x 50.8 cm (16 x 20 in). © Mary Ellen Mark

[61] **Mary Ellen Mark**
Hydrocephalic Girl with her Sister, Turin, Italy, 1990. Black-and-white print, 40.6 x 50.8 cm (16 x 20 in). © Mary Ellen Mark

[62] **Mary Ellen Mark**
Girl jumping over a wall, Central Park, New York City, 1968. Black-and-white print, 40.6 x 50.8 cm (16 x 20 in). © Mary Ellen Mark

[65] **Martin Parr**
G.B. ENGLAND. Henley-on-Thames, 1996. C-print, 30.5 x 40.6 cm (12 x 16 in). © Martin Parr/Magnum Photos

[68–69] **Martin Parr**
G.B. ENGLAND. New Brighton, 1985. C-print, 30.5 x 40.6 cm (12 x 16 in). © Martin Parr/Magnum Photos

[72–73] **Eugene Richards**
Still House Hollow, Tennessee, 1986. Gelatin silver print, 50.8 x 61 cm (20 x 24 in). © Eugene Richards

[77] **Sebastião Salgado**
Marine iguana

(Amblyrhynchus cristatus), Rábida Island, 2004. Black-and-white silver print, dimensions variable. © Sebastião Salgado /Amazonas Images/NB Pictures

[83] **David LaChapelle**
Jurassic Moment (Italian *Vogue*), 2004. Digital c-print photograph on paper, dimensions variable. © 2006 David LaChapelle

[84–85] **David LaChapelle**
House at the End of The World (Italian *Vogue*), 2005. Digital c-print photograph on paper, dimensions variable. © 2006 David LaChapelle

[87] **David LaChapelle**
My House (French *Vogue /Couture Story Icons*), 2001. Digital c-print photograph on paper, dimensions variable. © 2006 David LaChapelle

[88–89] **David LaChapelle**
Jesus is My Homeboy "Foot Wash" (i-D), 2002. Digital c-print photograph on paper, dimensions variable. © 2006 David LaChapelle

[90] **David LaChapelle**
Death By Hamburger (Italian *Vogue*), 2001. Digital c-print photograph on paper, dimensions variable. © 2006 David LaChapelle

[93] **David Sims**
Boy with short hair and red light, Isolated Heroes, 1999. Colour print, dimensions variable. Courtesy David Sims

[94] **David Sims**
Benetton girls jumping in stripey tops (Benetton), 2005–06. Colour print, dimensions variable. Courtesy David Sims

[96] **David Sims**
Raquel Zimmerman in gold trousers with cigarette in her mouth (French *Vogue*), 2005. Colour print,

dimensions variable. Courtesy David Sims

[97] **David Sims**
Yellow Rose, Visionaire Rose Exhibition, 2002. Colour print, dimensions variable. Courtesy David Sims

[98] **David Sims**
Tom in briefs against a red and blue background, 1993. Colour print, dimensions variable. Courtesy David Sims

[99] **David Sims**
Lily Donaldson in blue/ violet light (Jil Sander), 2004–05. Colour print, dimensions variable. Courtesy David Sims

[101] **Mario Sorrenti**
Kate Moss (Calvin Klein Obsession campaign), 1993. Black-and-white print, dimensions variable. Photographer: Mario Sorrenti. Calvin Klein Obsession Campaign

[102–03] **Mario Sorrenti**
Refugee, 2005. Colour print, dimensions variable. Photographer: Mario Sorrenti. Originally published in *W*

[104] **Mario Sorrenti**
Goya donkey (*Another Magazine*), 2004. Colour print, dimensions variable. Photographer: Mario Sorrenti. Originally published in *Another Magazine*

[105 l] **Mario Sorrenti**
Kate Moss (Calvin Klein Obsession campaign), 1993. Black-and-white print, dimensions variable. Photographer: Mario Sorrenti. Calvin Klein Obsession Campaign

[105 r] **Mario Sorrenti**
Shannon with Hand in Mouth, 1996. Colour print, dimensions variable. Photographer: Mario Sorrenti. Originally published in *Art Forum*

[107] **Mario Sorrenti**
Image of Davide (The Machine), 1992. Colour print, dimensions variable. Photographer: Mario Sorrenti. Originally published in *The Machine*

[109] **Ellen von Unwerth**
Paradise Lost (Japanese *Vogue*), 2002. Black-and-white print, dimensions variable. © Ellen von Unwerth/Art + Commerce

[110] **Ellen von Unwerth**
Claudia Schiffer (Guess campaign),1990. Black-and-white print, 50 x 61 cm (19 ⅔ x 24 ⅛ in). © Ellen von Unwerth/ Art + Commerce

[111] **Ellen von Unwerth**
Betty Page (*Interview*), 1999. Black-and-white print, dimensions variable. © Ellen von Unwerth/ Art + Commerce

[112] **Ellen von Unwerth**
In Great Shape (Italian *Vogue*), 2006. Black-and-white print, dimensions variable. © Ellen von Unwerth/Art + Commerce

[113] **Ellen von Unwerth**
In Great Shape (Italian *Vogue*), 2006. Black-and-white print, dimensions variable. © Ellen von Unwerth/Art + Commerce

[114] **Ellen von Unwerth**
Adriana Lima (Victoria's Secret campaign), 2003. Colour print, dimensions variable. © Ellen von Unwerth/Art + Commerce

[116] **Ellen von Unwerth**
Revenge, 2003. Black-and-white print, dimensions variable. © Ellen von Unwerth/Art + Commerce

[117] **Ellen von Unwerth**
Revenge, 2003. Black-and-white print, dimensions variable. © Ellen von Unwerth/Art + Commerce

[118–19] **Tina Barney**
Jill and Polly in the Bathroom, 1987. Chromogenic colour print

in an edition of ten, 121.9 x 152.4 cm (48 x 60 in). Courtesy Janet Borden, inc

[120] **Tina Barney**
The Trustee and the Curator, 1991. Chromogenic colour print in an edition of ten, 121.9 x 152.4 cm (48 x 60 in). Courtesy Janet Borden, inc

[122–23] **Tina Barney**
Sunday New York Times, 1982. Chromogenic colour print in an edition of ten, 121.9 x 152.4 cm (48 x 60 in). Courtesy Janet Borden, inc

[125] **Tina Barney**
Father and Sons, 1996. Chromogenic colour print in an edition of ten, 121.9 x 152.4 cm (48 x 60 in). Courtesy Janet Borden, inc

[127] **Anton Corbijn**
Clint Eastwood, 1994. Lith mounted & framed, 68 x 69 cm (26 ¾ x 27 ³⁄₁₆ in). Photo © Anton Corbijn 2006

[128–29] **Anton Corbijn**
Tom Waits (blue), 1999. Polaroid perspex/dibond, 188 x 124 cm (74 x 48 ¹³⁄₁₆ in). Photo © Anton Corbijn 2006

[131] **Anton Corbijn**
Lars Von Trier, 1997. Polaroid perspex/dibond, 124 x 188 cm (48 ¹³⁄₁₆ x 74 in). Photo © Anton Corbijn 2006

[132] **Anton Corbijn**
A. Lennon, Strijen, Holland, 2002. Colour print perspex /dibond/framed, 156 x 114 cm (61 ⁷⁄₁₆ x 44 ⁷⁄₈ in). Photo © Anton Corbijn 2006

[133] **Anton Corbijn**
Marianne Faithfull, 1990. Lith mounted and framed, 68 x 69 cm (26 ¾ x 27 ³⁄₁₆ in). Photo © Anton Corbijn 2006

[134] **Anton Corbijn**
Miles Davis, 1985. Black-and-white print mounted and framed, 110 x 160 cm (43 ⁵⁄₁₆ x 63 in).

Photo © Anton Corbijn 2006

[137] **Rineke Dijkstra**
Tiergarten, Berlin, Germany, June 27, 1999. C-print, 137.2 x 106.8 cm (54 x 42 ¹⁄₁₆ in). Rineke Dijkstra courtesy Marian Goodman Gallery, New York

[138] **Rineke Dijkstra**
Odessa, Ukraine, August 11, 1993. C-print, 152 x 128 cm (59 ¹³⁄₁₆ x 50 ⅜ in). Rineke Dijkstra courtesy Marian Goodman Gallery, New York

[139 l] **Rineke Dijkstra**
Olivier Silva, The Foreign Legion, Quartier Viénot, Marseille, France, July 21, 2000. C-print, 125 x 106 cm (49 ³⁄₁₆ x 41 ⁵⁄₁₆ in). Rineke Dijkstra courtesy Marian Goodman Gallery, New York

[139 r] **Rineke Dijkstra**
Olivier Silva, The Foreign Legion, Camp Raffalli, Calvi, France, June 18, 2001. C-print, 125 x 106 cm (49 ³⁄₁₆ x 41 ⁵⁄₁₆ in). Rineke Dijkstra courtesy Marian Goodman Gallery, New York

[140] **Rineke Dijkstra**
Almerisa, Asylum Center, Leiden, Netherlands, March 14, 1994. C-print, 125 x 106 cm (49 ³⁄₁₆ x 41 ⁵⁄₁₆ in). Rineke Dijkstra courtesy Marian Goodman Gallery, New York

[141] **Rineke Dijkstra**
Almerisa, Leidschendam, The Netherlands, December 9, 2000. C-print, 125 x 106 cm (49 ³⁄₁₆ x 41 ⁵⁄₁₆ in). Rineke Dijkstra courtesy Marian Goodman Gallery, New York

[142–43] **Rineke Dijkstra**
Kolobrzeg, Poland, July 27, 1992. C-print, 152 x 128 cm (59 ¹³⁄₁₆ x 50 ⅜ in). Rineke Dijkstra courtesy Marian Goodman Gallery, New York

[143 r] **Rineke Dijkstra**
Jalta, Ukraine July 30, 1993. C-print, 152 x 128 cm (59 ¹³⁄₁₆ x 50 ⅜ in). Rineke Dijkstra courtesy Marian Goodman Gallery, New York

[144] **Rineke Dijkstra**
The Buzzclub, Liverpool, England, March 3, 1995. C-print, 152 x 128 cm (59 ¹³⁄₁₆ x 50 ⅜ in). Rineke Dijkstra courtesy Marian Goodman Gallery, New York

[145] **Rineke Dijkstra**
Isabel, Berlin, Germany, June 26, 2003. C-print, 125 x 106 cm (49 ³⁄₁₆ x 41 ⅝ in). Rineke Dijkstra courtesy Marian Goodman Gallery, New York

[146] **Rankin**
The Queen, 2000. Edition print, 50.8 x 61 cm (20 x 24 in). Courtesy Rankin

[148] **Rankin**
Tuuli, 2006. Edition print, 50.8 x 61 cm (21 x 24 in). Courtesy Rankin

[150] **Rankin**
Tony Blair, 2003. Edition print, 50.8 x 61 cm (20 x 24 in). Courtesy Rankin

[151] **Rankin**
Bjork, 1995. Edition print, 50.8 x 61 cm (20 x 24 in). Courtesy Rankin

[152] **Rankin**
Tuuli, 2006. Edition print, 50.8 x 61 cm (20 x 24 in). Courtesy Rankin

[153] **Rankin**
Tuuli, 2006. Edition print, 50.8 x 61 cm (20 x 24 in). Courtesy Rankin

[155] **Rankin**
Marilyn Manson, 2003. Edition print, 50.8 x 61 cm (20 x 24 in). Courtesy Rankin

[157] **Charles Fréger**
Rikishi 15, from the 'Rikishi' series, 2002–03. Chromogenic colour print, 72 x 58 cm (28 ⅜ x 22 ¹³⁄₁₆ in). Courtesy Charles Fréger

[158] **Charles Fréger**
Water polo 3, from the 'Water Polo' series, 2000. Chromogenic colour print, 72 x 58 cm (28 ⅜ x 22 ¹³⁄₁₆ in). Courtesy Charles Fréger

[159] **Charles Fréger**
Lovely girls de Féchain 1, from the 'Majorettes' series, 2000–01.

Chromogenic colour print, 72 x 58 cm (28 ⅜ x 22 ¹³⁄₁₆ in). Courtesy Charles Fréger

[160] **Charles Fréger**
Libertines de Billy-Montigny 2, from the 'Majorettes' series, 2000–01. Chromogenic colour print, 72 x 58 cm (28 ⅜ x 22 ¹³⁄₁₆ in). Courtesy Charles Fréger

[161] **Charles Fréger**
Majorettes de Looberghe 2, from the 'Majorettes' series, 2000–01. Chromogenic colour print, 72 x 58 cm (28 ⅜ x 22 ¹³⁄₁₆ in). Courtesy Charles Fréger

[162] **Charles Fréger**
Grande Escorte Royale 2, from the 'Guards of the Empire' series, 2004–06. Chromogenic colour print, 72 x 58 cm (28 ⅜ x 22 ¹³⁄₁₆ in). Courtesy Charles Fréger

[163] **Charles Fréger**
Boucher 30, from the 'Bleus de travail' series, 2002–03. Chromogenic colour print, 72 x 58 cm (28 ⅜ x 22 ¹³⁄₁₆ in). Courtesy Charles Fréger

[164] **Charles Fréger**
2 Nelson 23, from the 'Double Nelson' series, 2004. Chromogenic colour print, 72 x 58 cm (28 ⅜ x 22 ¹³⁄₁₆ in). Courtesy Charles Fréger

[165] **Charles Fréger**
Steps 17 (Dream Steps), from the 'Steps' series, 2001–02. Chromogenic colour print, 72 x 58 cm (28 ⅜ x 22 ¹³⁄₁₆ in). Courtesy Charles Fréger

[166–67] **Naomi Harris**
Clare and Daughter Ronda at the Rascal House, Miami Beach, Florida, March (*Heeb* magazine), 2002. Cibachrome, 50.8 x 61 cm (20 x 24 in). Courtesy Naomi Harris

[168] **Naomi Harris**
Leigh Smoking, Haddon Hall Hotel, Miami Beach,

Florida, 1999. Cibachrome, 50.8 x 61 cm (20 x 24 in). Courtesy Naomi Harris

[169] **Naomi Harris**
Marie and Sonja by the Pool, Miami, Florida, 2000. Cibachrome, 50.8 x 61 cm (20 x 24 in). Courtesy Naomi Harris

[170–71] **Naomi Harris**
Drinking Franzia, Swingstock, Wisconsin, July, 2003. C-print, 50.8 x 61 cm (20 x 24 in). Courtesy Naomi Harris

[172–73] **Naomi Harris**
Viking And Girlfriend, Swingstock, Wisconsin, July, 2003. C-print, 50.8 x 61 cm (20 x 24 in). Courtesy Naomi Harris

[173] **Naomi Harris**
Ribs, Swingstock, Wisconsin, July, 2003. C-print, 50.8 x 61 cm (20 x 24 in). Courtesy Naomi Harris

[174] **Naomi Harris**
New Years Eve, Live Oak Resort, Washington, Texas, December, 2005. C-print, 50.8 x 61 cm (20 x 24 in). Courtesy Naomi Harris

[175] **Naomi Harris**
Harem Nights, Niagara Entice, Niagara Falls, New York, October, 2004. C-print, 50.8 x 61 cm (20 x 24 in). Courtesy Naomi Harris

[176] **Naomi Harris**
Red Glove Fan, Michael Jackson Trial, Santa Maria, California, June, 2005. C-print, 50.8 x 61 cm (20 x 24 in). Courtesy Naomi Harris

[177] **Naomi Harris**
Number 1 Fan, Michael Jackson Trial, Santa Maria, California, June, 2005. C-print, 50.8 x 61 cm (20 x 24 in). Courtesy Naomi Harris

[179] **Alec Soth**
Rebecca, 2005. C-print, 127 x 101.6 cm (50 x 40 in). Courtesy Alec Soth

[180] **Alec Soth**
The Voyageur, 2004. C-print, 127 x 101.6 cm (50 x 40 in). Courtesy Alec Soth

[181 l] **Alec Soth**
Two Towels, 2004. C-print,
60.9 x 76.2 cm (24 x 30 in).
Courtesy Alec Soth

[181 r] **Alec Soth**
Michele and James, 2004.
C-print, 101.6 x 81.3 cm (40
x 32 in). Courtesy Alec Soth

[182] **Alec Soth**
Charles, Vasa, Minnesota,
2002. C-print, 101.6 x 81.3
cm (40 x 32 in). Courtesy
Alec Soth

[183] **Alec Soth**
*Peter's Houseboat, Winona,
Minnesota*, 2002. C-print,
81.3 x 101.6 cm (32 x 40
in). Courtesy Alec Soth

[184–85] **Alec Soth**
Helena, Arkansas, 2002.
C-print, 81.3 x 101.6 cm
(32 x 40 in). Courtesy Alec Soth

[187] **Alec Soth**
*Charles Lindbergh's
boyhood bed, Little Falls,
Minnesota*, 1999. C-print,
81.3 x 101.6 cm (32 x 40
in). Courtesy Alec Soth

[189] **Neil Stewart**
Tretorn-bike in motion,
2004. Colour print,
dimensions variable.
Courtesy Neil Stewart

[190–91] **Neil Stewart**
Folk One – Cathal laugh,
2003. Colour print,
dimensions variable.
Courtesy Neil Stewart

[192] **Neil Stewart**
Folk One – Original Crew,
2003. Colour print,
dimensions variable.
Courtesy Neil Stewart

[193] **Neil Stewart**
Folk One – Football Heads,
2003. Colour print,
dimensions variable.
Courtesy Neil Stewart

[194] **Neil Stewart**
Tretorn – 70s girls, 2004.
Colour print, dimensions
variable. Courtesy Neil
Stewart

[195] **Neil Stewart**
Brasil – Capoeira kids, 2002.
Colour print, dimensions
variable. Courtesy Neil
Stewart

[196–97] **Neil Stewart**
Editorial – ska band, 2005.
Colour print, dimensions
variable. Courtesy Neil
Stewart

[199] **Neil Stewart**
Editorial – ska band, 2005.
Black-and-white print,
dimensions variable.
Courtesy Neil Stewart

[202] **Gary Lee Boas**
*Gary Boas with Frank
Sinatra at Jilly's restaurant,
NYC*, late 1970s. Colour
photograph, 8.9 x 8.9 cm (3
½ x 3 ½ in). Courtesy of Gary
Boas and Dilettante Press

[203] **Bettina von Zwehl**
Alina, no.8, 2004. C-type,
46.4 x 59.8 cm (18 ¼ x 23
⁹⁄₁₆ in). Courtesy Bettina
von Zwehl

[204] **David Spero**
*Brigyn's, Tir Ysbrydol
(Spiritual Land),
Pembrokeshire, Oct*, 2004.
C-type print, 60.2 x 76 cm
(23 ¾ x 30 in). Courtesy
David Spero

[205] **David Spero**
*Communal kitchen round
house and chicken coop,
Tinker's Bubble, Somerset,
Feb*, 2005. C-type print,
60.2 x 76 cm (23 ¾ x 30 in).
Courtesy David Spero

[206 l] **Milena Bonilla**
121 Bohios Centro Hortúa,
from the *Plano transitorio
/Transitory Map* project,
2003. C-print, 15.4 x 18.4
cms (6 x 7.4 in). Courtesy
Milena Bonilla

[206 r] **Milena Bonilla**
Z-53 Betania, from the
*Plano transitorio/Transitory
Map* project, 2003. C-print,
15.4 x 18.4 cms (6 x 7.4 in).
Courtesy Milena Bonilla

[207 l] **Milena Bonilla**
E-21 Bilbao, from the *Plano
transitorio/Transitory Map*
project 2003. C-print, 15.4
x 18.4 cms (6 x 7.4 in).
Courtesy Milena Bonilla

[207 r] **Milena Bonilla**
E-48 Verbenal Lijacá, from
the *Plano transitorio*

/Transitory Map project
2003. C-print, 15.4 x 18.4
cms (6 x 7.4 in). Courtesy
Milena Bonilla

[208] **Adam Broomberg
and Oliver Chanarin**
*Naema Erasmus, 11,
Mannenburg, South Africa*,
2004. C41 print, 102 x 127
cm (40 ³⁄₁₆ x 50 in). Courtesy
Adam Broomberg & Oliver
Chanarin

[209] **Adam Broomberg
and Oliver Chanarin**
*Mandlenkosi Nopqhayi, 19,
Motherwell, South Africa*,
2004. C41 print, 102 x 127
cm (40 ³⁄₁₆ x 50 in). Courtesy
Adam Broomberg & Oliver
Chanarin

[210] **Ori Gersht**
The Clearing. Trace 1, 2005.
C-print mounted on
aluminum, 82.6 x 100.8 cm
(32 ½ x 39 ¹¹⁄₁₆ in). Courtesy
Ori Gersht

[213] **Jackie Nickerson**
*Chipo, Farm Worker
Zimbabwe*, 1997. Lambda
photograph, 149.9 x 119.4
cm (59 x 47 in). Courtesy
of Jack Shainman Gallery

[214 l] **Hajo Rose**
*Self Portrait from the
Bauhaus I portfolio, (1910–
1989)*, 1932. Photomontage,
22.9 x 17.1 cm (9 x 6 ¾ in).
© Rudolf Kicken Galerie,
Cologne, 1985

[214 r] **Cindy Sherman**
Untitled (Bus Riders), 1976
–2000. Black-and-white
photograph, 18.3 x 12.7 cm
(7 ³⁄₁₆ x 5 in). Courtesy of
Metro Pictures

[215] **Ed Ruscha**
*Phillips 66, Flagstaff,
Arizona from Gasoline
Stations*, 1962. Gelatin
silver print, 49.5 x 58.4 cm
(19 ½ x 23 in). Courtesy
of The Margulies
Collection

[216] **Justine Kurland**
*Gibraltar (Highway 1,
California)*, 2000. Satin
laminated c-print, 76.2
x 101.6 cm (30 x 40 in).

Courtesy of Mitchell-
Innes & Nash

[217] **Albert Renger-
Patzsch** *Machine Detail*,
c.1950. Vintage silver print,
16.6 x 22.6 cm (6 ¹¹⁄₁₆ x 9 ⅛
in). Courtesy of The
Margulies Collection

[218] **Andreas Gursky**
Prada I, 1996. C-print, 132
x 224 cm (51 ¹⁵⁄₁₆ x 88 ³⁄₁₆ in).
Courtesy of The Margulies
Collection

[219] **Anastasia
Khoroshilova**
Maria Iwanov, 2004.
C-print, 100 x 72 cm
(39 ⅜ x 28 ⅜ in). Courtesy
of Galerie Ernst Hilger

[221] **Eva Leitolf**
*Youth in their parent's
bedroom, Rostock –
Lichtenhagen* (from the
'German Images – Evidence
in Rostock, Thale, Solingen
and Bielefeld 1992–94'
series), 1993. C-print, 66.5
x 53.5 cm (26 ³⁄₁₆ x 21 ¹⁄₁₆ in).
Courtesy Eva Leitolf

[222] **Eva Leitolf**
*Following the arson attack 20
May 1993, Bielefeld* (from the
'German Images – Evidence
in Rostock, Thale, Solingen
and Bielefeld 1992–94'
series), 1993. C-print, 66.5
x 53.5 cm (26 ³⁄₁₆ x 21 ¹⁄₁₆ in).
Courtesy Eva Leitolf

[223] **Ricarda Roggan**
Bett, Tisch und Eimer,
2002. C-print, 100 x 125
cm (39 ⅜ x 49 ³⁄₁₆ in).
Courtesy Galerie EIGEN
+ ART Leipzig/Berlin

[224] **Sabine Hornig**
Rear Window, 2004. C-print
face-mounted to Perspex,
150 x 190.5 cm (59 ¹⁄₁₆ x 75
in). © Sabine Hornig and
VG Bild-Kunst, Bonn

[225] **Sabine Hornig**
Radikal Reduziert, 2004.
C-print face-mounted to
Perspex, 140 x 183 cm (55 ⅛
x 72 ¹⁄₁₆ in). © Sabine Hornig
and VG Bild-Kunst, Bonn

[226] **Yto Barrada**
Toilet Lady, Tangier, 1999.

Colour print, 80 x 80 cm
(31 ½ x 31 ½ in). Courtesy
Galerie Polaris – Paris

[228] **Yto Barrada**
*Girl in Red, playing jacks,
Tangier*, 1999. Colour print,
125 x 125 cm (49 ³⁄₁₆ x 49 ³⁄₁₆ in).
Courtesy Galerie Polaris – Paris

[229] **Yto Barrada**
Wallpaper, Tangier, 2001.
Colour print, 60 x 60 cm
(23 ⅝ x 23 ⅝ in). Courtesy
Galerie Polaris – Paris

[230] **Josef Sudek**
Bread, Egg and Glass, 1950.
Gelatin silver print, printed
1982, 15.5 x 11.7 cm (6 ⅛ x
4 ⅝ in). © Rudolf Kicken
Galerie, Cologne 1982.
Courtesy Kicken Berlin

[231] **Albert Renger-
Patzsch**
Farbenkasten/Paintbox,
1925. Gelatin silver prints,
16.6 x 22.6 cm (6 ¹¹⁄₁₆ x 9 ⅛
in). © VG Bild-Kunst, Bonn.
Courtesy Kicken Berlin

[232] **Heinrich Riebesehl**
Schillerslage, Hannover,
1978. Gelatin silver prints,
24 x 32 cm (9 ⅛ x 12 ¹¹⁄₁₆ in).
© Heinrich Riebesehl.
Courtesy Kicken Berlin

[233] **Hans-Christian
Schink**
A20 Peenebruecke Jarmen,
2002. C-print/diasec, 177.8
x 210.8 cm (70 x 83 in).
© Hans-Christian Schink.
Courtesy Kicken Berlin

[234] **Götz Diergarten**
Untitled (Gouville) 5, 2002.
C-print/Diasec, 100 x 100
cm (39 ⅜ x 39 ⅜ in).
© Götz Diergarten.
Courtesy Kicken Berlin

[235] **Götz Diergarten**
o.T. (Borrstadt 1), 1998.
C-print/Diasec, 80 x 60 cm
(31 ½ x 23 ⅝ in). © Götz
Diergarten. Courtesy
Kicken Berlin

[237] **Wilhelm Schürmann**
Verviers, 1976. Gelatin
silver print, 51 x 61 cm
(20 ³⁄₁₆ x 24 ³⁄₁₆ in).
© Wilhelm Schuermann.
Courtesy Kicken Berlin

Acknowledgments

[239] **Magnum collective**
Magnum Stories, published 2004. Phaidon Press
[240 l] **Raymond Depardon**
7x3, published 2004. Actes Sud
[240 r] **Magnum collective**
Euro Visions, published 2005. Magnum Steidl/Editions du Centre Pompidou
[241 l] **Bruce Davidson**
England / Scotland 1960, published 2006. Steidl
[241 r] **Henri Cartier-Bresson**
De qui s'agit-il?, published 2006. Gallimard
[242] **Lise Sarfati**
The New Life, published 2005. Twin Palms Publishers
[243] **Martin Parr**
Fashion Magazine, published 2005. Magnum Photos
[245] **Katy Grannan**
'In The Shadow of Wealth' cover (*The New York Times Magazine*), 19 Mar 2000. Courtesy Katy Grannan and *The New York Times Magazine*
[246] **Taryn Simon**
Photo from 'The Animal Self' (*The New York Times Magazine*), 10 Dec 2000. Courtesy Taryn Simon and *The New York Times Magazine*
[247] **Erwin Olaf**
Photo from 'You Think I'm a Smart Ass?' (*The New York Times Magazine*), 22 Jan 2006. Courtesy Erwin Olaf and *The New York Times Magazine*
[248 above, centre and below] **Eugene Richards**
Photos from 'The Global Willowbrook' (*The New York Times Magazine*), 16 Jan 2000. Courtesy Eugene Richards and *The New York Times Magazine*
[249] **Gilles Peress**
Photo from 'The Salvadorization of Iraq' (*The New York Times Magazine*),

1 May 2005. Courtesy Gilles Peress and *The New York Times Magazine*
[250 above] **Alfred Seiland**
Photos from 'Style: Hanging Gardens' (*The New York Times Magazine*), 16 May 2004. Courtesy Alfred Seiland and *The New York Times Magazine*
[250 below] **Vik Muniz**
Photos from 'Ready to Wire' (*The New York Times Magazine*), Fall 2004. Courtesy Vik Muniz and *New York Times Magazine*
[253] **Joel Sternfeld**
American Prospects, published 2003. Steidl Design at Steidl Publishers/Gerhard Steidl Druckerei und Verlag GmbH & Co.OHG
[254] **Robert Polidori**
Zones of Exclusion: Pripyat and Chernobyl, published 2003. Steidl Design at Steidl Publishers/Gerhard Steidl Druckerei und Verlag GmbH & Co.OHG
[255 l] **Robert Polidori**
Havana, published 2001. Steidl Design at Steidl Publishers/Gerhard Steidl Druckerei und Verlag GmbH & Co.OHG
[255 r] **Mitch Epstein**
Family Business, published 2003. Steidl Design at Steidl Publishers/Gerhard Steidl Druckerei und Verlag GmbH & Co.OHG
[256 l] **Arnold Odermatt**
Karambolage, published 2003. Steidl Design at Steidl Publishers/Gerhard Steidl Druckerei und Verlag GmbH & Co.OHG
[256 r] **Hiromix**
Hiromix, published 1999. Steidl Design at Steidl Publishers/Gerhard Steidl Druckerei und Verlag GmbH & Co.OHG
[257 l] **Mitch Epstein**
Recreation: American Photographs 1973–1988, published 2005. Steidl

Design at Steidl Publishers/Gerhard Steidl Druckerei und Verlag GmbH & Co.OHG
[257 r] **Frank Robert**
Story lines, published 2004. Steidl Design at Steidl Publishers/Gerhard Steidl Druckerei und Verlag GmbH & Co.OHG
[258 l] **Joel Sternfeld**
Sweet Earth – Experimental Utopias in America, published 2006. Steidl Design at Steidl Publishers/Gerhard Steidl Druckerei und Verlag GmbH & Co.OHG
[258 r] **Collier Schorr**
Jens F., published 2006. Steidl Design at Steidl Publishers/Gerhard Steidl Druckerei und Verlag GmbH & Co.OHG
[259] **Robert Frank**
New York to Nova Scotia, published 2005. Steidl Design at Steidl Publishers/Gerhard Steidl Druckerei und Verlag GmbH & Co.OHG
[261] **Libération**
9 May 1998. Courtesy Libération
[262 l] **Libération**
18 Mar 2003. Courtesy Libération
[262 c] **Libération**
27 May 1997. Courtesy Libération
[262 r] **Libération**
20 Mar 2003. Courtesy Libération
[263 l] **Libération**
17 May 1998. Courtesy Libération.
[263 c] **Libération**
30 Apr 2002. Courtesy Libération
[263 r] **Libération**
5 Aug 1996. Courtesy Libération
[264 l] **Libération**
22 Apr 2002. Courtesy Libération
[264 r] **Libération**
12 Sep 2001. Courtesy Libération
[265] **Libération**
25 Apr 2003. Courtesy Libération

Danke Mama und Papa. Für alles. But especially for introducing me to art before I could even spell my name. Cathal, thank you for being my flatmate, my family and for making me believe I could write this book. And thanks to Pacolito for giving me the strength to put in sixteen-hour days when all I wanted to do was have a wee nap.

Thanks to Tina Barney, Camilla Brown, Anton Corbijn, Thomas Demand, Rineke Dijkstra, Diane Dufour, William Eggleston, Charles Fréger, Dr Inka Graeve Ingelmann, Naomi Harris, Katherine Hinds, Rudolf Kicken, David LaChapelle, Mary Ellen Mark, Boris Mikhailov, Martin Parr, Rankin, Eugene Richards, Kathy Ryan, Sebastião Salgado, Stephen Shore, David Sims, Mario Sorrenti, Alec Soth, Gerhard Steidl, Neil Stewart, Dan Torres and Ellen von Unwerth for their inspired contribution, and to Janine Altongy, Janet Borden, Chris Burnside, Winston Eggleston, Barbara Gross, Annette Kicken, Montserrat Llaurado de Castellarnau, Meredith Lue, Vita Mikhailov and Fred Torres for their kind assistance. Special thanks also to Jamie Camplin, Rebeka Cohen and Anna Perotti at Thames & Hudson.

Index